(Re)Thinking "Art"

(Re)Thinking "Art"

A Guide for Beginners

Steve Shipps

Blackwell Publishing

BLACKWELL PUBLISHING

350 Main Street, Malden, MA 02148-5020, USA
9600 Garsington Road, Oxford OX4 2DQ, UK
550 Swanston Street, Carlton, Victoria 3053, Australia

First published 2008 by Blackwell Publishing Ltd

1 2008

Library of Congress Cataloging-in-Publication Data

Shipps, Steve.
 (Re)thinking art : a guide for beginners / Steve Shipps.
 p. cm.
 Includes bibliographical references and index.
 ISBN 978-1-4051-5563-2 (pbk. : alk. paper) — ISBN 978-1-4051-5562-5
(hardcover : alk. paper) 1. Art. 2. Art—Language. I. Title. II. Title: Rethinking art.

 N7425.S53 2008
 701—dc22

 2007024789

A catalogue record for this title is available from the British Library.

Set in 10/12pt Galliard
by SPi Publisher Services, Pondicherry, India
Printed and bound in Singapore
by Utopia Press Pte Ltd

The publisher's policy is to use permanent paper from mills that operate a sustainable forestry policy, and which has been manufactured from pulp processed using acid-free and elementary chlorine-free practices. Furthermore, the publisher ensures that the text paper and cover board used have met acceptable environmental accreditation standards.

For further information on
Blackwell Publishing, visit our website at
www.blackwellpublishing.com

Contents

Illustrations

Preface

This book grows out of bewilderment, skepticism, and something like awe.

Forty years ago, fresh out of college and naïve about most things but few so much as art, I found myself starting all over again, largely on a whim, at the School of the Museum of Fine Arts in Boston. In three years there I learned volumes about how to *make* things that were evidently art ... but in the unlikely event that someone – my parents, say – had ever asked me what the term "art" *meant*, at base, I wouldn't have had a clue. Still, I muddled along through an eight- or ten-year career as a working artist ... until, in what turned out to be my last one-man show, the point of the conceptual installation piece I was showing utterly escaped everyone at the opening except for seven colleagues, and they only knew what I was doing because they'd already thought of it on their own. So now I not only didn't know what "art" meant, I couldn't see what good the art to which it presumably referred was doing anybody, either. At that point my skepticism took over; I quit making art, and started thinking about those things.

In the meantime I'd been teaching about art at Emerson College, having been hired away from the Museum School to help a colleague start a photography program in the Fine Arts department there. And in response to a plea from a Provost at Emerson some 20+ years ago, I dreamt up a course aimed at helping students who shared my bewilderment about the whole idea of "art." In it, I tried to share with them the way(s) in which I was coming to sort out that bewilderment.

If one is to believe student testimonials, that course, "The Artist and the Making of Meaning," has proven quite stunningly successful in bringing students into newly meaningful relationships with art. Many of those students have been artists themselves in one way or another (actors, film makers, writers); many have been interested in the arts, but like me, bewildered by and skeptical about them, especially lately; others have been mostly disinterested, and there only under duress, aka the dreaded "distributive requirements."

This book is essentially a transcription of that course, with adjustments and expansions here and there which have struck me as likely to be good ideas, as I've been typing. To quote from the course syllabus, this book will be "about thinking, about 'art.' It will offer a way to do that which has proven useful not only in thinking about 'art,' but in thinking about thinking itself."

Now as to the awe I mentioned. Thirty years ago, in the Whitney Museum in New York, I turned around and beheld Willem de Kooning's painting *Door to the River*, which I'd never seen or known about … and I'll never forget that moment, of … what? … absolute, visceral recognition, I guess, of some kind of truth that I knew inside myself but couldn't possibly explain in words until much later – and then, only haltingly. A few years after that experience of the de Kooning, in an eclectic summer show at the Boston Museum of Fine Arts, I happened on a small Renaissance altarpiece that was so inexpressibly beautiful that it literally made me gasp – and I would have told you at the time that I didn't care much about Renaissance altar pieces. When I finally got to Florence in 2003, I was afraid that Michelangelo's statue *David* would be a disappointment, given that I'd been looking at pictures of it for decades; when I actually stood before it, it brought me to tears, for no apparent reason (my son, then 13, thought I was nuts). I'll never forget sitting on the lawn one summer at Tanglewood, the summer home of the Boston Symphony, with a girlfriend and her grandmother, listening to Beethoven's "Pastorale" symphony while a thunderstorm rolled through the hills behind us just as the orchestra was playing the "thunderstorm" part of the music. Johnny Hodges' saxophone gives me chills, as does John Mellencamp's *Authority Song*. It took me about three readings of T. S. Eliot's poem *The Love Song of J. Alfred Prufrock* before I could recite it from memory, so deeply did it resonate. And so on.

So, don't let yourself be seduced, by all the apparent skepticism in the first few chapters of this book, into thinking that I think that "art" is some sort of hoax. I do not. It is not.

But the idea of it sure can be confusing. The numbers and range of people who have been helped in sorting out that confusion by the approach I'll offer here give me hope that you will be, too, no matter what your relationship to "art" may be at the moment.

As to that last consideration, perhaps I need to offer here a reassurance of sorts. This approach to the question of "art," as you'll see, ultimately implies that one's response *to* art has first and foremost to be based in one's own idiosyncratic reactions to it, and a close examination of those – before, or even in the absence of, any consideration of other people's established ideas and pronouncements about it. To me at least, that's one of the distinct benefits of thinking about "art" in the way suggested here.

But of course a lot of perfectly respectable people – possibly including you – may not feel that way. In their view, the approach we're proposing here – that *you* can figure out what artworks mean to *you*, on your own, and that that indeed would seem to be the most appropriate way *to* establish meaning for it – may seem irresponsible at best (and subversive, at worst). For it offers the possibility that in doing so, one might miss entirely the conventionally accepted ideas offered by the conventionally recognized experts. There's the fear that you may go out on too much of a limb, in making your own meanings for artworks, *so* far out indeed that you may lose sight of the "correct" understandings of what are thought to be definitive cultural artifacts. It's a legitimate concern, about art or indeed about anything else. And it's doubtless because so many people feel this way that I have students coming to me all the time, saying incredulously, "You mean ... you want to know what *I* think??!!?"

Well, yes I do; so I think should all of us. And with all due respect to those concerns about missing the "accepted" significance of an artwork, I know from long experience in teaching people to think about art this way that the more *thoroughly* one can explore the experience of an artwork and the more carefully one can articulate whatever "sense" one makes of it, the less risk there is of lapsing into self-indulgent free-association, and the more one's sense of the work tends to approach – or even augment – conventionally-accepted interpretations.[1] It's just that in the approach to art that I propose

here, one comes to those understandings – initially, at least – by one-self, rather than learning them as givens from books and/or author-ity figures. Doing that, of course, involves a lot more work than simply taking notes on received information and memorizing them; but it's also what can be empowering about all this (even makes it, at least potentially, "fun") and maximizes the potential for *new*, idio-syncratic insights, over and above the "given" ones. And as I've sug-gested, people who've tried out this approach to "art" seem overwhelmingly to like it, extra work notwithstanding.

So. That said, let's get on with it.

Note

1 At least one significant scholar corroborates this experience. See Eco, Umberto, "Interpretation and history," "Overinterpreting texts," and "Between author and text," in Stefan Collini (ed.), *Interpretation and Overinterpretation* (Cambridge, Cambridge University Press, 1992).

Acknowledgments

Thanks to so many people: first, as always, to Hayes Kruger and Tom Dahill for mentoring and inspiration, way back when; then to Deb and Harry for backing me at home, Jayne Fargnoli and Ken Provencher for backing me at Blackwell, Catherine Snow for backing me at Harvard; Clive Dilnot, Ellen Dissanayake, Mark Getlein, Sue Lezon, Jonathan Wilson, for backing me in writing; Stelios and Helen Moschapidakis for backing me in Crete (and here); Ned Bayrd, Tim Butterworth, Kathy Desmond, Sharon Kaitz, Roy Rubin, Sarah Sutro, for backing me, period; to all those at Emerson who've believed in me, usually more than I have myself; and many more.

Thanks.

Introduction: What's The Big Idea?

So ... what about this whole idea of "art"?

It's seemed to be such a *big* idea, in Western culture, for such a long time ... all those grand edifices built to house it, prices paid, claims of its being somehow essentially good for us, if not indeed the salvation of us all. But, what *is* the big idea, exactly, and how did we come to have it? Moreover, what of recent claims, by some of the people who think a lot about "art," that it's "over"? And if it were, what might *that* mean? These questions are the kinds of things we'll be dealing with in this little book. The idea is to give relative newcomers to the complexities of "art," lately, a broad basis for sorting them out.

But ... does that need a whole *book* (even a little one)? Most of us can – I'm sure *you* can – easily cite some clear examples of "art" things, probably note some characteristics that they share, maybe even think of some things that, as far as you know, *can't* be "art," or things that "art" can't be. Almost without question, though, whatever you suggest along any of these lines will be open to genuine challenge. There'll be acknowledged "art" things that aren't what you say they must be, to be art, or that are what you say "art" can't be, or a little bit of both ... because when you *do* think about it, this term "art" gets tricky. Consider just three examples (for now).

As it happens, when I began writing this book, an AM radio station in Boston was airing an ad promoting a rug dealer in one of the suburbs. In it, an announcer told us that people who know a little about oriental rugs will frequently turn back the corner of a rug that they're thinking about buying, and examine the underside. They can

tell by feel, he said, whether the rug is machine made (the back will be smooth and feel stiff) or hand made (the back will be bumpy, and supple). We're further told that those who look even more carefully will often count the number of knots per inch, in a hand-tied carpet ... and then the announcer abruptly says that "Some works of art" – still talking about rugs, obviously, but now not calling them rugs or carpets, but rather, "art," all of a sudden – "may have as many as three or four hundred knots per inch." The implication here seems to be that if a rug is handmade, to some high degree of "fineness" – expressed here as the number of knots per inch – it's more than just a rug; it qualifies as "art." Well, fair enough; most of us would readily accept such "fineness" as a valid criterion for describing something as "art."

But if it *is* valid, and something we can reasonably expect of artworks, by definition ... then what about the appearance, in the summer 2002 edition of the College Art Association's respected *Art Journal*, of an article on a young New York installation artist named Doug Fishbone? Having work featured in a journal as prestigious in the world of art as this one is amounts to absolute cultural acknowledgment that the work in question *is* "art," not only "art," indeed, but *"fine* art," worthy of inclusion in those museums and such. Fishbone's art/work, though, involved his having dumped, on three separate occasions at that point, huge piles of bananas (see cover) – as in, 25–40,000 bananas in each – in selected public spaces in the world, and then leaving them there, and recording, via seemingly "artless" snapshots, the dismantling of the piles by passers-by, who took the bananas home (Fishbone even gives out bags, to encourage people to thus take part in/of the work). That – and some writing by him about those banana piles and what happens to them (which reads more like radical sociology than traditional "artspeak") – is it. It's difficult, isn't it, to see this work as "fine" in anything like the sense we had in mind when we thought about that rug?

And then again, early in 2003, when my family and I arrived in Crete for a six-month stay there, and befriended the proprietor of our local convenience store, he asked me what I did for a living. "I'm a professor," I responded. "What do you teach?" Dimitri asked. "I teach about art," I replied, at which he looked puzzled, and called to his wife Maria, whose English was slightly better than his. "Again?" she requested. "Art," I replied, enunciating carefully. "Ah!" she cried, *"Technologie!"*

We could go on and on with examples like this, each seeming to give the lie to assumptions about "art" that we'd deduced from those that came before. So ... you begin to see the problem (which we'll be looking at further, later). What *about* this word "art," anyway, and that big idea that we're referring to when we use it?

Lately, as the examples above suggest, the term "art" has come to be used in so many different ways, to refer to such a radical diversity of things, that it has become next to impossible to tell whether any given thing might in fact *be* "art," or not ... and if so, in what sense. Given that confusion (and a number of other factors, which we'll also get to later), it has lately begun to seem that, well ... *maybe* "art" is a good idea ... *probably*, even. But then again, in some ways ... maybe it's not. Some philosophers and aestheticians have even put forward the proposition that though the idea of "art" may indeed have benefited us in various ways at various points in the past, at *this* point, it's not doing us much good at all, anymore. Their suggestion is that the idea has run its course, and thus that "art" – and with it, its history – have *ended*.

This is not the first time that serious thinkers-about-art have suggested that "art" was over (far from it); but it may be the first time that the situation that gives rise to the idea has been so readily recognizable, empirically, to those of us who are not professional theorists about it. For those of us who pay more-or-less passing attention to art things, whenever we can – either because we've had direct experience that doing so improves the quality of our lives in subtle ways, or because we've been conditioned to believe that it does – much of the artwork produced in the last, say, 50 or 60 years (certainly in the last 20), has seemed increasingly problematic. You yourself may not have dismissed Jackson Pollock's (in)famous "spatter paintings" of the 1950s, or John Cage's "sound works" (see Chapter 4) of the 1950s and 60s as "art," but you surely know people, whom you generally like and respect, who have. And artworks produced since the early 1980s have been even harder to understand as "art," in any of the ways we've been accustomed to doing so. Much of it, indeed – like Doug Fishbone's banana piles – is so difficult to distinguish from what we have long recognized as "non-art" as to make the effort seem hardly worth the trouble.

When I asked a class of college freshmen – all, as it happened, more in touch than most with issues of recent (Postmodern) art – whether or not Fishbone's work was likely to *be* "art," as far as they

could tell, nearly all of them said that it just couldn't be, regardless of its notable validation as such by *Art Journal* ... though they couldn't say why, exactly. I expect that the few students from that class who still remember that question, are still arguing about it (though they're likely forced to do so pretty much solely with themselves). To their teacher, at least, that in itself seems a good thing deriving from the "art" in question ... but more on that, later, too. For now, though, insofar as this is a fair example of a typical response to the arts today, the implication – that by and large, distinctions between "art" things and others are lately so difficult to establish as to be moot – is clear. And if that is the case, if practically speaking, such distinctions are *not* available, then as Arthur Danto, among others, has eloquently pointed out, the idea of "art," as opposed to anything else, *is* logically over.[1]

But ... now ... wait a minute. To judge at least by the claims of professional defenders and interpreters of the arts, including many of my colleagues, in introductory books and courses hither and yon, we humans have apparently produced "art" – that is, indulged in some or all of the behaviors we have lately *called* "art" – for 40,000 years, the whole of our history *as* humans. Are these people suggesting, even arguably, that now ... we're not?

In fact, that *isn't* what they're suggesting, at least not in the common, reactionary sense that often takes the form of "You call *that* 'art'? *That*'s not art – why, my three-year-old could (make that, do that, whatever)." To consider more closely what they probably *are* saying, we need to do some careful differentiating. We need to distinguish between at least three aspects of "art" to which the term is used, fairly seamlessly, to refer: the process(es) by which people produce the things that we think of as "art"; those "art" things themselves; and the social institution, the "art world," that has grown up over time, around both. And we need further to consider the term itself, "art," by which we refer to all of those things, to see how *it* works.

I want to address all this in a kind of reversal of the order in which it's traditionally been addressed in books like this one. That is, I want to approach it not so much on the basis of a consideration of artworks themselves (except as examples, here and there), and/or the physical processes by which they're made, but rather, first, by considering the *term*. Considering "art" in this way – not, first, as a body of objects and events, but rather as a linguistic phenomenon – can shed light on *how* the current crisis in the arts may have arisen. And I will suggest, further, that certain broad linguistic shifts in the

Western world in the last few centuries can point us toward at least one intriguing way of thinking about *why* it has.

In Chapter 1, then, I'll try to establish some very broad basics about how such terms work at all, at least usually, and about how we think in terms of them. In Chapters 2, 3, and 4, we'll consider how "art" may indeed have come, in its history, to work differently from most such terms, and whether the "history of art" – its processes and products – is in fact any different from the history of the term – the history of "art" – itself.

By then our question here – of what the idea of "art" at all might be – will be looming large, and in hopes of answering it by comparing and contrasting "art" with something that's sort of like it but different, Chapter 5 will look a little more closely at what languages are, and how they work.

Chapter 6 will offer one useful way of thinking, given all of the above, about what "art" might be thought to mean lately; and Chapter 7, examples of how, if one *does* think about "art" in this way, one would/could usefully respond to and interact with art *works*, of whatever kind.

Finally, in Chapter 8, I hope also to note some things about how we do use the term today, and about the sociocultural situation in which we do, that may bear pondering with regard to the question of whether indeed it *is* worthwhile to think about "art" at all, any more, or not.

I should perhaps emphasize that this book is meant only as a broad introduction to these concerns, and that hence I'll be dealing here almost exclusively in gists, and overviews, and big ideas. As far as I know, though, they'll all be true, or at the least, true enough to provide a better sense of how to think, in a pragmatically useful way, about the whole idea of "art." And the teacher in me feels that if, on that basis, they raise questions – as they likely will, at least for those who, like those students still scratching their heads over Fishbone's banana project, tend to like that sort of thing – so much the better.

Note

1 See Danto, Arthur C., "The End of Art," in *The Philosophical Disenfranchisement of Art*. New York, Columbia University Press, 1986. [See also Danto, Arthur C., *After the End of Art*. Princeton, NJ, Trustees of the National Gallery/Princeton University Press, 1997.]

Chapter 1

Being Human

If we're going to try, as we suggested we would in the Introduction, to understand the term "art" as it's used to refer to this rather confusing idea in Western culture, we need first to establish that in fact "art" *does* refer to an idea. This seems a bit counterintuitive, for it generally seems pretty obvious that we use most words to refer directly to *things* that *are* what the word suggests.[1]

But is that really the case? Imagine for a moment a single, specific, black-and-white cow, just standing in a field somewhere, being observed by three people – a dairy farmer, say, and a zoologist, and a member of a cult that happens to worship cattle. Now, each of those observers sees precisely the same cow, but they refer to it differently: the farmer is likely to call it a "Holstein," the scientist knows it as a "bovine," and the cultist sees it as a "god." So there are four words (including "cow"), at least, that can be used to point to the same specific phenomenon in the world, to that specific cow. They're not interchangeable, as you'll see if you try to say "It's time to milk the god," or "We must do what we can to behave as our Holstein would have us behave," while keeping a straight face. And they're all perfectly valid, though none of them change the fact of that cow itself, which is still just standing there in the field, as it was before anybody came along and started referring to it. Most words, then, refer to different *ideas* we have about aspects of the world, rather than referring in any essential way to those aspects themselves, or, for that matter, changing them any.

And "art" is no exception … except that in the case of "art," there's a curious sort of reversal going on. Our cow is just standing

there, directly observable to any normally functioning person who might happen by, regardless of the diverse words such persons might use to describe it, what diverse ideas of it, that is, they might chance to have. "Art," though, is only one word, and so presumably only describes one idea (however ill-defined, which of course is our issue here) ... but we can apply it to great numbers of diverse phenomena – indeed, to virtually anything at all. So, while I can't, if I wish to make sense, call an oriental carpet a "cow," I *can* call it "art." Now, how does *that* work?

In the name of trying to figure out how *all* this works – and in the process, what the idea behind this odd word "art" might be – we'll probably do well to review some basics about ideas and words per se. And here's the *most* basic thing: both ideas and the words we use to express them have necessarily to do with the fact that we human beings are *self-conscious*. (I know, I know – everybody is, well ... *conscious* of that; but on the other hand, some days we're more so than others, and in what follows here, we need to have it in the forefront.) That is, we humans experience ourselves, understand ourselves, describe ourselves, as *having* "selves," as being essentially autonomous beings, existing as distinct from everything else. "There's me," we say, however subliminally, "and there's ... all the rest of it."

It *may* be, in fact, that we're the only ones of whom this is so, and that accordingly it's *the* – not just *a* – definitive human characteristic ... though in fact that seems less and less likely. For what it's worth, the prevailing scientific view has long been that we humans do seem, at least, to be the only beings on earth of which this is true, with the possible exception of the whales and dolphins (research results on them are still pending). But there is also a considerable, and growing, amount of anecdotal evidence that suggests that this may not be the case, that other animals *do* exhibit varying degrees, at least, of self-awareness. Both of these positions have their avid defenders; nor is it necessary to our purposes here to decide this question one way or another, even if we could. Perhaps the simplest and safest way to describe the situation, then, is to note that, speaking strictly and carefully, we *know* that humans are aware of themselves, in their interactions with their environment(s), and that the Cetaceans *might* be ... but it seems most *likely* that no other animals (and almost certainly, no plants) are, *at least not to the same degree.*

And given that we are what *we* are, i.e., self-conscious, it is next to impossible for us to imagine what our experience of the world

would be like if we were *not*, if we were, that is, as the other animals have long been thought by the scientific community to be. It would certainly seem, though, that the most immediate difference between our experience of the world and (supposedly) theirs would be that without the "remove" that self-consciousness provides us, there would be no need for us to *have* ideas, to *think*, in the abstract, about anything ... for there would be no experience of anything to have ideas or think about.

Rather, in the absence of a sense of self, experience would presumably be of a kind of sensory continuum, of all-things-as-one-thing, in which everything would be *sensed* – one would feel pain, tickles, probably even elation or depression, and so on – but nothing would be *perceived*, as there would be no oppositions, no breaks in the sensed continuity of it all, *to* perceive (much less *con*ceive ideas about). Presumably, everything in such a consciousness would just ... Be, and there would only be an endlessly shifting Now. (This is a hard idea to "get," just because we *are* self-conscious.)

In such a coterminous relation with experience it would be possible, certainly, to learn more-or-less complicated patterns of pragmatic *reactions* to it – as, say, your Labrador retriever appears to do, and to a greater degree than does your guinea pig, not to mention your guppy – but there would be no *consciousness* of doing even that. And insofar as this characterization of consciousness other than our own may indeed be the case, for animals (and plants) other than ourselves, it suggests that, for better or for worse and to whatever degree, *they* live lives of *direct, unmediated* experience.

But we humans don't; indeed, we can't. Given our fundamental consciousness of "self" as distinguished from "other," we look out *at* the world, as it were; and we see it as composed of perceptible distinctions that mimic that fundamental one of which we understand ourselves to be a part. Just as there's "us" and "other," that is, there's also this and that, and these and those, making up our world. And so we humans *think*, about those distinctions we *per*ceive, and then we express our ideas, what we *con*ceive, about them. And we do that, of course, in language(s). Thus our human, *conscious* experience[2] is – in direct opposition (supposedly) to that of all the rest – *in*direct, and *mediated*.

Perhaps we should take a minute to be sure that that word "mediated" is clear. We're all at home lately with the idea of "the media" – radio, television, photography and film, the electronic media, and so

on; and we know too of "mediums" (in the original Latin, the plural of "medium" would be "media"), people who claim to be able to bring the spirits of the dead together with the living, for conversations. Mediums and the media are, if you think about it, essentially *interfaces*, that exist "in the middle," between spirits and people, or between events that happened somewhere else at some other time, and audiences who want to know about them (and so, turn on the seven o'clock news).

Those people and those audiences would have no *awareness* of those spirits' ideas or of those events without those interfaces, those intermediaries; and in the same way, humans have no *conscious* awareness of their experience, except through language. While that grizzly bear over there certainly "knows," at some level, that you're standing between him and that elk he was eating, he (presumably) doesn't think it over as we do, and decide what to do about it; he just reacts, and charges. When we see him charging, though, while we may surely react instinctively to some degree, we *do* think, too, about what to do ("Should I go for that tree? Play dead? What?"), by our nature (and ideally, fast), and *then* we do it. And when we think, we're describing the situation to ourselves, in *language*. Language exists "in the middle," between our conscious experience and our reactions to it; hence our experience is "mediated," in a way that the bear's – or that of any other (supposedly) pre-linguistic species – presumably is not.

And it's our nature, *as* humans, that this is so; just as beavers build dams, and flowers turn to the light, humans describe their experience. This idea of the "naturalness" of this "languaging" that humans do is important here, and in the name of making it as clear as we can, let's add now, to this fact of our self-consciousness, an impossibly cartoonish version of evolutionary theory – one that presents evolution as straightforward, simple, and fast (none of which, of course, it actually is).

If we consider those first two factors – our self-consciousness, and the apparent "naturalness" of it – in terms of this new silly one, we can imagine a scenario in which at some point, some time, some beastie would have been the first to evolve into this state of human self-consciousness. In truth, of course, it took a nearly infinite number of infinitesimal changes, over millennia, for this to happen. But in our cartoon version, some creature must have been the first, that is, to find itself looking around at the world, rather than just

participating in it, the first to recognize fully that – ohmigod – there's "me," and there's … Everything Else.

Thus faced with the chaos – for so it surely would have seemed – this newly self-conscious beastie (this proto-human, if you hadn't seen that coming) would have had to try to "make sense" out of it all, if only in the name of sheer survival. And it would have done so by identifying aspects of that chaos that seemed to have something to do with *it*self (for it couldn't possibly have dealt with it *all*, all at once) and then *relating* those perceived aspects, in ways that seemed to … "make sense" – which only it could recognize. Then, on the basis of those perceived, now *con*ceived, relationships, it would have proceeded, tentatively, augmenting and amending as necessary, as it went.

So, for instance (and to continue the silliness a little longer), our newly self-aware beastie might notice that sometimes, in hot, humid weather, the sky got really dark, and big jagged flashes of light came from it, accompanied by loud booms and rumbling noises … and sometimes, some of those flashes hit the ground. And sometimes when they did, circles of hot, reddish-yellow, flickering substance moved outward along the ground; and the ground that it passed over turned black … and when that happened, if you could find any bunnies in that blackened area, while they may have been sort of … charred, still they didn't run away like they usually did, and were much easier to chew. And pretty soon, if those things kept happening in that way, causal relationships would begin to be assumed by the beastie, who'd then proceed on the bases of those assumptions, at least until some experience came along to change its thinking about them, in which case, it would amend them accordingly.

As time went on, those tentative ideas, those tentative *descriptions of the world*, that did not need much augmenting or amending, would have begun to seem less and less tentative, more and more the way things essentially "were"; they would, that is, have morphed from hypotheses about how that beastie *supposed* the world *might be* understood, into established ideas of how it was *supposed to be* understood … to which ideas, other ideas about it could then be related. "Okay," our beastie might have thought to itself, "if I think about this thing in this way, then it only makes sense to think of that thing in that way …," and so on.

And eventually, when some other beastie crossed the evolutionary bridge into self-consciousness, rudimentary language would have

been developed, as a way of passing along these apparent under-standings in the abstract. If you wanted to explain what you knew about thunderstorms, for instance, but the weather wasn't such that there were any around to point to, you needed to find a way to refer to them. And in time, via the same process, metalanguage – basically, language that's used to talk about language – would have been developed too, so that you could refer to the language which was now understood as part of things over here on this side – as in "Oh yeah, and we've developed this thing called 'language' – see? I'm using it now."

And as the philosopher Suzanne Langer,[3] among others, has noted, so it has presumably gone, for us humans – that's just what we've all been doing, she suggests – ever since. Just as did the beastie(s) in this admittedly silly but perhaps not fundamentally misleading scenario, we humans have been thus *describing* the ideas we have about how the world seems to make sense, and sharing those descriptions, via language, since we *became* humans. We spend our time perceiving the chaos, beholding our experience of the world … and then trying to order that experience, by conceiving ideas about it, and *relating* them in ways that seem to make sense. And then we "relate" it again – this time in the sense of *describing* what we've conceived – to ourselves and/or to others, using language.

It may be difficult at first to think of ourselves in this way, because by now, so much of the world has *been* described, long since, and these descriptions have been presented to us as the way things "are" – as, for instance, the idea that there *is* "art." There's no sense of having figured these things out by ourselves, based on our own experience and speculation. But though we may thus be passive receivers much of the time, we still do "buy in" to those descriptions at some level, and then, one hopes (for this is how human progress happens) add our own ideas of how we think they might be somewhat adjusted to better effect. This is, indeed, the human condition … or at least, it's one way of *describing* it.

And if this brief chapter has served to present the first aspect of that condition – the beholding and conceiving and relating part – Chapter 5 will talk a bit more about the second, i.e., language. First, though, we'll look in the next three chapters at how this idea of "art" has evolved and manifested itself, from its roots in Western culture, until now.

Notes

1 Most languages include *some* words, which we might refer to as "func-
 tion words," which don't refer to much of anything, on their own, but
 instead serve just to make the language work as it does ... articles (like
 "the," or "a"), conjunctions (like "and," or "but"), and so on.
2 We humans surely have kinds of awareness and ways of knowing that are
 not conscious, too ... intuition, deep emotional responses, understand-
 ings of the world held so long as to have become virtually instinctive,
 and so on. But our *conscious* functions are our primary concern here.
3 Langer, Suzanne K., *Philosophy in a New Key*. Cambridge, Harvard,
 1957.

Chapter 2

The History of "Art"

If we think back now to our imaginary proto-human beastie – the first to *per*ceive the world, *con*ceive how it might make sense, and coin a linguistic description for that conception ... and then if we acknowledge Langer's idea that what that beastie was doing was basically what we humans have been doing, ever since ... it should be obvious that somewhere along the line, we English-speakers must have had the idea that a part of our experience could be seen as different from all the rest, and was likely something we might want to talk about, and we decided to call it "art." This seems to have happened, in fact, in the thirteenth century, when the word first appeared in the language. And at the time, its referent was quite clear: "art" meant human skill, and could be applied to virtually any such skill, from mathematics to fishing.

But by the mid-eighteenth century, a fundamental shift was well under way. While the term was still used, as it always had been, to refer to human skills, it was now increasingly used to refer as well to objects and events that were the products of *some* of those skills. And in that usage, "art" connoted not just technical prowess, but also a difficult-to-demonstrate complex of such qualities as creativity, inspiration, eloquence, some degree of genius or "vision," and, at least in a secondary sort of a way at that point, physical beauty – all of which were thought to be present, in "art" things or in their makers, at levels well beyond the norm. This changing referent for "art" was in fact a shift not only in the meaning of the term, but in the very way it *did* mean, as we shall see, and its effect was to make it much harder to know just how the term might *be* meant, in any given usage.

Today, that confusion is still with us. It's difficult for most of us to say with any certainty what we mean, lately, when we say that something's "art." Those of us who care enough to consider the question at all (presumably including you, if you're reading this book) may suggest that the difference between a thing that's "art," and a similar thing that isn't, lies in the presence, or lack of it, of just such qualities as those noted above. We may also have the sense that the maker's intent has something to do with it, and/or the autonomy[1] of the thing, the degree to which it justifies itself, rather than serving some external, "non-art" purpose.

But as we've suggested, those various qualities are notoriously difficult to point to with any certainty; and intent and autonomy really don't qualify as criteria for the vast majority of today's acknowledged artworks (we'll consider this further in Chapter 3). So, what *does* "art" seem to mean, lately? As we noted in the Introduction, examples are easy to find, but the question remains: what is it about those examples that make them qualify as such?

If we try to figure that out by observing the ways in which the term is used, things only get more confusing. Lest there be any mistake about the implications of the application of "art" to rugs and bananas and "*technologie*," as noted in the Introduction, let's look again now at what happens when we take this approach. For most people, "art," unencumbered by any modifiers, means *visual* art, first. But we all know that it is used to refer to things beyond *just* visual art – there are the "Fine Arts" (which include, but are not limited to, the visual arts, or at least some of them, depending on how you mean "visual") and the "Liberal Arts" (which sometimes include the "Fine Arts," but not always); there are such apparent subcategories as "Commercial Art" and "Decorative Art" (both of which are visual, but usually not "Fine"), and "Applied Art"; there are the "Dramatic Arts" (which one does usually look at, after all, but which nonetheless are not thought of as "visual"), and dance (though one doesn't say "Dance Art" ... and does "the art of the dance" suggest that there's some dance that isn't?); poetry (which is one of the "Literary Arts," though many other sorts of writing aren't) ... and on and on and on. Are we including all of these when we speak of "The Arts"? (Perhaps, sometimes ...) And then there are all those book titles: famous ones like Ovid's *The Art of Love* and Sun Tzu's *The Art of War*, and less-famous ones on the "art" of virtually anything and everything else (gardening, beekeeping, Italian regional

cooking ...) ... are all *these* among "The Arts," too? Are they "art" in the same way that "Fine Art" is, whatever that may be? What about related terms, as, say, for people who *make* "art" ... are "artisans" and "artists" the same thing? If so, why the two terms (and what are "artistes")? Do conventional oppositions in the lexicon tell us anything? Art and Design; Arts and Crafts; Art and ... Technology? You do see the problem.

If we give up on that approach, and try instead to determine the referent of "art" by deduction, from examination of a representative sample of things culturally acknowledged as *being* "art," the task becomes one of finding some common denominator that is shared by, say, the remains of ancient Anatolian villages, Beethoven's symphonies, some mummified Egyptian cats, folk dancing, certain old ship models, pieces of canvas covered uniformly in flat blue paint (more on this in Chapter 4), some furniture but not all of it, most poems, some jewelry, and arguably Madonna ... but *not* by the old four-cylinder Volvo engine, Big Macs®, *The* Madonna, or this book. Small wonder that by the middle of the twentieth century, most philosophers had pretty much given up on the assumption that there *was* some essential referent of "art," and so stopped trying to figure out what it might be ... or that by the end of that century, some of them were even beginning to wonder, as we've noted, whether indeed it made sense to use the word at all, anymore.

That latter question is, again, what this book is mostly about; and we need now to look a little more closely, in this and the next two chapters, at how we seem to have reached a point at which it could *be* a question. As we'll see, that shift in what and how "art" meant, which occurred gradually between the thirteenth and nineteenth centuries (most dramatically between the sixteenth and nineteenth), will prove to be the root of all the recent confusion.

Way, Way Back When

The idea of "art" in the original sense of the term – that referring to human skill, per se – existed in Western cultural history long before the thirteenth century, when the word first appeared in English. Its history extends back at least as far as the Classical Age, in which, of course, the roots of Western culture itself – notably, here, including its ideas of "art" – are thought to have first been

established. The ancient Greeks and Romans had different words –
the Greek *techne* ("τεχνη," which meant "an art or craft"), and the
Roman *ars* (the Latin root word for "art") – but they both referred
to essentially the same idea as did the English "art," 1,700 years
later. (And in fact, they still do, to my Cretan friend Maria, among
many others ... her word "*technologie*" is obviously a derivative of
that ancient Greek word.)

In Chapter 1, we noted the human propensity to see the world in
terms of *distinctions*; and when Greek authors first spoke of "*techne*,"
they were in fact referring to human activity in general, which they
saw as distinct from nature. Somewhat later, they used the term to
refer more specifically to human skills that could be taught and
learned, as opposed to those that couldn't, that instead were more-
or-less instinctive. But at no point did the great Classical thinkers
entertain the idea that "*techne*," or *ars*, referred to any such esoteric
and specialized and supposedly "inspired" activity as we take "art" to
mean today. Most of their concern about what they thought of as
"arts" had nothing to do with their being any sort of out-of-the-
ordinary phenomena, but rather with the same problem referred to
here, four paragraphs ago (and ongoing, obviously, to this very day):
how most sensibly to sort – as humans by their nature will do – these
observable human skills into coherent sets of distinctions. Which
"arts" shared what qualities with which others? Which were noble
and elevating, which mundane? ... and so on.[2]

This overriding Classical worldview of (some) human activities
as distinguishable from nature, and the pursuit of ordered distinc-
tions within that view, may – and should – remind us of our imagi-
nary proto-human, in the silly evolutionary scenario we described
in Chapter 1; but there was nothing silly about it for the Greeks.
One of the fundamental ideas the Greeks had about *their* world was
that it *was* ordered, and that the order that organized the world
was reflected in that of the human mind.[3] Hence inquiry into how
either of these might sensibly *be* ordered was of equal value, and
crucial to the understanding of both. This description of man and
nature as equally significant, and inextricably intertwined in the
world, was embodied in Classical mythology, in which mortals and
the gods of nature intermingled and interacted freely in constructing
the world as the Greeks described it, each partaking of the status
and characteristics of the other as the need arose.

It can also be seen as a source of the Classical emphasis on *mimesis*, on the attempt, that is, to mirror the appearances and experiences of nature. The Greeks and Romans saw mimesis as a definitively human pursuit, and as the whole point, accordingly, of those "arts" as they understood the term, which we still consider to be "arts" in our modern version of the term, today: poetry, theater, music, and dance (all of which were often conjoined, in ancient Greece); painting and sculpture; and (surely for them, maybe for us) oratory.[4] As far as the ancients were concerned, the imitation of idealized human experience, in any of those endeavors, *was* the "art," the skill. Painters manipulated plasters and pigments, and sculptors cut stone, to look as much as possible like idealized natural forms; orators used words, and poets and dramatists words and music and dance, to evoke responses which were clearer "distillations" of those their audiences knew, rather more vaguely, from "real" life. And these efforts resulted, of course, in what we now view – and so, experience as – some of the great examples of Western "art" in the modern sense of the term.

But when they were made, it's important to note, they were not that at all, for the idea that there was "art" in the modern sense of the term did not exist then, nor, accordingly, could one experience them as we do "art" today (we'll touch on this point in more detail in Chapter 5). All those great "artworks" were made not by people thought of as we now do those we call "artists," but rather by "artisans," craftsmen (often even by slaves, and anonymously), and they were understood and experienced at the time as simply examples of human skill, some better (mimetically) than others, of course, but nonetheless not appreciably different from the products of any other human knack. Indeed, at one point mimetic painting and sculpture – the very things we first think of today when we hear the word "art" – were thought of as essentially on a par with the ability to imitate animal noises; and for a long time they were considered inferior to most "arts," as they, unlike music or poetry or rhetoric, involved manual work, which the ancients held in contempt.[5]

These ancient ideas, of human skills as a category apart (albeit notoriously difficult to order), and of its expressive members as ideally mimetic, held sway in the Western world for two thousand years and more, up to and well beyond the thirteenth century, in which, as noted, we English-speakers acknowledged it in our culture by calling it "art."

Big Shift(s)

After the fall of Rome, though, as the Dark and Middle Ages progressed, the referent of "art" began gradually to shift, toward an idea of skills that were more specialized in ways closer to those which we typically assume of the term today. Much of that gradual shift had to do with the fact that the relationship between humankind and the rest of the cosmos was described very differently in medieval times than it had been in the Classical Age that preceded them. The old Greco-Roman idea of man and nature as essentially opposed, but as working together, as it were, to constitute the world, was replaced now in the prevailing Western view by that of the one Christian God, more powerful than either humankind or nature, overseeing both, and effectively mediating their interface.

If, that is, the citizens of Greece and Rome had experienced themselves as at least somewhat autonomous beings with at least partial responsibility for their own conceptions of and actions in the world, for medieval Christians (which in the Western world was nearly everybody) the fundamental issue in any situation was what God would have to say about it – in Richard Tarnas' words, "the basic tenets of their faith were … the very substance of their experience."[6] Not only human accomplishments, but indeed human worth itself, were now understood as functions, first and ultimately, of one's involvement in and adherence to the teachings of the church. This new view of things, coexisting with and in large part supporting the feudal system, manifested itself in a situation in which any of the *expressive* "arts" (see below) that were indulged were practiced almost exclusively by people who worked within or directly for the church.

In Athens, virtually all privileged male citizens (and to some degree at least, many females … though no slaves, of either gender) had been literate, with formal education in reading, music and rhetoric. In medieval times, however, a much smaller percentage of the populace – only those most directly involved with the church – had such access to such "arts." Monks copied and illuminated manuscripts, priests preached and, with their wealthy patrons, commissioned paintings and chants and cathedrals. Virtually everyone else, though – tens of thousands of illiterate churls and serfs and slaves, the socioeconomic heirs of the slaves of the Classical era – were more-or-less dutiful adherents to the teachings of the church

(for therein, after all, lay any hope they had of experiencing themselves as worthy beings), but not otherwise participants in it.

"Art" in the Middle Ages, then, though still understood as denoting human skill, began effectively to refer as well to *certain* skills, *certain* of the "arts" – those that we referred to a couple of paragraphs ago as "expressive." While most "arts" in the original sense of the term produced purely functional products like cooking pots or shoes or wagon wheels, whose quality could be judged on the up-or-down basis of whether or not they worked in the way they were intended to work, the "expressive" arts resulted instead in things that ... well, *expressed* ... intangibles, such as ideas or conventions or religious truths. And while they could certainly be judged on such bases as craftsmanship ("I *guess* this is a great text, but the penmanship's so bad I can't be sure ..."), or mimesis (the time-honored "My five-year-old could paint a better horse than *that!*"), the expressive "arts" *always* did what they were intended to do – they just did it more-or-less well.

And in the Middle Ages, given that these "arts" were pretty much the exclusive province of an elite group of churchmen, they came to be seen as likely more *God-given*, than as arising directly from mere human endeavor, the mere teaching and learning of more mundane skills. While these attributes may at the time only have been connotations attaching to the term, they would in time, as we shall see, come to be understood as at the core of its meaning, even as these "expressive arts" would eventually become what we generally think of today as "*the* arts."

In any event, the Middle Ages eventually wound to a close, in response to a broad range of shifting socioeconomic factors, most of which are not directly relevant to our purposes here. One of them though – the gradual emergence of a socioeconomic phenomenon that had not been a significant part of Western culture since the Classical Age – was. Since the fall of Rome, medieval Western culture had been made up of essentially two levels, two classes – the wealthy and powerful and, in much greater number, the not. There was of course a social class situated *between* these two broad ones – quite literally, a "middle" class, of merchants and the like, neither terribly rich and powerful, nor terribly not – but it was extremely small. For all those centuries, and for most of the people involved, this was the way the world had come to be described, and so to make sense: there were us, and them (and a mere scattering of other

folks in between), all justified in their sociocultural roles, indeed in their very existence, by their adherence to the Church. For all those centuries, this was the way the Western world was understood to "be" (and the way God, the great mediator of experience, was said to have said it *should* be).

As time went on, though, and in response to those complex evolutionary social and economic pressures, that middle class slowly began to grow; and as it did, it became increasingly obvious that the roles its members performed in the culture – having to do with commerce, communication, and so on – were in no way functions of religious dogma, but instead could be described only in terms of *secular*, societal, definitively *human* needs.

A New Description

The effect of this gradual but nonetheless radical shift in the configuration of the Western world was to necessitate an equally radical shift in thinking about it. Anyone who wished to "make sense" of the Western world in the fifteenth century and beyond was called upon now to describe it in a way that included the possibility of humans being worthy of consideration *in their own right*, rather than just as function(arie)s of the church. Such thinking about humans had not existed since the Classical era, and its rebirth (its re-*naissance*, in French) was one of the great watersheds in the history of Western thought – which came to be known just *as* (no surprise by now) the Renaissance. This Renaissance shift in the way humans and their abilities were described pushed the meaning of "art" much further in the direction of the specialized one(s) understood by most of us as attaching to it today. It did so in a number of ways.

By the time the new middle class had evolved to a point that demanded this vast Renaissance shift in thought, the *expressive* "arts" most familiar to the bulk of medieval society – all those illiterate feudal serfs – were the visual arts. For centuries, the masses – indeed, everyone – had been exposed to religious themes and stories and dogmas embodied in commissioned paintings and icons and architectural features, all designed primarily to instruct and reaffirm in them the truths and wonders of the faith which was the basis of their world. Oratory and music and even theater served these purposes too, but sermons and plainchants and plays were transitory: as far at

least as their audiences were concerned, they were by their nature there and then gone[7] ... whereas images, not to mention cathedrals, had lasting presence, and were there to stay, day in and day out. Hence, by the time the Renaissance began – and still today, as we've noted – the *first* "art" the term conjured for the majority was visual.

And much of this visual art was, we should acknowledge, sensually – and so, seductively – beautiful, made of ground lapis and beaten gold, hung in the light of marvelous stained-glass windows, in those soaring architectural spaces, the better to impress the faithful. But as the Renaissance began, the primary function of the expressive "arts" was still understood as primarily instructional, and/or ceremonial; the idea that "art" should be appreciated for its sensual beauty per se would not fully emerge for another two or three hundred years, as we'll see. The idea of "special," expressive "art" in the early Renaissance was still essentially what it had been in medieval times – this "art" (as opposed to the mundane "arts" referred to by the *old* meaning of the term) was made to accompany texts or commemorate specific social or political rites and events, or as noted, to instruct; and its "beauties," be they musical or poetic or visual, had to do only secondarily with how pretty they sounded or looked. First and foremost, the beauty of the expressive arts was that of the holy teachings or moral truths they embodied; effectively, one "looked through" the image or the words, as through a window, at their subject matter. Appreciation of their form, however splendid, came second.

As the Renaissance proceeded, though, and the renewed idea of human beings as worthy in *secular* ways took ever firmer hold, the expressive arts became more secularized, too. Visual artists' subject matter(s) gradually moved from the depiction of sweeping religious themes to images of rich people's day-to-day lives (we'll consider this again in Chapter 3). Music, which during the Middle Ages had been primarily liturgical (and/or studied as a discipline, closely related to mathematics), had by the sixteenth century moved beyond church confines into a broad range of secular forms. Theater, which had been essentially snuffed out by the church by the fifth century, then gradually resurrected in the church's service, had by the late sixteenth century reached a point where people of all walks thronged to the Globe Theater to watch Shakespeare's plays; and so on.

This gradual shift in "art" toward the secular was accompanied, too, by an equally gradual shift from emphases on the institutional

messages embodied in the "arts," to emphases on how those messages were presented. Wealthy patrons, commissioning more and more paintings and music for their own enjoyment, rather than for their churches, paid increasing attention to how those commissions looked and sounded, rather than focusing primarily on what they were about.

One breakthrough occurred in the visual arts, though, which was unique in that it was at once intellectual, and presentational, *and* a huge push toward secularism. Whether it was in fact a function of the renewed Renaissance respect for humanity in its own terms, or merely a stunning coincidence, is open to debate (though the latter explanation pushes the idea of "coincidence," as mere happenstance, to its extreme limits); but in any event, almost as soon as the shift in thinking that was the Renaissance had begun, two Italian architects finally succeeded in perfecting a system, called "linear perspective," for convincingly rendering the appearance of three-dimensional space, and forms within it, in two.

The ability to do this had been sought after by painters and draftsmen for centuries, but with only partial success at best, until the Renaissance. We know, of course, of the skill of the artisans in ancient Greece and Rome at reproducing the appearance of three-dimensional forms *in* three dimensions (i.e., sculpture), but what little two-dimensional art has survived from that era – mostly decorative painting from tomb walls, and mosaics – suggests that in that, they weren't so successful. And the religious painting of the Middle Ages – though it doubtless looked perfectly fine to observers at the time (as it was all they knew visual representation to be) – was notably "flat," by standards that have prevailed since the Renaissance; human figures, for instance, though clearly identifiable as such, in fact looked more like paper dolls on flat surfaces, than people in actual space (see Figure 1).

But with the mastery of formal perspective, the pursuit of mimesis, still perhaps the defining "artistic" skill, took a great leap forward. Renaissance painters, painting and drawing now for the benefit of audiences recently re-acknowledged *as* humans, were able to imitate with enormous accuracy how the world looked *to* humans; and they did so on the basis of a system based in mathematics (see Figure 2, which was painted a scant hundred years after the image in Figure 1). Whether or not it "caused" the invention of perspective, then, the Renaissance brought with it a new source of visual and intellectual wonder at the degree to which mimesis was now possible.

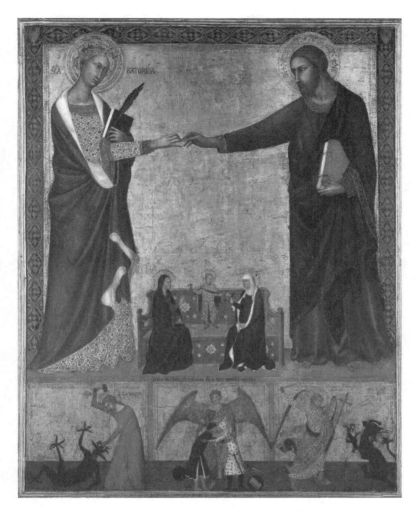

Figure 1 Barna da Siena, *The Mystic Marriage of St. Catherine* (ca. 1340), © Museum of Fine Arts, Boston. Sarah Wyman Whitman Fund / The Bridgeman Art Library

But still another shift in the understanding of "art" during the Renaissance was even more significant. The obvious implication of the "new" Renaissance view of humankind was that all those "artisans" who had plied their skills in these "arts" for centuries, often anonymously, were of course, like everyone else, autonomous *individuals*,

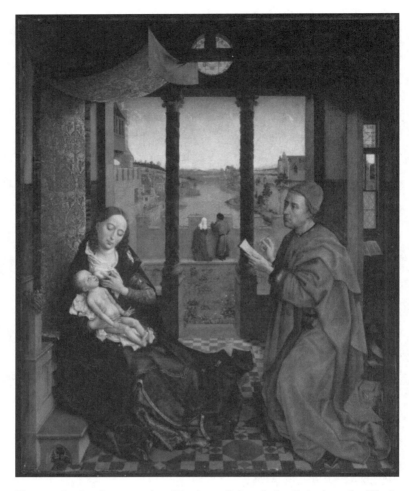

Figure 2 Rogier van der Weyden, *Saint Luke Painting the Virgin* (ca. 1435–40), © Museum of Fine Arts, Boston, Massachusetts, USA / Gift of Mr and Mrs Henry Lee Higginson / The Bridgeman Art Library

too. This was an idea that would have been next to impossible to have in Western culture, at least in any significant way, five hundred years before; and its most immediate pragmatic impact was that now, if a wealthy patron needed, say, the bedroom wall painted, he no longer simply went to the painters' guild[8] and asked to have some

journeyman come up and do it, as one would essentially have done for centuries. Now, increasingly, it was possible to acknowledge the talents of specific individual artisans, perceived as in some way(s) better than those of other individuals in the guild, and to seek out those extraordinary talents by name ... as in, "Oh, say ... is Botticelli free?"

As this new acknowledgment of individual human talent went on, it began to seem that while there were still artisans, of course, some of them were *so* good at what they did that they ascended to the level of ... well, "art*ists*." That word first appeared in English in the sixteenth century, and its progenitor, the Latin *artista*, had been around for a long time before that (the question of whether there was a word for "artist" in ancient Greek is notoriously problematic). *Artista*, though, had referred in the Middle Ages to practitioners of the "Liberal Arts" as they'd been defined in medieval universities – grammar, logic, rhetoric, arithmetic, geometry, music, and astronomy. And when the English word appeared, it was variously used to refer not only to those same practitioners, but also to men of science, and to physicians, astrologers, alchemists, and chemists, *and* as a synonym for "artisan."[9]

Still, as time went on, "artists" came to be *generally* understood as those whose skills were superior to those of "artisans," of a higher order, in an emerging difficult-to-define, though doubtless *human*, way ... and as this happened, the perceived "elite" character of "artists" began too to become secularized, to shift away from its original connection to the church. (Nor was it any coincidence, surely, that the word "genius," which had been available in English for 200 years as meaning "guardian spirit," began in the sixteenth century, too, to be used to refer to individual human "dispositions," tendencies to behave in idiosyncratic ways, such as those we now ascribe to "artists.")[10]

There is perhaps no better evidence of how the idea of "art" was shifting in the so-called "High" Renaissance than the publication by an Italian artist and writer named Vasari of a book entitled *Lives of the Most Excellent Painters, Sculptors, and Architects* (1550, expanded 1568), a collection, as the title suggests, of biographies of well-known visual artists working between the fourteenth century and Vasari's own time.

Vasari did not, you'll note, refer in his title to "Most Excellent *Artists*," though as we've seen, the term (or its Italian equivalent)

was available to him – it had been, and was, used to refer to a range of pursuits that had begun even then to approach the diversity of our own usage today. Perhaps Vasari was avoiding the potential for confusion, then, by referring to his subjects in terms of their trades – "arts" in the *old* meaning of the term – as they would have been referred to for centuries.

But in any event, he did write the book, and only about *selected* individuals – only those he saw as the "most excellent" of their kind, made the cut. And for Vasari, the distinction between run-of-the-mill artisans and the "most excellent" ones had become very clear by 1550, though that distinction was surely less clear to people who were not themselves directly involved in the "arts" to the degree that he was. Vasari himself makes this point in his biography of Giotto, the brilliant Italian painter of the late thirteenth/ early fourteenth centuries, in which he tells of a man who tried to hire Giotto to decorate his belt buckle. This man, clearly, still took "art" to simply mean "craft," and so saw Giotto as a craftsman – which of course he was, at one level. Vasari, however, obviously entertained the newer, emergent idea of "art" as referring to *special* talent; as Edwards suggests, for Vasari, "this man's mistake was a testament only to his stupidity and Giotto's refusal of his request signified his real standing."[11] Clearly, even in the High Renaissance, there was "art" (in the old sense) ... and then again, there was "art" (in the new).

In the Public Interest

And in the centuries between the High Renaissance and the eighteenth century, the idea of these *special* "arts," produced by elite "artists," became ever more established, ever more the way the Western world "was"; and the interests and products of those "artists" became ever more secularized, as noted. Those "art" products also, it's important to note, became ever more popular, ever more the object of public appreciation and wonder ... for they were now understood to have been made, after all, by people who were specially talented, maybe, but otherwise not *so* different from thee and me.

From our own perspective in the twenty-first century, with the "Fine Arts" by now widely perceived as elitist, arcane pursuits, far

removed from the concerns of most of us, it's hard to imagine the levels of public involvement in the arts that continued to prevail in Europe until not so very long ago at all. As indexes to this, though, consider two historical examples, both, as it happens, from France.

For one, in the mid–late seventeenth century, Louis XIV, the "Sun King" and for well over 50 years the single most powerful figure in the Western world, took due note of the rising middle class and realized correctly that if things continued as they were, that class would in time wield political power to a degree that would threaten, at least, the long-established rule of "Kings-appointed-by-God" … like himself, and, hopefully, his heirs. At least partially in an effort to forestall this, Louis abolished the artisans' guilds that had been a part of Western culture for centuries and which had allowed the artisans in them considerable professional autonomy, and replaced them with state-run agencies, among them, most notably for us, the *Académie royale de pienture et de sculpture* (loosely, the Royal Academy of Painting and Sculpture). Louis' *Académie* now took over the training of painters and sculptors; and it trained them to paint and sculpt not, as we might expect today, in idiosyncratic "artistic" response to the culture in which they worked – the culture, remember, that increasingly threatened the nobility's hold on power – but rather to produce imagery reminiscent of that which had been produced back in the last time when kings *were* kings (or back then, *Caesars*) and everybody knew it – in, that is, the Classical Age. And once artists had been thus trained, the Academy continued to influence what sort of art they made, now via commissions for paintings and sculptures that demonstrated the same state-backed focus on the "good old" Classical days when things – most importantly, social roles and issues – had been clear and ordered.

In this regard, at least, the Academy's emphases amounted to a huge, subliminal propaganda push aimed at keeping a grip on control of the masses. Whether the effort by Louis' *Académie* to control taste in the visual arts indeed succeeded in forestalling the French Revolution for awhile would be difficult to say. But the fact that he even hoped it might, speaks to our point here. Were such a campaign mounted today, when only the so-called "arts community" pays any attention to such puzzling "Fine Arts" products as large piles of bananas and (in the skeptical view) "worse," any campaign to shift

the overall sensibilities of the public by controlling the "Fine Arts" would surely fail – for how many would even notice, really? Perhaps a campaign to manipulate the so-called "Popular Arts" (more on that distinction in Chapter 4) would have greater effect ... but in the seventeenth century, no such distinction existed. Notwithstanding what appear from here to have been implicit issues of which subcategory of "art" was in play when, the expressive "arts" *at all* were of great and immediate interest to virtually *all* of the public.

Nor, to cite our second example, had this fascination fallen away by the time the eighteenth century began. Early in that century, the *Académie* began mounting annual (then biannual) public exhibitions of visual art called "Salons," which showed, at first, the work of recent graduates of its programs, then in time, of what it deemed the best painting and sculpture of the preceding period, from France and beyond. Framed works were hung side-by-side and top-to-bottom in huge public halls, with the larger works hung up high and cantilevered out at angles, the better to be seen by the audience on the floor ... and every year or two for close to 200 years, people from all walks of life, street sweepers to royalty, thronged to gaze up at them, and marvel at their – what else could we call it, by now? – artistry. And again, this "artistry" was exhibited in works that had been deemed *most excellent* examples – not just any skilful artistry made the Salons, only the *special* work, of a *specially talented* breed of artists (whose careers as such, incidentally, were pretty much assured once their work began appearing in the Salons).

It may be occurring to you to ask how the "most excellent" examples were decided upon; who chose? And the answer is that, at least at first, the members of the Academies (there were others, that followed the French) chose, or at least, those members who sat on juries at any given place and time. This is surely not surprising, given the roots of the Salons as we've described them. These academics were now becoming the arbiters of taste in the visual arts; they dictated what "art" would be and what would be "art," and they chose the best of the latter to convey their ideas to the public. In this, they formed the beginnings of what would in time become the "power structure" of the "art establishment" that would grow up around the arts in the nineteenth century and beyond.

That brings us to far and away the most fundamental of all the Renaissance and post-Renaissance changes in the meaning of "art."

A Whole New Sort of Category

For the emerging "new" meaning of "art" – as arbitrated, first, by the Academies – was not only a change in *what* "art" meant, but also the beginning of a fundamental shift in *how* it did. As it was beginning now to be understood, "art" no longer referred simply to the "natural category" of human endeavor per se (however well- or ill-sorted) to which it had referred for thousands of years; now, it began increasingly to be used instead as a selective term, which referred to a *constitutive* category.

"Natural categories" are those that include human experiences that can objectively be seen to exist in the world, independently, at least in essence, of our subjective descriptions of them. All those classical Greek and Roman statues, for instance, *were made* and *are there*, empirically available, as such, no matter who encounters them when, nor how they're described – as "art," or as "craft," or as "decoration," or whatever. In the same way, there are four-legged furry domesticated animals, most of whom bark, in the world, whether one describes them as beloved pets or as stew ingredients (and there's our "cow," from Chapter 1); and there is an emotion called (in English) "love," whether we characterize it as a glandular function, or divinely inspired, or a "compendium of needs,"[12] or whatever ... and so on. The only criterion necessary to a "natural category" is that it be *objectively discernible*, as such, in the world.

And the empirically observable presence of the members of a "natural category" tends to delimit, to some degree, what we can sensibly say about them, and to make what *is* said of any given member, go for all. Thus, while you might describe, say, a great boulder as a "bulwark," or even (metaphorically) as a "sculpture," you can't sensibly call a boulder, say, a "wink," because ... well, *there it is*, there's a really big rock, and it's clearly *not* a "wink" (there's not even enough similarity between the two to hang a metaphor on) ... nor are any other boulders, insofar as they are observably boulders, "winks" either.

We know by now that for two thousand years prior to the Renaissance, "art" had meant this way too, referring to skills that, call them what you will, humans clearly demonstrated. But as it began to be understood during the Renaissance (and has been increasingly understood since), "art" means differently, too, and in its newer, expanded meaning *it has no such objectively observable*

referent. "Art," understood now as a subjectively determined (by the Academy or by anyone else) complex of qualities, denotes not a "natural" category, but a purely linguistic, *constitutive* one: what is described as "art," what is *said* to be "art," *becomes* "art."

As we'll see in Chapter 5, this is true purely as a linguistic function – how we describe a thing is how it is, for us. But in the absence of an objectively observable natural category to back up one's description, it becomes even more pointedly the case. Now, if I call a thing "art," it becomes "art," if only long enough for us to argue about the designation ... and the argument is ultimately won, the designation determined as valid or not, not according to any objectively observable characteristic of the thing itself, but purely according to what the winner *says* about it. Thus "art" in this sense is a subjective determination that we *add to* certain members of preexisting "natural categories," which purely by virtue of *being* so designated thereby become something *other*, something more, than other members not so described.

Now things get a little complicated here, due to one more aspect of the thoroughgoing public fascination with the "arts" that we were discussing in the section above. As that enthusiasm for the new, now secularized "arts" continued, an even more subtle shift in what "art" meant was taking place. As it became more and more accepted that there *was* "art" in the new sense of the term – there was the evidence, after all, hanging in the Salons, as obvious to all as were those boulders we mentioned – the term came increasingly to refer not, as it had for centuries, to sets of skills that practitioners possessed – not, that is, to the *work of "artists"* – but rather, now, to the *works of "art"* themselves, that the "artists" had produced. This idea has of course also held sway until the present day, or at least nearly so (more too on why *that* began to change, in Chapter 4).

This shift in the conventional understanding of "art" may seem to suggest that those "art" things hanging in the gallery are part of a "natural category," just like boulders – I mean, again, there they are, all those paintings and sculptures (and writings and dances and songs, in other "art" venues). But in fact, what is "there" on the walls is an assortment of discrete surfaces with colored mud on them, most of which tend to look like something else – that's the "natural category," if there is one ... and it's only *selected* members of even *that* category that make the curatorial, constitutive cut, and become "art."

So, beginning in the Renaissance, one could describe Botticelli's wall painting as more "art"-like, in the dawning new sense of the term, than that of most of his fellow painters ... and so, it was. And the term has meant in that way, until the present day. By now, colored mud applied to canvas by acknowledged artists *is* art, by any conventional linguistic measure; while colored mud applied to the clapboard on my garage by Jimbo's Fly-By-Night Painters, *isn't*, no matter how skillfully it may have been done; and so on. What all this suggests is that the *recent* referent of "art" has been, increasingly since the sixteenth century, the __new idea__ of "art," per se, and *only* that. (And insofar as the term "art" seems a little ... suspect, relative to other terms like, say, "boulder" and "wink," this is probably why.)

So ...

... let's take stock. We've established that for the vast majority of its history, "art" has been synonymous with "skill," essentially. And as Ong has pointed out, "The elements out of which a term is originally built usually, and probably always, linger somehow in subsequent meanings, perhaps obscurely but often powerfully and even irreducibly."[13] So it seems clear that much of the time, when we use or hear the term "art" today, it is likely meant essentially as it *used* to mean exclusively, though now perhaps with occasional overtones of those other qualities, such as elitism, genius, beauty of one sort or another, even divine inspiration, that have been added since.

And for the rest of the time, the term does *seem*, at least, to amount to little more than a positive value judgment, describing various individuals' idiosyncratic, subjective descriptions of various things that people do or have made, at various points in time, which they have perceived as having qualities such as those noted above, in inordinate degree. If I describe a thing a certain way, and if I'm being honest with myself as I do, then that thing *is* for me as I've described it; and this is absolutely the case with "art," whether I apply the term to velvet paintings of Elvis, or Renaissance portraits, or Madonna, or a twelfth-century footstool, or whatever. As far as this goes, "art" is in the eye of the beholder, and nobody can deny the validity of that idea.

The bothersome question that begins to emerge from all this, though, that makes the idea of "art" seem a little ... suspect, as we've

suggested, is whether the idea of "art" is in fact any *more* than just idiosyncratic value judgment.

At this juncture it seems possible, at least, that that's all there is to it. In Chapter 6, we'll propose a way to think of it as more than that. But before we do, we need to consider that the idea of "art" referring *just* to idiosyncratic value judgments doesn't account for the status the idea seems to have achieved in Western culture. Among other things, it leaves open questions of how a bunch of seemingly random value judgments could constitute anything like a coherent "category," and of how things that you *don't* think are art, clearly are, in the overall perspective of the culture. What we need to do next, that is, is consider how the idea of "art," in its newer, more *specialized* sense, became *institutionalized* in Western culture; and then, what happened to it once it was.

Notes

1 Berger, Karol. *A Theory of Art*. Oxford, Oxford University Press, 2000. (p. 113).

2 Kristeller, Paul Oskar. "The Modern System of the Arts," in *Renaissance Thought and the Arts*. Princeton, 1980 (p. 166).

3 Tarnas, Richard. *The Passion of the Western Mind*. New York, Ballantine Books, 1991. (p. 69).

4 Kristeller, op. cit. (p. 171).

5 Kristeller, op. cit. (p. 171).

6 Tarnas, op. cit. (p. 169).

7 Orations could be – or could have been – written down, of course; and modern musical notation, which began to be developed in the ninth century, was essentially in place by the end of the fourteenth. But neither of these factors would have had any effect on the experience of the illiterate faithful.

8 Throughout the Middle Ages and beyond, artisans and craftsmen organized themselves into "guilds," professional organizations that more-or-less controlled training procedures, rankings, cost structures, production standards and the like in their areas of pursuit. The guild system weakened as the growing middle class threatened to usurp political power once held exclusively by the kings, who responded by co-opting the guilds and/or replacing them (as in France) with state-run agencies; most European guilds had been dissolved by the end of the eighteenth century.

9 *Oxford English Dictionary*, 1987. (p. 475).

10 Ibid. (p. 143).

11 Edwards, Steve, ed., *Art and Its Histories: A Reader.* London, Yale University Press, 1998. (p. 91).

12 Parker, Robert B. *A Catskill Eagle.* New York, Penguin, 1987. (p. 264).

13 Ong, Walter J. *Orality and Literacy.* New York, Routledge, 1982. (p. 12).

Chapter 3

The "History of Art"

The emerging "new" idea of a "special" art continued to develop and manifest itself in various ways throughout the eighteenth century – one of the many ideas developed and manifested during that period. For the eighteenth century, also known as the Enlightenment and/or the Age of Reason, was best known for its thoroughgoing fascination with what had come to be thought of as the defining quality of secular humankind – its capacity for *having* ideas. Throughout the period, inventions and scientific breakthroughs followed closely upon one another; philosophers pondered the nature of the intellect;[1] composers wrote variations and fugues based on intellectual formulas;[2] poets extolled ideas per se;[3] encyclopedists kept track of all this and more.[4] Late in the century, the middle class finally acted on the very *big* idea that it should assert its status as the new body politic, and in a stunning series of political revolutions – most famous among them the French and American, though there were several others – broke with and overthrew the monarchies that had held sway over it for centuries. Those revolutions, and the new descriptions of the world that *they* mandated, were the dawning of what came to be called the Modern Age.

Roughly coincident with those revolutions, and largely in response to a revolution of a very different kind, as we'll see, the idea arose that a "history of art" – of "art," that is, in the "new" sense of the term – should be developed. This history, as it took shape, amounted to the final institutionalization of the new idea of "art" as part of the way the Western world described itself.

Before that happened, though, two other things transpired, both of which proved integral to the way most of us now think about art – and both of which served to further confuse the issues of what this new "art" was, and of what was "art."

The first of these was more-or-less coincident with the establishment of the academic Salons. Given the immense popularity of those Salons throughout the eighteenth century, it will perhaps come as no surprise that the period also saw the establishment of the first public museums in Western culture. Private collections, of "art" and/or of other "special" things of various kinds, had long existed in the homes and cathedrals of the rich and powerful, both in Europe and in other parts of the world. And in the seventeenth century, as the middle class in Europe grew, people who were not so rich and famous, but simply well-to-do, also frequently kept in their homes collections of things that they found remarkable in any way – artworks, other seemingly unique or beautiful creations and curios, odd or exotic natural objects; these came to be known as "cabinets of wonder" (or *Wunderkammern*), after the cupboards in which they were often displayed. But access to any of these collections had traditionally depended on a privileged *entrée* of one sort or another – only members of the court might view the collections of that court, or perhaps one might be included in occasional invitation-only showings; or at least, in the case of the humbler cabinets, one needed to know the owners.

But in the face, again, of that rising middle class, the idea began to emerge late in the seventeenth century that these collections might be displayed to the public. In the first appearance in English of the word "museum," Oxford University's Ashmolean Museum opened in 1683 to display the natural history collections of John Tradescant, a former gardener to Charles I. And throughout the eighteenth century, the idea spread. The Uffizi gallery in Florence began when the Medici family bequeathed their art collection to the city in 1737. The British Museum opened to the public on a limited basis in 1753, exhibiting some of the nearly 70,000 treasures of Sir Hans Sloan, a physician and naturalist. The first of the Vatican's museums opened in Rome in 1756. In Paris, the Louvre opened in 1793, displaying the art collections of French royalty. And so on.

The advent of these public museums was surely the tangible beginning of the institutionalized confusion about the term with which this book is concerned. For again, while some of these new

museums, like the Uffizi or the Louvre, showed only artworks, others, like the British Museum, showed artworks too, but also curiosities of the natural world. And museums like the Ashmolean showed no "art" at all.

Still, they were all museums, and new to the public, and their displayed collections – of whatever sort – were thus rendered "special" by virtue of being displayed at all. And *this* "specialness" attached equally to the "art" things that were displayed *and* to the non-"art" ones. Thus began our current confusion about what might be "art" in a given museum, and what not, exactly, and why.

Further, what was exhibited in the museums, and how it was presented, was of course determined by the museum's donors and curators, who thus increasingly took their places in the art establishment's growing, taste-making, "power structure," and so further complicated the range of issues and opinions attending the whole new idea of "art."

As this was going on, another factor that most of us take as a given with regard to "art" today was also situating itself in the consciousness of the eighteenth century. In 1750, a German philosopher named Alexander Baumgarten published the first volume of a two-volume book (the second volume followed in 1758) called *Aesthetica*. That word was Latin, and derived from the Greek word *aesthesis*, which meant "sense perception" ... and as you've surely already guessed, our English word "aesthetics" eventually derived from it (though not for another hundred years or so). Baumgarten's idea, like so many others at the time, was about the nature of human knowledge, which *he* saw as divisible into two types: logic, and sensual knowledge. And as Williams tells us, he saw in "sensual knowledge" the primary source of "the specialized human creativity of art."[5]

We've noted that the increasing secularization of the expressive arts that began in the Renaissance had already brought with it an increase in appreciation for the beauty of artworks themselves, in addition to the traditional appreciation of the spiritual/intellectual beauties of the stories or truths they depicted. But as Baumgarten's crystallization of this trend gained credence, it worked to move sensual beauty, now, to the forefront, in considerations of "art." And it also opened a whole new dimension to the growing professional/academic discussion of "art," as those philosophers and theoreticians who could now be dubbed "aestheticians" joined the academics and collectors and curators in interpreting the new phenomenon.

But underlying both of these developments was another, ongoing one, the impact of which on the new idea of "art" was far more fundamental to our understanding of the term today. The development of textile mills in England in the 1740s was the first stirring of what by mid-century was well on the way to becoming the *Industrial* Revolution; in roughly 75 years, England was transformed from the primarily rural/agricultural society it had been for centuries, into a largely urbanized/industrialized one. And as that change proceeded, it also spread, across Europe and beyond, as it continues to do even now.

The Industrial Revolution was a watershed in Western cultural history every bit the equal of the Renaissance, for it amounted to and was experienced as the final, triumphal establishment in Western culture of the secularized middle class that would become the hallmark of that Modern Age. As Tarnas has put it, in the centuries between the Renaissance and the Industrial Revolution, the collective consciousness of the Western world had demonstrated a "shift of psychological allegiance from God to man, from dependence to independence, from otherworldliness to this world, from the transcendent to the empirical, from myth and belief to reason and fact, from universals to particulars, from a supernaturally determined static cosmos to a naturally determined evolving cosmos, and from a fallen humanity to an advancing one."[6]

The Industrial Revolution was an index to that advance. With the development of machines that could do what for all those centuries people had had to do for themselves, the sense arose that those people – "*we* the people," as it seemed at the time – were at last beginning to take full charge of their own destiny. And that growing sense of their definitive, assertive human *selves* effectively opened the way for the "new" idea of "art" to establish itself in Western culture once and for all.

We mentioned briefly in the Introduction that as far as anyone can tell, every known culture in human history has engaged in some or all of the behaviors we now understand as "art." Humans apparently have, that is, always made marks on things (whether to decorate, or commemorate, or as part of ritual behavior, etc.); have always sung, or chanted, or vocalized; have always danced; and so on. But the idea that these behaviors might be separated out as a category unto themselves, and called (in our case) "art," has occurred exclusively in post-industrial cultures – of which there have been very few,

our own of course included.[7] One reason for this is surely that as industrialization proceeds, things still made alone and by hand, as artists in the eighteenth century and beyond made theirs, are increasingly seen as "special." And industrialization by its very nature brings with it the sense of progress and pride, of cultural identity and control, that Europeans felt in the eighteenth century; perhaps it is this that leads to the idea of the specially skilled "expressers" of that culture, its artists, as "other," even as heroes, and so to further distinguish their products from the rest. In any event, the spreading industrialization of Europe that began in the late eighteenth century did indeed serve to finally, fully enable the "new" idea of "art" to become part of our evolving description of the world.

Only one thing had still to accrue, to render that idea an institution. And that brings us to Johann Winckelmann, and *his* idea.

Winckelmann, and "Art History"

Johann Winckelmann was born in 1719, in Prussia, into the cultural milieu variously described in Chapter 2: an increasingly weakened ruling class hanging on by its fingernails to control of a burgeoning middle class, which happened to maintain an avid interest in "art," understood by then as primarily things (and/or events), rather than the skills that had produced them. And by the time Winckelmann was 20, those first stirrings of the Industrial Revolution were making themselves felt in England.

Though he was well educated in theology, ancient literature, mathematics, and medicine, Winckelmann's career partook of none of these, involving instead a series of librarianships which in time came to involve curatorial supervision of a number of antiquities collections. When he died in 1768, he was Superintendent of Antiquities in Rome, and had supervised the beginnings of archaeological excavations at Herculaneum and Pompeii. Because of these latter efforts, he is known today as the father of modern archaeology, the systematic study of which was only just beginning during his lifetime.

More significantly for our concerns here (though only slightly more, as we'll see), Winckelmann is also, and equally, known today as the father of art history. Not surprisingly, in the course of his career(s) Winckelmann developed a deep fascination for the "art" of antiquity, of, that is, the Classical "art" of Greece and of Rome. We

need to remember here, though, that insofar as that "art" had been art when it was made, it was art only in the original sense of the term ("art" as human skill), and so not art at all in the way Winckelmann understood the term in the middle of the eighteenth century. And had Winckelmann and his peers been asked, in the middle of the eighteenth century, to point to some examples of things they knew for sure to *be* "art," the art that they would have cited, speaking conservatively/safely as we did here a few paragraphs ago, would have been "academic" and/or "Neoclassical" art, art that consciously emulated, in one way or another, the "art" of the Classical era – the sort of art that Louis XIV's *Acadèmie* had begun mandating, a century before. (In fact, Winckelmann's enthusiasms for this kind of work were at least partially responsible for its resurgence in Europe, later in the century.)

But in the presence of actual antiquities dug out of the ground, Winckelmann began in time to discern a subtle difference between those "real" antiquities and their eighteenth-century imitators. The original works, he felt, embodied qualities that he famously referred to as "noble simplicity and quiet grandeur"; whereas the eighteenth-century works that emulated those original ones didn't, so much. Given what Winckelmann knew to be the great mimetic skills of the artists of his time, he came to the conclusion that the differences between their artworks and the originals they emulated must be attributable to something other than any deficiency on the parts of the artists; rather, it seemed that it must derive from the cultures themselves, that gave rise to the works. In 1764 he published a scholarly volume entitled *The History of Ancient Art*, which discussed the "arts" of antiquity on this basis.

This was the first time the terms "history" and "art" had been directly linked in print, and it came in time to be seen as the first embodiment of yet another idea about how we might look at the world: Winckelmann had effectively suggested that there ought to be a "history of art" that would explain all the differences in all the artworks that humankind had produced over the ages, in terms of the cultures that produced them.

By the end of the century, scholars who saw the merit in this idea had set out to make such a history. Had these early historians looked back only as far as the beginning of *their idea* of "art" as a class apart, even to its very first stirrings in the Renaissance, some 300-or-so years before, all the ensuing confusion about what "art"

seemed to mean might have been less so. But they didn't, for a couple of reasons.

One was that the awareness that the idea *was* just an idea had by now been pretty much lost in the shuffle. It had been increasingly insinuating itself into Western culture for all those 300 years, and by the late eighteenth century, not only had it become part of the way the world self-evidently *was*, that growing critical/theoretical establishment had also arisen, to explain, discuss, and argue about it. (And again, that "art," by then, was thought of not so much as skills, but rather as *things*; and Winckelmann had of course written his book *about* things, made 2,000 years earlier.)

The other reason was that, while Winckelmann surely knew about and recognized "art" in the newer sense of the term, he also knew about and recognized, from his archaeological and curatorial experience, "art" in its original sense. That, in fact – whether or not he thought about the distinction at all, which seems unlikely[8] – is what his book had been about. Hence, the makers of this "history of art," following Winckelmann's lead, looked back not just to the beginnings of "art" as they had come to understand the term, but rather as far back as their knowledge of human history would take them, looking back down the ages at essentially all the things that they knew of that humans had ever made, and picking some of them from which to weave their history. This history wasn't written, of course, in anything like short order; it's been developing and evolving from then until now. But by now, the history of art has extended itself all the way back to the beginning, to the Stone Age, when humans were just becoming humans, and beginning to *make* things.

The things chosen for inclusion in the "history of art" were picked then, of course, as they have been since and are now, on the basis of perceived similarities to what the historians at any point understood "art" to be. And that idea shifted subtly every time something new was discovered and added to the history, for now, as the historians picked and chose, that *constitutive* nature of the term as it had evolved served to render all those things chosen into "art" in the *specialized* sense. So, if historians understood, say, certain sorts of marks on certain sorts of surfaces – academic paintings of neoclassical subjects, for instance – as "art," then, well, perhaps other sorts of marks on other sorts of surfaces – like maybe the paintings on the walls of Lydian tombs – should be thought of as "art," too … and if that's the case, then perhaps prehistoric paintings of animals in

subterranean caves (more on which, below) should qualify as well ...
and once they – and the growing critical community of which they
were now a part – decided that these things *did* qualify as art, well,
then they *were* art.

The "Drawing Down" Effect

We should emphasize again that the very earliest historians, tenta-
tively following on Winckelmann's big idea, certainly hadn't assem-
bled art history as we know it by, say, the end of their century. Rather,
the early historians assembled what they could, from what they knew,
which was basically about things that people like themselves – that is,
white Europeans, or their forebears – had made. And as time went
on, later historians added to and/or amended those efforts, extend-
ing them forward and backward as new things were discovered and
as their ideas of "art" accordingly evolved, in a process that's contin-
ued to the present day. (Thus "art"-works of other cultures and of
minorities were only included in "histories of art" much later.)

And again, those earliest historians necessarily approached their
task on the basis of their late-eighteenth-century understanding of
what visual "art" things were – hand-made, on-purpose images of
recognizable subject matters, rendered with high degrees of mimetic
skill and sensual appeal, which could be seen as more pointedly
expressive than utilitarian. They looked, surely, for things that had at
least some correspondences to at least some of those qualities.

They also, remember, were aware as they looked not only of their
own, specialized "art," but also of the "art" of the Classical Age.
That the latter had never been "art" in the way they understood the
term no longer really mattered, by the very nature of their pursuit.
These two bodies of work were givens; and so the historians'
attempts amounted basically to "filling in" a history, around and
between them.

If one takes a sufficiently broad view of the results of those
attempts to "fill in," a telling pattern emerges. The things (eventu-
ally) chosen to mark the very beginning of art history were, relative
to the eighteenth-century model on which the whole idea was orig-
inally based, mimetically quite crude; and they were apparently
concerned with, were "about," great cosmic themes far removed
from the day-to-day doings of the eighteenth century. From that

designated beginning, the choices made to fill the gaps between it, the Classical era, and the late eighteenth century can be seen to "draw down" ever more closely to their human sources – to look more and more the way humans actually see things, and to depict ever more "humanized" subjects.

That may not seem surprising, either, for the idea that "art" should be expressive of the culture that produced it seems, to most of us, a given; that idea was at the core of Winckelmann's idea *of* art history. As Western culture gradually became more secularized, it only makes sense that the "expressive" arts that it produced – those that the historians were primed to look for – reflected that secularization. But at this point in *our* inquiry, at least, we still have to wonder whether all those things chosen for "art history" *were* "art," in some essential way that the historians somehow knew – which of course would beg our whole question here (what was it that they knew?). To an archaeologist like Winckelmann, who had posited the whole "history" question in the first place, any cultural product at all that emerges in the field is seen as expressive of the culture that produced it – so how were the things dubbed "art" by the historians any different, in that regard, from any of the things *not* so chosen? Or were they not essentially any different, but rather chosen on the basis of those shifting understandings of what "art" was? Again, are we seeing them as "art" today simply because the historians say we should?

We'll consider that issue further too, in Chapter 6. But for now, let's just look at the progression that I've called "drawing down."

Any general survey of Western art history as we know it today places its beginnings in the Stone Age, 15,000 to 40,000 years ago, with two sorts of artifacts cited as evidence: prehistoric cave paintings, most famously from caves in southern France (Lascaux, Chauvet, and others) and northern Spain (Altamira being the best-known); and small, carved or shaped stone or bone or clay female figures found in many places in Europe and North Africa, and known collectively as "Venus figures" (or sometimes "fecund Venuses," or "fecund women").

The paintings, most of which depict primarily animals of various kinds (see Figure 3), with only the occasional "stick-figure" representation of humans, are, obviously, where they are – in the caves where they were made. And insofar as they are depicted or directly referenced in museums, those museums tend not to be museums of

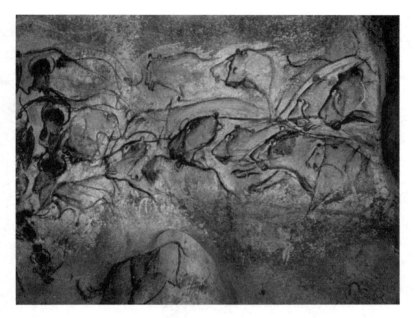

Figure 3 Image from Chauvet cave (Pride of lions hunting bison),
© DRAC Rhône-Alpes

"art," but of natural history or anthropology. This is also the case
with the "Venuses," small figurines of women's torsos, most of them
faceless and footless, some without arms, but all with exaggerated
breasts, buttocks, and genitals; the most famous of these, the
so-called "Venus of Willendorf" (Figure 4), seems clearly to be
pregnant, too.

The cave paintings of the animals were quite stunningly beautiful
and seem utterly expressive of how the experience of these things in
the wild might *feel*; but if mimesis is the imitation of how we *know*
things actually look, then mimetically, they're not very strong. And
so too with the Venuses: Willendorf, for instance, positively reeks of
fecundity, but – faceless, footless, virtually armless – is hardly mimetic
of most actual women.

As to what functions these paintings and figurines may have served
in the societies that produced them, we of course cannot know for
sure; but theories have been extrapolated from such sources as anthro-
pological investigations of Stone Age tribes found in the jungles of

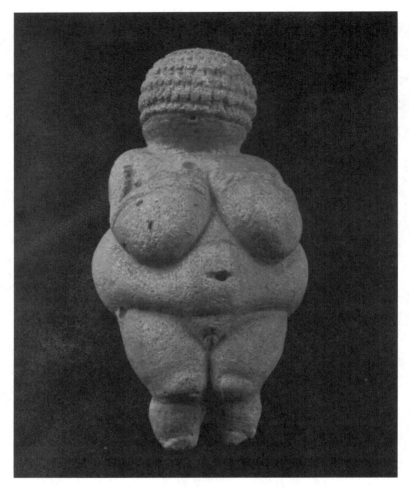

Figure 4 *Venus of Willendorf,* from Naturhistorisches Museum, Vienna. Photo akg-images / Erich Lessing

New Guinea and Brazil in the mid-twentieth century, still living as they had for thousands of years. And to one degree or another, most of those theories suggest that these artifacts likely served functions that were closer to what we might today (or in the eighteenth century) call "magic," the paintings possibly made as part of rituals

aimed at increasing the success of the hunt,[9] and the figurines as fertility amulets.

Surely they weren't "art," then, in anything like the eighteenth-century sense of the term (nor, for that matter, in even the earlier sense, at the time they were made). They were, relative to the "art" of the eighteenth century, mimetically crude; and they seem to have been concerned primarily with ritual efforts to exert some degree of control over the cosmos. Small surprise then that the *only* venue in which these artifacts are directly referenced as "art" per se is within the art history literature, where, as noted, they are cited as the beginning of it all.

From that starting point, the "drawing down" that I'm trying to suggest here is not in any way a smooth and steady process. It is at best uneven and choppy, in anything like a close view of history. But if in the name of suggesting its broad *general* thrust we leap forward, over the various civilizations that arose around the Mediterranean over time – including the Classical ones, about whose "art" the early historians already knew – to the Middle Ages, we find that here, historians chose, for fairly obvious reasons by now, the "art" made to wow the vassals and serfs: biblical imagery made, as we've noted, of the richest materials the churches who commissioned them could afford (see Figure 1). Mimetically, these paintings and sculptures were (arguably) more successful than had been their prehistoric forebears – certainly the artisans were trying to make them so – but they still didn't look the way things actually look to us. As we noted in Chapter 2, the characters represented in Figure 1, while clearly meant to be human figures (except for a few devils at the bottom), look more like paper dolls on a flat surface than actual figures in space. And while the subject matter of this work surely had to do with great cosmic themes, as had the "works" thought of as the beginning of Western art history, it approached them now not in any sort of supernatural context, but rather in that of a *human institution*, namely the church.

A little later, in the Renaissance, visual art continued to address these themes, in this context … but with another big difference. Once formal perspective had been invented, Renaissance imagery, though still "about" the teachings of the church, actually looked the way things *actually looked*, to humans (see Figure 2, which was painted just 100 years after Figure 1).

Again, what I'm trying to suggest here, leapfrogging cavalierly through Western art history, is that the historians' choices, in selecting for their history expressive artifacts made before the idea of "special" art had even begun to be possible, demonstrate a gradual, uneven, but overall progression that moves, as do the cultures that produce it, ever closer to the interests and the vision of the people doing the selecting. Mimetically crude imagery aimed at getting some sort of magical grip on the cosmos (eventually) gives way to mimetically better imagery aimed at the same thing, but now from within a human institution, which then – just as the "new" idea of art begins to be possible – gives way to similar subject matter in the same institutional context, but now looking much more as humans see it.

And as the "new" idea of "art" continued to develop and spread, as "art" and "artists" increasingly became part of the way Western culture understood itself, that drawing-down continued, and accelerated. In the eighteenth century – just before Winckelmann had his big idea – artists like the Italian painter Tiepolo (Figure 5) were making highly mimetic imagery that still dealt with cosmic themes like, in his case, Time[10] and Truth (and Love … note Cupid down below, with the quiver); but now they were presented in *secular* terms, now in a mythic rather than a religious context.

And at the same time, notably in Holland, painters were painting things that had nothing to do with the cosmos or religion or mythology at all – their subjects were things from the everyday environments of people (albeit rich ones); and they were painting them in a way that was *so* highly mimetic that one wants to call it *super*-mimetic (see Figure 6). Indeed, in the presence of work like this – which one could argue marks the absolute apogee of mimetic illusion in painting – it becomes all but impossible to look "through" the painting as if through a window, and dwell only on its represented subject matter, all but impossible, even, to consider only how "pretty" it is. Rather, here, for *perhaps* the first time in the history of art, the viewer's involuntary reaction must almost certainly have started with wonder, with a gasp and an inward exclamation of the sort, "Would you look at how he *did* that!"[11] Insofar as this was the case, it would have marked a sort of eleventh-hour (as we'll see) reminder of the sort of skill the term "art" had originally signified, and in that, a reminder of the necessity of a *human presence* in the whole "new" idea of "art" as *things*.

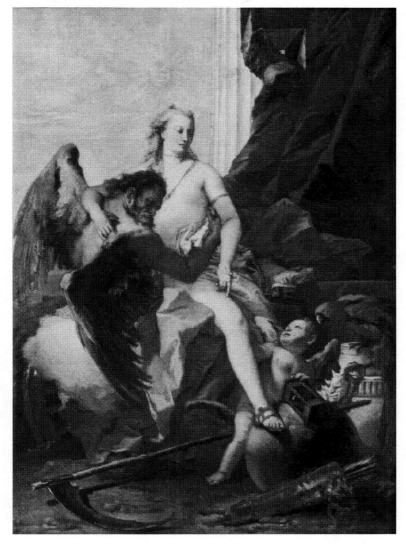

Figure 5 Giovanni Tiepolo, *Time Unveiling Truth* (ca. 1745–50), © 2007
Museum of Fine Arts, Boston. Charles Potter Kling Fund, 61.1200

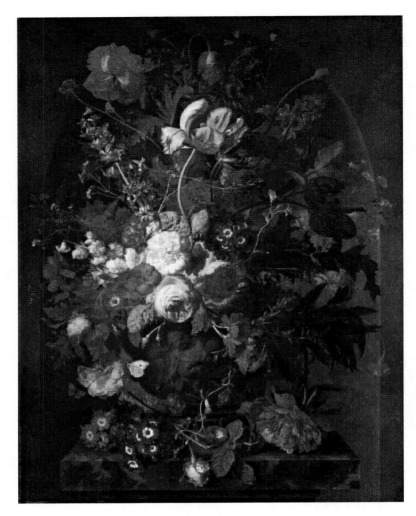

Figure 6 Jan van Huysum, *Vase of Flowers in a Niche* (ca. 1732–6), © Museum of Fine Arts, Boston. Bequest of Stanton Blake 89.503 / The Bridgeman Art Library

We'll refer again later to this apparent "drawing down" effect, and to what it may imply about "art." For the moment, though, we should note that this process of historical selection, as contemporary cultural theorists and historians have since realized, has served to distort our understandings of cultures that preceded ours, as we have come to see

as special "art" things in those cultures that hadn't ever been that …
but that surely *had* been something else. (We'll refer to this point again,
too.) It's for this reason that the tentative criteria for "art" that we
thought about at the beginning of Chapter 2 – the maker's intent that
the thing being made should be "art," and/or its status as an autono-
mous object, to be appreciated in its own right rather than serving
some other end – don't hold up. For all the things made prior to the
dawning of our current idea of "art" – everything made prior to the
Renaissance, at the earliest – were made to be and do other things.

Most importantly, though, for our immediate discussion here, the
historicization of art effectively (and eventually) accomplished two
things. It institutionalized the idea that "art" meant *visual* art, first –
for *visual* art was in fact what the "history of art" was about. And at
the same time, it institutionalized, once and for all – or at least, from
the eighteenth century to the present (read on) – the whole "new"
idea of "art." That idea, once historicized, had finally become an
established part of the way the Western world was understood to be,
the way, experientially, it *was* … for how could it have been other-
wise? Clearly, given the new and developing *history* of "art," not only
was there "art" in Western culture now, there had evidently *been*
"art," since the beginning.

And then, as noted, the Modern Age was upon us. And as promised,
we'll talk about that – and continue as we do this "drawing down"
discussion – in Chapter 4.

Notes

1 David Hume wrote his "Inquiry Concerning Human Understanding"
 in 1748.
2 Prime examples include J. S. Bach's *Goldberg Variations* and *Art of the
 Fugue*, both written in the 1740s. (Some scholars believe, indeed, that *Art
 of the Fugue* was intended by Bach as a purely theoretical exercise.)
3 See for instance Mark Akenside's "Pleasures of the Imagination," of
 1744.
4 The first *Britannica* was published in 1771.
5 Williams, Raymond. *Keywords.* Oxford, Oxford University Press, 1983.
 (p. 31).
6 Tarnas, op. cit., p. 319.
7 Dissanayake, Ellen. *What Is Art For?* Seattle, University of Washington
 Press, 1988. (p. 35).

8 In my limited experience with Classical archaeology – for eight years
 I was a photographer/photographic consultant to the Harvard/Cornell
 Archaeological Exploration of Sardis, in western Turkey – the issue doesn't
 much arise in that field even today. And art history has over time effec-
 tively narrowed its purview to include primarily the graphic arts (paint-
 ing and drawing and printmaking), sculpture, and architecture.

9 Recent research has questioned this long-held theory of the paintings'
 relationship to the hunt, though no other theory has as yet been con-
 vincingly been put forward to take its place. And the idea that they
 were involved in *some* sort of ritual remains largely intact ... though one
 new book, *The Nature of Paleolithic Art*, by R. Dale Guthrie (University
 of Chicago, 2006) suggests that the paintings were just kids' doodles.

10 That's "Father Time" there, with the wings (time flies ...); he's also
 known as the "Grim Reaper" (note the scythe he's dropped) ...

11 This seems logical to me, in the progression I'm describing; but I do
 not know whether it's true. There are paintings from the Italian
 Renaissance, for instance – in my own experience, a particular triptych,
 centering on the Madonna and her child, by Bellini, in the Frari Basilica
 in Venice – that are every bit as breathtaking, perhaps in some ways
 even more so. But when these were made and originally viewed, the
 understood presence of God in them was at least on a par with the
 presence of the artists themselves. This was much less the case in
 Holland 300 years later.

Chapter 4

"Art," Lately

Before we consider what happened to the idea of "art" in the so-called Modern Age – and a lot did – let's get two potential sources of confusion out of the way.

For one, we need to do what we can to sort out this word "modern" and some of its derivatives, which taken together tend to be at least as confusing as does "art."

There's the general term "modern," with a lower-case "m," of course. If something happens more or less "lately," or if it partakes of ideas prevailing more or less "lately," it's "modern." And "modern" is relative – it doesn't just mean *now* (whenever you're reading this), and a little bit before; it means anytime, and a little bit before. So, whatever kind of farming was being done in, say, six-teenth-century France, was, in the sixteenth century in France, "modern" farming, even though now, it's not. And if someone had written a novel in the sixteenth century that shared several character-istics with what we understand as a novel today, though at the time it would probably have been dismissed as "weird" or "blasphemous," today we'd call it "modern."

Of course just what "lately" means, in any given context, is ever open to debate. Is it a matter of months, before something ceases being "modern"? Years? Decades, maybe? What about centuries? Certainly most of us wouldn't think of, say, 800 years ago as "lately," but in fact the term "modern history" often refers to history as it has unfolded since the end of the Middle Ages ... just the period, yet again, in which that renewed consideration of human beings as worthy of attention in their own right first began to reappear, and

make possible the "new" idea of "art." That's at least convenient for us here, for we can seize on that usage of "modern" and stop calling the "new" idea of "art," "new," which as we've noted, it really isn't anymore. So from now on – take notice – we'll call it the "modern" idea of "art."

And in fact, though at first it seems rather a "stretch," that particular use of "modern" – to refer to history since the end of the Middle Ages – makes sense. For many scholars who use the term this way, "modern" suggests a reflexive awareness, on the part of the people living in "modern" times, that they are part of a "new" culture that has broken with tradition and seeks to reexamine and renovate the cultural conventions of the past. As we've seen, the radical shift in thinking that arose in response to the emergence of the middle class in the West did indeed begin at – indeed it *was* – the end of the Middle Ages. As we've also noted, the Industrial Revolution was experienced as a sort of culmination of the emergence of that middle class as the predominant sociopolitical force. And as we're about to see, this was surely the kind of "modern" awareness that prevailed in the wake of the Industrial Revolution. So extending this sense of "modern" back far enough to label the sixteenth century that way is not only convenient for us, it's justifiable. (And of course it underscores how nonspecific and slippery the apparently simple term "modern," in the sense of "lately," can be.)

One thing small-m "modern" *doesn't* mean, though – usually – is capital-M "Modern."[1] Capitalized, the word generally refers to the fairly specific historical period spanning much of the nineteenth and twentieth centuries, and/or to certain features and products specific to that period. Just to complicate things a little more, the "Modern Age," in this sense, is sometimes also referred to as "Modernity" ... though *that* term sometimes refers too to the systems of ideas that characterized the period. "Modernism," which is close to a synonym for "Modernity," works in the same way ... except when it's used more selectively, to designate a specific body of artworks made between roughly 1890 and 1940, according to some historians, or between 1860 and 1970, according to others. "Modernist," like "Modern," is an adjective applying to things made or ideas had during the Modern Era. And *a* Modernist is usually someone who favors that "Modern," or "Modernist," set of ideas, whether or not s/he actually lives in what's called the "Modern Age." As you can

see, the potential for confusion in all of this is significant, particularly when academic writers about it all sometimes see no need to capitalize, trusting their contexts to make clear which "modern" they mean.

But the important thing *here* is the awareness that "modern architecture," for instance, is any architecture made at any time at all, so long as it's been made "lately," relative to that time, or according to ideas held at that time; while "Modern architecture" is architecture made in the Modern Age, and/or according to Modernist architectural principles, even if, as would be the case today, it's not really very "modern" anymore. For the record, *here*, when we say "modern," we mean the last 175 years or so, from roughly the end of the first quarter of the nineteenth century to the present. And when we say "Modern," we mean the period from about 1850 to about 1975.

The other potential confusion that we can try to clarify before it arises is much more straightforward (you'll be happy to hear): it has to do with the two histories of "art" that we've been describing thus far – that of the term itself, and that of the things. As Modernity began, the two histories became one.

We noted in Chapter 3 that once the idea of "art" as *things* had been culturally validated at the end of the eighteenth century by the making of a history for it (for *visual* "art," that is, which by then had become, at least in general usage, almost synonymous with "art" itself), it tended to push the whole *idea* of "art" at all, with which we're concerned here, ever farther from view. That there *was* "art," in the *modern* sense, had long since become a given; the idea had come over the centuries to seem, at least, to be about a natural category of our experience – for as we said at the end of Chapter 2, just as you'd always been able to point to that "boulder" over there on that hillside, now you could point in the same way to that "art" over there on that wall. For most of the nineteenth and twentieth centuries, then, the idea that "art" *was* an idea was essentially subsumed by questions about art*works* … and as those questions yielded theories and those artworks continued to be made, it was all seen, of course, as simply extending, now, the recently established, retrospective "history of art."

Those things said, let's try now to sort out the Modern evolution of that underlying idea of "art," as hard as that idea may have been to see as such, at the time.

Modernism (aka Modernity)

What *is* (or was) Modernism (or Modernity)? Essentially – and that word is a sort of pun, as essences are integral to Modernism, as we'll see – Modernism is a way of thinking about the world. It grew, as all ideas must, out of ways of thinking about the world that had existed before it – most "lately," in this case, the complex weave of ideas that had characterized the Enlightenment. Again, the Enlightenment is called that primarily in reference to the great explosion of and thoroughgoing fascination with ideas that set the tone of the eighteenth century. By the middle of that century, though, initial excitement over the proliferation of those new ideas was beginning to give way to consternation, as some of them began to challenge – again, as ideas will – other, long-held ideas about how the world could/should be understood. The institutionalization of the modern idea of "art," for instance, may have been relatively benign; but the ideas of Darwin, say, or of Marx, were less so, relative to traditional understandings of how the world worked. Thus as excitement over the positive implications of the Industrial Revolution grew in the second half of the century (most people saw only the "good" ones, at first), doubts about how well traditional descriptions of the world were working grew too.

By the end of the century, the way of thinking about the world that came to be called Modernism (or, "modernism," in the sense of "modern history," as described a few paragraphs ago) had begun to emerge. Modernism sought to capitalize on that historic shift in self-awareness and the excitement that accompanied it, to acknowledge those doubts and find ways to reconcile them, and to move forward – with any luck, triumphantly – into the future. As the change to industrialization progressed, so too did a sense of the great promise of it all; and an old Enlightenment idea – that change was progress, and that progress was, in fact, inherently good, and so could lead only to further good – began to reassert itself.

In time, all of this coalesced into what came to be called the "Modernist Agenda" (or the "Modernist Project"), which began to be articulated by social theorists and philosophers and – interestingly – by artists and writers about the arts.[2] Essentially (there's that word again), the Modernist Agenda held that the past was effectively dead, and the future was all; the *next* thing was the *best* thing, and we

should seize the moment and shape the new age – the Modern Age, that is – in ways that would make all things, from teapots to housing to social and political systems and everything in between, better for all people. The way to do this, it was thought, was to determine, here in the growing light of the dawning of this latest new world, the *essences* of virtually everything in the culture, so that things could in time be reduced *to* those essences. This, it was thought, would eliminate the sorts of unnecessary characteristics, of teapots and housing and sociopolitical systems and all, that marked perceived differences between people and classes, which ultimately led to discord and strife. The Modernist slogan – now a modern cliché – that most famously expressed this new ethic was "form follows function." Though this phrase grew specifically out of Modernist architecture and design, it could in fact be taken to refer to the whole Modernist approach to bettering that new world that they foresaw: that is, that the *form* a thing takes in a culture should ideally follow, directly and only, from an enlightened understanding of what it is intended to *do*, in that culture.

So, in terms of things whose functions were relatively simple to describe – as, again, teapots and housing, say – *Modern* teapots and houses were increasingly stripped of extraneous ornamentation until they became purely functional objects, the teapots sleek, simplified forms, Modern houses essentially elaborate (or not) boxes with rectangular openings in them to admit light and residents, and so on. And in terms of things whose functions were more nuanced and complex, and so more difficult to describe – as, those sociopolitical systems – Modernist intellectuals argued about their essential natures and functions, and accordingly about which forms such systems might take (Democracy? Communism? Capitalism? Marxism? … Anarchy?) to best fulfill their essential roles.

The Arts, Under Modernism

In the arts, the Modernist pursuit of essences was, predictably, as complicated as was the whole idea of "art" itself. "Art" things were understood to be somewhere between teapots and sociopolitical systems, in terms of complexity – they were just objects and events, on the one hand, but on the other, though they seemed to be so highly valued by the culture (remember all those people flocking to

the Salons and the new museums), what they *did* in the culture was difficult to say. So the Modernist inquiry in the arts had two thrusts: on the one hand, there was an examination of what artworks *were*, of their *form*; and on the other, theoretical approaches to how art "worked" and what it was *for*. An observation about the essential form of a symphony, or a play, or a poem or a painting ("You know, I've come to realize that what I've noticed about this poem is probably true of all poems ..."), would lead to a theoretical position based on that observation ("Why yes! And that being the case, we could say then that indeed poems are so-and-so ..."), which would lead to a new form of art that manifested that position ("Well then, if I write something ... *this* way, it ought to be a new kind of poem, no?") ... which new form, once acknowledged as such ("Yes! It's a little unfamiliar in form, of course, but if you think about it, it really *is* a poem!"), would then be examined, leading to altered theory, and so on.

As Modernism itself matured and progressed, then, new ideas about the essential form of music (think of tone poems, or the pentatonic scale) were assayed, and new forms developed, out of which new ideas emerged, and new works from those; and the same thing was happening in theater, in literature, in dance (consider the work of Martha Graham, in contrast, say, to *The Nutcracker Suite*); everywhere. But perhaps in no area were the effects of Modernism more pronounced and dramatic than in the visual arts. For in that domain specifically, an impetus for change arose that both reaffirmed and focused the dictates of the Modernist Project: in January of 1839 (or thereabouts),[3] photography was invented, and in a little more than a year it had exploded across the world.

Photography, and a Very Big Question

It's possible to see photography as having been inevitable,[4] a function of hundreds of years of demand within the burgeoning middle classes for affordable imagery (which had been, remember, in the years before that burgeoning began, the exclusive province of the rich and powerful). And it's all but impossible *not* to see it as a function of the "technologizing" that was the Industrial Revolution. But in any event photography certainly *was* the repudiation of what had been understood since the Classical Age as the central defining

characteristic of the expressive "arts," no matter how one meant that term. For photography effectively repudiated mimesis, as a necessary factor, a "given," in the production of "art." For all that time, the human ability to mimic the appearances of "real (or idealized) life" had been the bottom line, when it came to "art." This was most immediately and obviously true of the visual arts – by now, in most people's minds, the *definitive* ones – and now, there was a machine that could do what visual artists had striven for centuries to do, and within a year or two of its invention it could do that more accurately than any human could, and in a fraction of the time.

It took time for photography's impact(s) on the visual arts to make themselves felt. The new medium had to explore its own nature and parameters, and painters had to decide whether to use it or not, and if so, how. By 1900, virtually all of photography's technical potentials had been realized; many painters were using photographs as sketches while some flatly refused to have anything to do with it at all (and history painting[5] was essentially a thing of the past). But from its inception, and by its nature, photography raised a Very Big Question for visual artists of all persuasions: "Well, if mimesis isn't the point – and obviously it can't be, because *machines* can do that better than we can – then what *is* the nature of this pursuit?"

I do not mean to suggest, here, romantic as it would be to do so, that within weeks of the production of the first photograph, artists were booking passage to Paris, and flocking there to smoky cafés, to discuss this question (though I guess they might have been). Nor do I mean to suggest even that this question per se was the one that occurred to them. Many if not most artists couched their inquiries in different terms – should they be making paintings that were less spectacular and more personal? What should be the roles of invention, or convention, or politics, or emotion in their work? These were Modernist questions, to be sure, made the more pointed in the visual arts by the advent of photography. But whatever their motivation and however they were formulated, there those issues of the nature of the pursuit were, and visual artists were surely aware of them, at whatever level ... even as other Modern artists and intellectuals were thinking about virtually the same issues as they pertained to their own pursuits. And so the search for the essential nature(s) of "art" was on, and it continued for over a century.

"Drawing Down" All The Way

We'll continue to use visual art as a primary example of what happened to "art" under the Modernist approach, if only because the visual arts' responses to the Modernist question were easier to … well, *see*. But first we need to note that here – and by now, this should come as no surprise – even the word "see" isn't as simple as you'd think. In the arts (any of them) of the Modern Era, to "see" something almost never meant simply to look at or experience it, but rather, and almost always, to understand the point it made, as in, "I *see* what you mean."

Perhaps you've already noticed something here, about the questions raised about cultural artifacts and institutions – including artworks and art – by Modernism, and those raised even more pointedly in the visual arts by photography. What these questions brought with them was the need to *think* about art, rather than just to look at, or read, or listen to it. Under Modernism, that is, art – or at least, the new Modern art, which, because it *was* new, the "next thing," garnered all the Modernist attention – had become *idea*, first. In a curious way, this meant that the expressive arts under Modernism had returned to the sort of status they had had before (and indeed through most of) the Renaissance: they had now to be appreciated for the *ideas* they embodied, rather than just for themselves as sensual objects and events; though where those embodied ideas in the Middle Ages had been about issues outside those artworks themselves – Biblical stories, moral lessons, and so forth – now, under Modernism, they weren't. Modern artworks tended to be about ideas just about … artworks.

We need to be careful about this point. The ideas on which most Modern art were based were not ideas *of* art (like the one this book tries to be about), but rather, again, ideas *about* it. The idea *of* art, that there *was* such a thing at all, was, as we've said many times, an established (if unexamined) part of the Westernized world by the nineteenth century, and an issue from the past to boot, hence not particularly relevant to the Modernist outlook. Modernist ideas *about* art were not about whether or not there *was* such a thing, but about what the essential nature of *an* art thing might be.

Hence the "drawing down" phenomenon that we discussed with regard to art history at the end of Chapter 3 took, in the visual arts upon the invention of photography, a really radical leap: having gone

from mimetically crude, relatively inarticulate gestures aimed at effecting some control of the cosmos, through various stages of secularization, to almost unbelievably mimetic images of things on the sideboard or in the backyard, it now drew down all the way, and went, as it were, "behind the eyes." (And so, again, did the other arts, albeit a little less dramatically, as Modernist questions of form and function arose in them.)

When the French painter Claude Monet was born in 1840, just a year or so after photography had been invented, the idea of "art" was understood pretty much as it had been, art things looked pretty much as they had looked, and the art world worked pretty much as it had worked, for a very long time. The annual juried Salons, instituted over a century before to further the cause of Academic painting, were still being held; Monet took some of his first drawing lessons from Jacques Louis David, perhaps the greatest of all the French Neoclassicists. As time went on and Monet moved ahead into his career, however, he met and befriended other artists, all of whom were necessarily aware, at whatever level, of the Big Question raised for their medium by photography, and trying to work out some response to it. In 1872, Monet submitted a decidedly un-Academic painting – sketchy, flickering, "unclear" by traditional mimetic standards – called *Impression: Sunrise*, to the Salon, had it refused, and later showed it instead at a "breakaway" show, one of many soon to come, at the gallery of a sympathetic photographer. When it was lampooned in the arts press just for how "impressionistic" (as opposed to mimetically polished) it was, the name stuck ... as did the approach, "Impressionism," for Monet and many of his colleagues.

By the time they had brought this new approach to painting to maturity, the results were extraordinary. The quality of the depicted light in Monet's mature landscapes is so utterly specific that, to anyone who has spent any time in southern Europe (as I happen to have done), the very quality of the air over the poppies in his *Field of Poppies near Giverny* (Figure 7), for instance, is almost palpable. Don't let yourself think, though, that Monet and his colleagues woke up one sunny Thursday with a new idea and ran out as soon as breakfast was over and started making mature works like that. In fact, it took years to develop the sort of proficiency – of skill – demonstrated in the paintings for which we know them now. For whether the idea that such paintings could be made arose fully formed, or – more likely – took shape gradually in a series of smaller

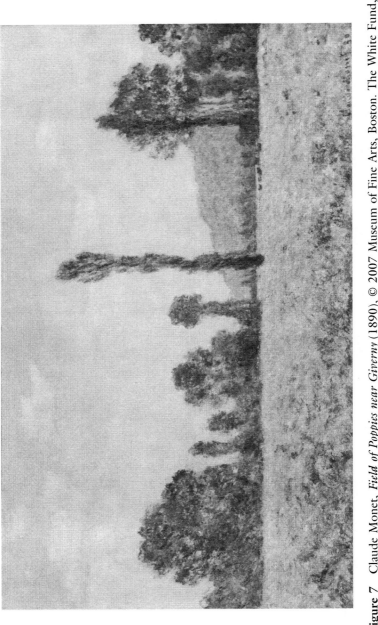

Figure 7 Claude Monet, *Field of Poppies near Giverny* (1890), © 2007 Museum of Fine Arts, Boston. The White Fund, Lawrence, Massachusetts, bequest of the Reverend William E. Wolcott. Lent to the Museum of Fine Arts, Boston

recognitions and decisions conditioned by that Big Question that photography had posed, once it *had* presented itself, it brought another question with it: "Okay, but ... I mean ... how would you *make* a painting like that?" The Impressionists' earliest attempts at figuring out an answer to *that* question, though entirely serious in intent, were in fact all but laughable, relative to the mature work they produced years later, once they'd mastered their approach(es). And the fact that they took years to work through them, of course, testifies to how compelling they found the pursuit.

Note carefully too that Impressionist poppies are not mimetic in anything like the way the flowers in Figure 6 had been mimetic, about a hundred years before. Monet's poppies do not look the way we *know* that poppies look, but rather the way they *actually look* to us, in a certain light (the only time things actually look to us as the flowers in that Dutch painting look, is in those first few moments after the optometrist puts those drops in our eyes – and they didn't have drops or optometrists, back then). And these two ways of look-ing are very different things, as the images demonstrate. It is easy, now, viewing these two paintings made such a long time ago in art history, to say, "Yes, well, they're different. But so what, really? All paintings are different from each other, right? And artworks from one place and time are different from those of other places and times – that's what Winckelmann's whole idea of art history was about." And that would be, factually, a justifiable response.

But what's significant about *this* difference is the nature of it, and its timing. *This* difference wasn't a product of variation in individual styles, from one to another, or of cultural differences; it was the product of an intellectual decision – an *idea*, however well- or ill-formed at first – to *be* different, by taking out of the equation one of the most fundamental, time-honored criteria of what a painting had to be to be "art," i.e., mimesis, in the original, strict meaning of the term. And this radical break appeared just a few years after photo-graphy had stolen the mimetic limelight, seemingly once and for all.

Modern "Art" and the Avant-Garde

Most art historians today count the Impressionists as modern, of course, but as pre-Modern; so too, the Postimpressionists whose work evolved from theirs. Whatever one calls it, though, Impressionism

was the first major post-photographic break with mimetic tradition, and the first instance of the removal of one of the fundamental characteristics of what "art" was by then thought to be, by (loose) definition. And regardless of where one draws one's pre-Modern/Modern lines, what the Impressionists began continued for about a century, one "ism" supplanting another, each of them either embodying new ideas about the essential nature of "art" spurred by the new works made by the "isms" before theirs, or proposing new theories about what art was for, and making work that embodied that, or both. All, though, were more-or-less consciously pursuing the answer to the overarching Modernist question of the essence of "art."

And so, after Impressionism had shown that non-mimetic paintings based on direct visual impressions could not only be made, but also culturally validated (at least after a while) *as* "art," Picasso and Braque considered this, and thought that, "Well, if *impressions* are what it's all about, I have more impressions of how that friend of mine looks than just the one I can directly *see* at any given time ... I mean, I have the impression that there's a back to her head, even though I can't see it from here"; and in time they developed and refined another, highly intellectualized approach called Cubism, that produced paintings that embodied that variation on the Impressionists' idea, showing – if you understood the idea behind them, and so knew how to "read" them – many visual impressions simultaneously ... and it was validated as "art," too. The Italian Futurists incorporated some of Cubism's principles, duly adapted, into much of their work, but essentially *they* were responding with hysterical excitement to a stimulus from outside the arts, namely the wondrous implications of the Machine Age ... and so on, and so on. (For a full chronicling of all the Modern "ists" and "isms," and of how they evolved and meant, consult any standard art history text.)

In time, the artists involved in these movements and more (and in similar ones in other fields) came to be known as the "avant-garde," a French term meaning "vanguard," with connotations of "cutting edge." These artists, all seeking, then doing, the "next thing," whatever that was at the moment, accordingly received virtually all the attention of the Modernist arts community, for the better part of a century at least. It's very important to recognize, though, that only *some* of the artists working in any artistic field in the Modern Age

were the avant-garde. The arts as they had been traditionally under-stood continued on; indeed, the vast majority of the artists who constituted the avant-garde had initially been classically trained, and gravitated to the vanguard – as had the Impressionists – in response to genuine excitement at and fascination with the issues it addressed. Those that didn't so gravitate kept working as they had, throughout; it's just that nobody took much notice, at the time.

The progress that the avant-garde made toward its Modernist goal of stripping "art" down to its essence was just as uneven as the "drawing down" of which it was a part, characterized by fits and starts, insights large and small, ideas from without (as in the case of the Futurists), and failed attempts. But in the broad view, the avant-garde's efforts were tantamount to peeling an artichoke – the "artichoke" being the set of assumptions about what constituted an "artwork" that had prevailed at the end of the eighteenth century and, as we've noted, still does for many of us today.[6] As the Modern Age progressed, the process begun by the Impressionists continued. One defining assumption after another was examined, and tenta-tively discarded … ways were found to make new "works" without that characteristic, and those works were tentatively presented, then recognized, as "art" … and the deed was done: the idea of what a "work" had to be to be an "artwork" had changed, and we were one step closer to the essential nature of the category.

So again, the Impressionists, for all their innovation, were still making handmade paintings that looked like something they weren't (as, water lilies, and boaters on the Seine), as visual artists had done for centuries before them … albeit with mimesis, as it had long been understood, removed. The Cubists produced handmade visual objects, too, but theirs were not just depictions of things external to the work itself; Cubist works were also *direct* representations of *ideas*, which, though they were *about* seeing and painting, weren't themselves necessarily visual. That freed subsequent "ists" and "isms" (again, see any art history survey text, to follow this through) to make artworks that weren't about anything *but* their ideas of things, and so didn't *have* to look like anything other than what they actually were (i.e., paint on a substrate), to be "art." That took representation itself increasingly out of the picture (pun intended) even as it opened the door to abstraction … and so it went, fueled by the excitement and momentum of the Modernist juggernaut, for years and years.

Three Corollaries

We'll speak to the remarkable, and problematic, culmination of this whole reductive inquiry, below. But first we need to note three things – all huge factors in the confusion surrounding "art" today – that were happening as functions of it.

The first of these corollaries was a logical one, and seems at first to be a paradox. As the Modern arts narrowed ever further their idea of what artworks seemed to be at core, the field of things that *could be* artworks expanded proportionately. In fact of course this isn't a paradox at all. If, to be considered in a certain way (as "art," for example), a thing must demonstrate six or eight characteristics simultaneously (it needs to be, say, made on purpose, by hand, with a high degree of mimetic skill, unique, beautiful in some way, and so on), only a relatively small number of things will likely be found that demonstrate all those characteristics at once, and so qualify to be considered in that way. But if that list of necessary characteristics is revised downward, so that fewer and fewer things are needed to qualify, then there are likely to be more and more things that *do* qualify, for the requirements are no longer as stringent as they were.

So, under Modernism, as artists and theorists peeled that "art" artichoke and closed – they assumed – on the heart, the essence, of it, the field of things that had the potential to be *considered* "art" grew. As one avant-garde approach after another had produced reductive works that ultimately were accepted, one after another, as "art," it ultimately became possible, as we've seen, for non-representational smearings of paint on surfaces, squares of raw pig iron (see below), and ultimately, piles of tropical produce, to be "art." But ask yourself: could such things have qualified, been thought of, as "art," at all, in, say, sixteenth-century Florence?

The other two corollaries of the Modernist quest were, in a way, functions of this logical one. As artists had probed more and more deeply into issues intrinsic to their common, Modernist endeavor, their conversations, their insights, their *ideas* about it had, predictably, became more and more arcane. This of course is true of any conversation that attempts to get at the roots of anything – if it goes on long enough, it will narrow itself to fundamental issues so far beneath the surfaces of the topic that they are all but unintelligible to anyone but those who've been in on the discussion from the beginning.

In the case of "art," though, in its new, modern sense, this phenomenon caused two things to occur. One was a huge surge in the importance of that varied community of "art experts" which, as we've noted, had been growing for some time now.

Philosophers, who'd been dealing for centuries with abstractions attaching to "art," were typically thinking about it on a level somewhat removed from that of most of us (and as we've noted, by the 1950s, in the face of all this, most of them had stopped trying to figure "art" out anyway). But the philosophers had been joined as time had gone on by those academics who "professed" at the Academies and so tended to approach questions of "art" at more practical and accessible levels. Critics, who had begun to make their presence felt mostly in the eighteenth century and who wrote about actual works of "art," and a relatively new category of aesthetic theorists who based their thinking on such works, fell somewhere between the philosophers and the teachers. Once art history had come to pass, historians of "art" had joined the chorus, telling us how to think about "art" from their perspective. As they had for centuries, the wealthy patrons who commission, buy and collect "art," though they may or may not have *said* much about it, "spoke" too to the questions of good or important "art" by the choices they made in what they commissioned and bought. And as private, then public, museums of "art" began to proliferate, also primarily in the eighteenth century, curators and then gallery owners had joined in in the same way.

These critical/interpretive voices now took on the task of mediating the increasingly obscure ideas that characterized the arts under Modernism in terms palatable to art's audiences. And as they did, and as those ideas became ever more obscure, the community of the "arts-initiated" – the artists themselves, those critics and theorists, gallery-owners and curators, wealthy buyers and patrons – began again to take on an aura of elitism, in an odd return to a position not unlike the one that had attached to "art" back at the very beginnings of modern history. Back then, though, *all* art *had* been the province of an elite group, whereas now, only *some* was, or perhaps more accurately, only some was seen that way by the public.

For despite these experts' best efforts, as the Modernist conversation about "art" continued, the public, who had been so hugely involved in the arts at the end of the eighteenth century, flocking to the Salons and museums and marveling at what they saw, now

increasingly fell away. As artists and commentators in and around the avant-garde produced ever more abstruse insights, and ever "odder" works in response to them, they moved ever further beyond the ken of average, relatively uninitiated art appreciators, who accordingly and not surprisingly, increasingly lost interest. (Ultimately, indeed, more than a few got angry, feeling that they were being cheated by Modern artists of what for centuries had been a great source of pleasure to them.)

As far as the public was concerned, all the art that was still being made in more traditional ways – mimetic images, made with observable skill, that looked nice and were about things and themes that regular people understood – was where *their* interest lay, even though the increasingly assertive Modernist arts establishment found it boring and old hat, and so largely ignored it. That public had photography, too, of course, though for a least half of the Modern Age, photography didn't really seem like what they understood as "art" – for virtually everyone, after all, could and did do it, and it was, after all, "made" by a machine.

There was, though, by the turn of the twentieth century, a photographic development that moved mimesis – still the "art" bottom line for all those people – to new levels so amazing that, art or no art, the public flocked, once again, to behold it. Now, wonder of wonders, there were pictures that actually … *moved* (and soon they'd be able to talk). Almost equally remarkable was the arrival, at about the same time, of the picture press, whereby photographic images could be reproduced directly in print.

Thus as the twentieth century began, the idea of "art" included *two* "arts": the increasingly elitist "High" or "Fine" arts involved in the Modernist, avant-garde quest, and the "Low" or "Popular" arts – the movies, magazine illustration and photography, the rather prosaic traditional works that were still being made, and so on. And the divide extended into all of the arts – there were strange, Modernist novels on the one side, romantic thrillers on the other; compositions on the octatonic scale and Primitivist music on the one side, popular songs and jazz on the other; later in the century, Strindberg and Ibsen on the one side, Rodgers and Hammerstein on the other. Lines between the "High" and "Low" arts were not, and have never been, anything like clear; there is ample overlap, and plenty of room within it for debate. But still, in what seems yet another odd sort of regression to an earlier state, under Modernism

(and since) there were now – again – two ideas of "art." (Actually of course there were three, if we include the original meaning of "art" as any human skill.)

Throughout the twentieth century, one could look from either side of the fuzzy divide between those two modern ideas of "art," over at some object of wild enthusiasm on the other side, and as we suggested here in the Introduction, sniff dismissively, "Well, but *that's* not '*art*.' " Perhaps no more classic example of this exists than one from the late 1950s. Norman Rockwell was a draftsman and painter of enormous skill who most typically made images depicting America's romanticized, mythic idea of itself, at mid-century; many of his paintings, famously, appeared as covers of a magazine called the *Saturday Evening Post*, and subscribers by the tens of thousands looked forward anxiously every week to the next Rockwell cover. At exactly the same time, a Modern artist named Yves Klein was making a name for himself on artistic/academic high by, among other things, painting innumerable canvases completely, and only, in utterly flat, even coats of blue – or, as Arnason and Prather tell it in their *History of Modern Art*, "a powdery, eye-dazzling, ultramarine pigment that he patented as IKB ('International Klein Blue')." It's telling, given the title of their book, that Arnason and Prather never mention Rockwell, or anyone else of his ilk, at all.

Thus as the evolution of "art" has grown even more confusing and problematic, the opinions of those "experts" have become increasingly important to that part of the culture's understanding of so-called "high" art; the experts have become the taste- and decision-makers for that narrowing group who listens to their opinions and attends their openings and auctions. By now, this group has itself become institutionalized, into what we often refer to lately as the "art world." The concerns, activities, and behaviors that characterize that world have come to be known as the "art game." And those experts have emerged finally as the "power structure" in that "game": they make the rules, call the shots, and decide who gets to play.

For die-hard romantics about "art," the idea that there should be an "art game" at all is abhorrent. "Art," in the romantic view, is thought to have something to do with universal truths and beauty, and so to "rise to the top," as it were, and be recognizable as such by all who encounter it. "Art," in that, is thought to be special, inherently better, more culturally valuable than is, say, insurance (no one, you'll note, has any particular problem with the idea of "the

insurance game"). And that there should be "rules" in "art" is repugnant, as is the idea that artists should have to play by them.

In fact, though, the institution of "art" has become no different in this regard than any other institution; general agreement in a culture about the conventions that define a set of behaviors and products as this or as that (as "art," say, or as "insurance") is in fact a necessary condition of *being* a cultural institution. So, probably, is a "power structure," though that may be more startling in a hallowed institution like "art" in the modern sense, than it is in other fields.

But the truth today is that the most insightful, beautifully made "art" by the most dedicated and talented artist, if it is not seen, deemed and so shown as such by at least one influential member of that "power structure," will never become, will never function in the culture as, "Art," "High Art," "art" with a capital "A." On the other hand, if one of those experts *does* acknowledge something as "Art," then it *becomes* "Art," at least within the "game."[7] And artists today who hope to have their work recognized as "Art" do indeed spend considerable time being in the right places and saying the right things to the right people – playing "the game," as people do in virtually every field – in hopes of making this happen.

Finally, here, we need to note carefully that *anything* that is so acknowledged in the art world has – whether actively or passively, whether in the moment or *centuries after the fact* (think of those prehistoric cave paintings and "Venuses") – "played the game." And this explains how things that you think aren't "art," are (are "Art," in fact), as far as the culture is concerned, and how some things you yourself acknowledge as "art" never get that capital A. As in any area of human endeavor, the fact that opinions differ is all there is to it, and power is distributed unevenly.

The End (?) ...

In any event, the reductive inquiry in the arts that gave rise to these corollary developments continued, accompanied by more and more arcane ideas about it, listened to by fewer and fewer people, until by the mid-1960s, there wasn't much left of that Modernist artichoke. One of the last of the "isms," Minimalism, an avant-garde movement primarily associated with sculpture, was the current "next thing." The Minimalist sculptors typically exhibited works of one of

two types. Some were raw materials on/to which absolutely minimal "work" had been done: Carl Andre's *Herm* of 1966, for instance, was a three-foot length of a wooden beam, just as it came from the lumber yard, stood on end in the gallery. Others were pointedly simple forms, usually geometric and/or boxlike, typically metal, featureless, and appearing, at least, to have been made by machines (very often they were presented in sets of identical objects, lending an aura of the assembly line; or in sets of similar objects in graded sizes, lending an aura of expanding – or contracting – ideas).

And as we've tried to suggest as we've followed the visual arts here, the other arts had been keeping pace, with their own Modernist, reductivist inquiries, right along. While Minimalist sculptors made objects such as we've just described, those other arts – or at least, their "High" components – had come down to equally minimal products. In music, just before Klein started painting those canvases flat blue, the Modernist composer John Cage (whom we mentioned briefly in the Introduction) had presented his *4'33"* (1952) – a composition consisting solely of three movements, all of them completely silent – and by the time Minimalism appeared, he had moved on to concerts in which he sat alone on a stage, on a chair before a small table with a crook-neck lamp on it, and read aloud, at random intervals, randomly chosen individual letters ("a" ... "w" ... "g" ...) from randomly selected pages of a randomly selected book, for as long as any of the audience remained attentive (often for hours). In theater, Samuel Beckett wrote *Breath* in 1969: in this avant-garde work, as the play begins, the light grows slowly to reveal a stage strewn with debris; one hears a faint cry, then the sound of human breathing, then another faint cry, and the light fades away again; *finis* (the whole thing takes 35 seconds). And so on, in literature, dance, throughout the whole range of the "High" Modern arts.

The Minimalists (in sculpture), and what we could conveniently call the minimalists (in everything else), had, then, peeled away from the artichoke every last vestige of anything like the skills that had long been assumed of "artists" ... except, of course, the intellectual skills. Avant-garde artists in the '60s were still having ideas, as had all artists before them. In the case of the avant-garde, those ideas were about presenting these utterly simple things as "art" – which of course, once presented, they became ... and the category widened.

And then, those *ideas themselves* became the "next thing." In the late '60s, an approach called Conceptualism began to emerge, in

which *concepts*, those ideas per se, began to be seen as the stuff of "art." Early Conceptualists did still make "things" (or events), though the range of *kinds* of things they made was by now all but infinite. Early Conceptual works might appear either in galleries or in unexpected, non-art venues and contexts, and seemed to say simply, "I am an artist and I had an idea about something I could do here, and so I did it." One might encounter, for instance, an unannounced, unexplained color-striped rectangle on the face of a building in a gritty part of a city (Daniel Buren's *Untitled*, 1973); or

wa·ter (wȧ'tẽr), *n.* [AS. *wæter* = D. *water* = G. *wasser,* akin to Icel. *vatn,* Goth. *wató,* water, also to Gr. ὕδωρ, Skt. *udan,* water, L. *unda,* a wave, water; all from the same root as E. *wet:* cf. *hydra, otter*[1], *undine,* and *wash.*] The liquid which in a more or less impure state constitutes rain, oceans, lakes, rivers, etc., and which in a pure state is a transparent, inodorous, tasteless liquid, a compound of hydrogen and oxygen, H_2O, freezing at 32° F. or 0° C., and boiling at 212° F. or 100° C.; a special form or variety of this liquid, as rain, or (often in *pl.*) as the liquid ('mineral water') obtained from a mineral spring (as, "the *waters* of Aix-la-Chapelle".

Figure 8 Hans Kosuth, *Titled (Art As Idea As Idea) [Water]* (1996), Solomon R. Guggenheim Museum, New York. Gift, Leo Castelli, New York. 1973 73.2066. © ARS, NY and DACS, London 2007

an artist standing in an otherwise empty gallery while an assistant (and marksman) shot him in the arm (Chris Burden's *Shoot*, 1971). A broad "class" of Conceptual works were representations (often photographic) of representations (often linguistic) of meanings of ideas ... of which there can be no better example, perhaps, than Joseph Kosuth's 1966 *Titled (Art As Idea As Idea) [Water]* (Figure 8).

And by the mid-1970s, *some* Conceptual artists found they didn't even have to go *that* far, didn't have to make *things* at all, to make "art"; it had become possible to simply write down an "art-idea" – by now, virtually *any* idea – on a piece of notebook paper, and the possibility at least existed that a museum would buy it (as many did), and by so doing, validate it as "art."

From there, it was but a half-step to an ending, at least of a sort. For the move from "idea as art" to "art as idea" was almost no move at all – Kosuth, in fact, had even previewed it, a decade before. By the early–mid-1970s, the artists who had been enthusiastically engaging for more than a century in the Modernist quest for the essence of what they were doing found themselves painted into a theoretical corner, as it were, in which they came face-to-face with the answer: "art" was, in essence, *just an idea.* (One has to wonder whether Robert Morris, one of the most serious and thoughtful of the Minimalist sculptors, hadn't foreseen this too, when he exhibited – outdoors – his *Steam Cloud* of 1969. *Steam Cloud* was just what its title suggests, and it – an art*work*, remember – just ... blew away.)

This sudden (re)realization that art was just an idea coincided almost perfectly with the acknowledgement of the failure of the Modernist Agenda, and so effectively the end of Modernism itself.[8] Virtually none of the utopian visions of Modernism had come to pass, at least to any significant degree; the whole excited pursuit of essences had all come down finally to ... just ... ideas, most of which had failed to produce any fundamental differences in the state of the world. The community of social commentators and art critics, whose pronouncements had driven and interpreted the Modernist quest for all that time, fell strangely silent, as if at a loss for anything else to say. Deprived of the sense of urgent direction toward a goal that Modernism had provided for over a century, the question now, both socially and artistically, was one of what to do ... next? But of course there was no "next," or at least so it seemed, for the Modernist reductive thrust that had dominated everything for more than a

century was over. And even had it not been, where *could* we go from the idea that it all came down to … idea?

PoMo

This book, of course, has suggested from the beginning that "art" was just an idea; but remember that this book is written on the basis of 35 or 40 years of hindsight. Most responsible historians will tell you that to try to make sense of events much closer in time than that is foolhardy, that one needs at least a couple of decades, preferably more, to develop any sort of informed perspective on things. But rather than just leave the history of the idea of "art" hanging, in 1975, we should at least sketch – even more broadly that we've done so far – what seems to have happened to it since.

When the realization that art was just an idea *first* began to dawn on the arts community in the 1970s, their response was, effectively, one of stunned silence. As we noted above, the critics and theorists who had explained art to those interested since it had first become an essentially intellectual pursuit that *needed* explaining, and who in the process had come to take the evolutionary, "next-thing-growing-out-of-the-last-thing" approach as their guiding principle, were at a loss for words, for there seemed to *be* no "next thing," anymore. The people we had come to think of as "artists" kept making the sorts of things that we were used to thinking of as "art," but the energy and the sense of direction that had characterized the Modernist Agenda seemed to have gone out of it.

This sort of stunned disorientation began gradually to be replaced in the 1980s by a tentative, renewed acknowledgment of all the expressive forms that had been ignored and/or discarded by "High" art (though embraced by the public) as the Modernist juggernaut had dominated everything. Realist painting, of all things – painting that looked like something it wasn't – began haltingly to reappear in mainstream galleries. So did visual forms that had never been considered "art," once the idea had begun its modern evolution. So-called "outsider art" – works made by people who were not professional artists, and who had previously been dismissed by the High-Art establishment as inconsequential eccentrics and/or vandals (as in the case of graffiti "taggers") – began to appear, as did cartoons, and things previously thought of as craft.

As this reassertion of long-ignored and long-discounted art forms was happening, assumptions about how art had to work in the world were being reconsidered by the High Art establishment, too. One of the foremost such assumptions, for instance, had long been that artworks were sacrosanct: once someone made (wrote, composed, choreographed ...) something, and it had been acknowledged as "art," it belonged, as such and forevermore (or until the copyright expired), to its creator alone, and could never, ever be tampered with or used in part or in whole by anyone else without the artist's express permission. Now, though, it began to seem that it made more sense to see other people's artworks as potential elements in new artworks, just as were any other cultural products – for they were all the same, really, all just ideas, or embodiments of them, after all. So now one could "appropriate" the *Mona Lisa*, say, either intact or in part, and include it in one's own artwork, to express whatever idea. At the same time, things that could never have been "art" before – a pile of bananas, say, or a quote from a dictionary – now could be "art," and were.

As this artistic chaos – for so it surely seemed, relative to the Modernist past and beyond – continued, the theorists and the critics, elevated by Modernism to hugely influential positions in the art world and now struggling to re-find their voices, began tentatively to refer to the identifiable ideas and products of the chaos as "post-Modern." At first, this designation only made it clear that what was being talked about had happened after Modernism. In time, though, as the critics began to be able to sort the chaos and establish, at least tentatively, patterns and tendencies and structures within it (remember our beastie, millennia ago, there on the near side of the evolutionary bridge?), the "p" in "post-Modern" began to be capitalized, the "M" in "Modern" reduced to lower-case, and the hyphen dropped ... and we began to think of ourselves in a Postmodern Age.

Postmodernism is by now a fully articulated cultural ethos, just as was Modernism before it. For our purposes here, three primary components of that ethos are important to recognize. First, Postmodernism accepts the overarching premise that "it's all language," that virtually all of human experience, that is, is experienced linguistically (you heard mention of this, you'll remember, in Chapter 2, and you'll hear more in Chapter 5).[9] Second, that being the case, discussion of any sort about any thing in a Postmodern culture, given that any (cultural) thing is by definition linguistic, can

be seen as commentary on everything else in that culture, for everything else is of course linguistic, too – an observation about one linguistic entity or system goes for all.[10]

The third component that concerns us here is the recognition that in the Postmodern world *any human product at all* can be "art," given that the category is by now completely open to anything that begins with or embodies an idea. This grows organically out of the first two components and, of course, out of the histories we've just described. One critical thing to notice about it, though – critical, that is, for our purposes here – is the phrase "can be," which obviously makes the statement one of potential only. In Postmodernism, any human product *can be* "art" ... but not everything is.

And So, The Question (Again)

All of this comes down finally, then, to our original question.

That question has been lurking in the background since the end of Modernism, at least (and probably for a long time before that): if "art" is just an idea, well, so is everything else, especially in the Postmodern world-as-language view ... and so ... what's the difference, really, that makes certain human products "art," in the modern sense, and others not? If art's just an idea, well ... what *is* that idea?

This, finally, is the question with which most of those theorists mentioned in the Introduction here, who suggest lately that "art" is *over*, are concerned. They take the position that, if the term "art" refers, like any other term, to an idea, and if that idea is of a category that is impossible to objectively demonstrate, then it's *just* an idea. It's not the behaviors that we call "art" that are over – people will presumably continue to paint and sing and dance and tell stories and so on, as they always have – but that the usefulness of the word as a meaningful descriptor of the world has come to an end. "Art" or "not-art," they're suggesting, is no longer a meaningful question.

And maybe they're right. For most of us, though, the idea of "art" has been such a hallowed idea, for so long, that to declare it "dead" at this point, notwithstanding the logic of that position, is all but sacrilege. Is there no way to describe the world that makes more sense than this?

Again: maybe; probably, even. We'll look into one such description, in Chapter 6. But before that'll make any sense, we need to change the subject for a while, in Chapter 5.

Notes

1 Things get tricky, here. For one thing, there's always uncertainty when the word begins a sentence: is that (only) why it's capitalized? And for another, there's that fact that, for most of the nineteenth and twentieth centuries, what was "Modern" *was* "modern."

2 It has long been held that leisure time is necessary to the production of philosophy and art in a culture ... and as noted, leisure time was surely one of the foreseeable "positives" of industrialization. This may go a long way toward explaining the involvement of practitioners in these fields, in the Modernist Project.

3 To be a little more accurate, the *daguerreotype* was *patented* in January of 1839. The daguerreotype was not "true" photography, in the modern sense, though it was a close and spectacular cousin; so this date has come to be thought of as the invention of the medium itself. In fact, though, various pieces of the "true" photographic process had been being developed (pun intended) in various parts of Europe since late in the eighteenth century, and virtually all were in place by the end of 1841. It's possible, indeed, depending on how one defines "invention" and "the photographic process," to say that the medium was "invented" in as many as seven different places within a few months of January 1839.

4 See Ogburn, William F., and Dorothy Thomas, "Are Inventions Inevitable? A Note on Social Evolution," in *Political Science Quarterly*, March 1922 (37: 83–98).

5 History painting, as the name implies, was the painting of images of historical events, whether instructive or inspirational ones from the Classical Era, or the painter's "interpretations" of more modern ones ... none of which, of course, the history painter was likely to have ever actually seen, in the days before photography.

6 That those eighteenth-century assumptions about "art" *do* still prevail for many of us today is what makes it so confusing – not to say infuriating – that all those odd, reductivist Modern works – not to mention the Postmodern ones that followed, as we'll see – seem to be considered "art" too. This book hopes to help with just that issue.

7 If some of their choices seem "iffy" when viewed from outside the "art world" where the game is played, well, again, perhaps the skeptical

viewer doesn't understand the "rules," or, perhaps the experts have made a mistake – misjudged the work in question, misinterpreted the conventions as they exist at the moment (it does happen to everyone).

8 As you might expect, there is no date on which this happened; Modernism ended not with a bang, but in a sort of gradual whimper.

9 Hence the critical buzzword "text": until recently, a "text" was something that you read. Now, though, given that all cultural products are understood to be linguistic, and hence available to be read, "text" tends to mean "any human cultural product that one seeks to come to terms with."

10 The critical/theoretical term for this is "intertextuality."

Chapter 5

"Art" and Language

It looks as though we're not going to get to the modern meaning of the term "art" by examining the history of the ways it's been used; and when we considered the sorts of things to which it has variously referred, back in Chapter 2, that didn't get us very far either. So I want now to try a different sort of tactic. I want to try comparing and contrasting "art" with something that seems very like it, but that's (usually) thought of as different, in hopes that some of the disparities between the two will suggest themselves, and perhaps advance our cause here.

Is there anything we can say *generally* about "art" that will offer some bases for comparison, and so suggest some other thing with which it might usefully be compared? If we think of the vast assortment of things to which "art" *has* variously referred, seeking characteristics they all seem to have in common, only three such characteristics suggest themselves. All the things we've ever called "art" in any literal use of the term – shoemaking, Tuvan throat-singing, the Sistine Chapel ceiling, piles of bananas, all of them – seem to be human-made, creative, and expressive.

As for that first characteristic, think back to the original root of the term "art" in Western culture – the ancient Greek term *techne*. As we noted in Chapter 2, that term was used to refer specifically to *human* skills, as opposed to natural phenomena; and as the idea behind the term *techne* has evolved, it hasn't lost that original sense. "Art," *meant literally*, has *always* meant human endeavor. Thus saying, as people often do, that a natural event like a sunset is "a work of art" is necessarily a metaphoric statement. A sunset may be

like some works of art, in that it's sensually beautiful, of course …
but until a human being affects it in some way – paints its likeness,
or photographs it, even holds up a frame for us to see it through, or
composes a poem or a symphony that tries to evoke the experience
of it – it's not in itself literally "art." The "art" is the painting, or the
photo, or the poem, or the music, or the conceptual act of holding
up the frame.

As to creativity, it shouldn't be difficult to see the cave paintings
or an operatic aria or that poem about the sunset as creative pro-
ducts, though more contemporary artworks can be a little more
problematic for some of us. People (maybe including you) will often
exclaim, "How can you call those blue paintings that Yves Klein
made 'creative'? Except maybe for shape, they're all exactly the same!
Or Andy Warhol's exact reproduction of a Brillo box? It looks just
like the real thing!" These apparent problems are resolved, though,
as soon as we remember that by the time Klein and Warhol were
working, the works were understandable as the embodiment of *ideas*
about "art" … and in the context of "art" as it had been previously
understood, the *ideas embodied* were undeniably creative.

In the same sort of way, artworks that tell or depict stories, or
evoke strong emotions, are easily seen as "expressive" … but again,
what of those flat blue canvases or Brillo boxes and the like? What
could *they* be "expressing," for heaven's sake? To answer these
concerns, we need only put ourselves again in the position of an
archaeologist, this one working several thousand years from now and
unearthing some of those canvases, or a Brillo box that isn't, really …
or for that matter, anything at all. As we said in Chapter 3, virtually
any cultural product – teaspoons, fur coats, coal hods, artworks, any-
thing – that emerges from the ground will be understood as in some
way expressive of some aspect of the culture that produced it. And
historical distance from the culture in question has nothing neces-
sary to do with it; all that makes those things understandable in that
way is the archaeologist's point of view, one which is easily available
to all of us. So seen in that way at least, *all* artworks, and all other
cultural products, for that matter, are expressive.

Thus, the three characteristics that seem to be shared by all "art"
things are shared by every other human product ever made, as well.[1]
This would be a problem here if we were still pursuing the difference
that we assume must exist between "art" and everything else. (We
assume that difference, remember, because presumably the word

"art" refers – as do most words, as we noted in Chapter 1 – to something that we can distinguish from other things.) But just at this particular moment, we're not pursuing that distinction, exactly; we're taking a slight detour. Right now we're seeking something with which we can usefully compare art, in hopes that we can use that comparison to get at "art's" presumed difference(s), later. And on that basis, if we try to think of something that's other than "art" but apparently very like it, my guess is that most of us would come up first with *language*.

Language, as we saw in Chapter 1 (and pending that further input from the Cetaceans), is apparently unique to humans; by definition, all normally functioning humans have it. It's creative; the design *of* a language is certainly so, as we'll see, and individually utterances *in* a language are too, if only in the sense in note 1 below. And as far as expressivity is concerned, language is perhaps more similar to art in that regard than any other human product might be. For both linguistic statements and artworks are *actively* expressive; that is, we use them, intentionally, just *to* express ourselves, rather than simply understanding them as *passively* expressive, in the way that those archaeologists might consider a potsherd.

Furthermore, language at least *seems*, to most of us, to be a lot more straightforward than "art" has proven to be, so perhaps this comparative approach will offer easier access to our question than those we've tried so far. Let's look a little more closely at *language* than we did in Chapter 1, then, and see what it might suggest to us about "art." (This may take a while, but it's likely to be worth it.)

The Basics

First, let's be clear that when we talk about "languages," here, we *mean* languages, fairly specifically. It's possible, of course, to say "language" when you really mean "communication system." But in fact, a language is one fairly specialized type of communication system, with characteristics and potentials unique just to languages (and/or to some other communication systems that are truly "linguis*tic*," as we'll see).

Given that stipulation, if you were asked what a language *was*, at its most basic level – and then maybe prodded just a little – you'd likely be able to say, based on the example(s) of the language(s) that

you use most of the time, that languages are systems of mutually opposed "signs" (you might be tempted to use the term "symbols," but "signs" is better),[2] and rules for organizing those signs relative to one another in ways that make sense. And if you were asked what they were *for*, you could likely now respond that we use them to refer, in the abstract, to our ideas about our experience of the world. So far so good; though there's a little more than that to say about them.

For one, the concept of "sign" may need some more careful attention. A "sign" is anything that we understand as signifying (*"sign*ifying"), or referring to, something other than itself. The "signs" involved in most *formal* languages (see below), like English or Turkish or Swahili, are certain patterns of sound – called "words," in English – to which we ascribe significance (*"sign*ificance"). And in written forms of such languages, the "signs" are certain marks, which refer to those sound patterns (and/or – as in the case of punctuation marks – to inflections and rhythms in which those sound patterns are intended to be uttered, if in fact anyone were to say them aloud).

Don't make the mistake, though, of thinking that the "signs" of a language *need* to be sound patterns, or written marks – consider, for instance, American Sign Language, which uses gestures, instead. Indeed, the "signs" of a language *could* be anything at all – sounds or gestures, obviously, but also, say, different sorts of stones, or of ball point pens, or any combination of any of these (all you'd have to do if you wanted to refer to a sunset is hold up the pebble that you'd decided would mean that, and if you wanted to say "beautiful," the Bic® that meant that), or anything else at all. The only thing required to make anything(s) at all into meaningful "signs" is *agreement*, on the part of the people using them as such, that they *will* be understood as referring to things other than themselves … and, of course, what specific "other thing" each of the "signs" will designate (*"des*ig*n*ate"). The relationship of signs to their referents, that is, is virtually always *arbitrary*,[3] and purely a matter of *convention*.

So, not only can a "sign," considered on its own, *be* anything … it can also *mean* anything, depending only on what a given linguistic community wants. All speakers of English, for instance, have agreed (on some level) that if they want to refer to four-legged, more-or-less furry domesticated mammals, most of which bark, they will use the sound pattern, the sign, "d-aw-g," to do so. And so, *in the English language*, that pattern of sound (or the set of marks "dog,"

which suggest it) does refer to that sort of animal. But if you consider that particular sound pattern *outside* that language, outside that sign system – indeed, outside any such system at all, as just existing as a sound pattern, entirely on its own – then it *doesn't* refer to, doesn't "mean," *anything*; it's not even a "sign" at all, but rather just a noise. Considered by itself, it's only *potentially* a sign. And by the same token, were it to become a "sign," were some community to include it in their language as a meaning-bearing entity, it has the *potential* to mean *anything*, depending, again, only on that community's agreed-upon whim. (We English-speakers *could* have decided, way back when, to use "dog" to refer to the doughnut-shaped air-filled rubber things that we mount on the wheels of our cars, or to the sweet sticky chocolate stuff that covers the outside of many birthday cakes, or ...)

Note carefully too that once some community has decided to understand some sign as signifying some thing in some system of related signs, it does so, as noted above, on the necessary basis of those *distinctions* that humans perceive and think about. Let's assume that the community in question perceives furry domesticated animals *that* bark, as being different from, say, elongate cylindrical sections of felled trees, sawn at the ends but still covered *in* bark. Because it sees those two phenomena as different from one another, it will – usually[4] – refer to those differing phenomena by using *signs* for them that are *also* different ... so that if one thing is referred to as "dog," the other must be called something else – like "log" – and so on. (This, again, is why the existence of the word – the "sign" – "art" makes us assume that there must be some distinguishable class of things to which the term refers.) And if we reemphasize here that linguistic signs do not refer directly to actual events and/or things in the physical world, but rather to our *ideas* of and about such events and things, that's probably enough about signs, for the moment.

By itself, though, conventional agreement, on the part of a community, on a set of linguistic signs and on what ideas each of them will represent, does not constitute a language. The community that intends to use the language has also to agree on some *rules* by which those agreed-upon signs are to be arranged, *in relation to* one another, if they're to make sense. We know these rules, typically, as grammar and syntax. And like the conventionally agreed-upon signs whose relations they mandate, these conventionally agreed-upon

rules can also work in any way at all; all it takes for them to "make sense" is the linguistic community's agreement that they should. Without them, though, the words of a language *don't* make sense. While these five words – "the justifies means end the" – are all perfectly valid, perfectly meaningful "signs" in the English language, they add up to nonsense ("non-sense") when assembled randomly as they are here. If one orders and shapes them according to the rules of English grammar and syntax, though, *voila*: "The end justifies the means."

These "rules" that organize and drive a language are, at any given point in time, "enforceable," if sense is to be made; one cannot simply ignore them, if one hopes to make it. But we should note that they are not as inflexible *over* time as the term might seem to suggest. Languages are shaped not only by social convention and "rules of proceeding," as we have noted, but also by "accumulated precedent."[5]

That is, the "rules" of a language can and do change over time, as the social conventions that inform them change, and so as does precedent. It's a function of "accumulated precedent," for instance, that we can lately make sense in English by adding "-ing" to the end of nouns, to form other nouns – "parenting," "networking," etc. – when in relatively recent days "-ing" only made sense at the end of certain verb forms ... and once we'd decided that that would be okay, the original nouns could then *become* verb forms – to "parent," to "network" – too.

And finally, as we suggested at the top of this section, we *use* language(s) to describe our experience of things, and to share our ideas about them.

So much for the basics.

But ... are there any differences emerging, at this very basic level, between languages and what we think of, however vaguely, as "art"? It begins to seem that there may be one – though at this point we can't quite be sure. It surely *seems*, though, that "art" isn't as "rule-bound" as we've said language is, doesn't it? Doesn't it seem that "art," at least lately, is "freer," in some difficult-to-explain, general-impression sort of a way, than a language is? Keep that in mind as a possibility, anyway, while we consider language a bit further. The next thing we need to look at is just how much of this rule-bound language there *is*, in our culture (there's a lot more than you may have thought).

Languages, Languages, and Linguistic Systems

Most of what we've said so far about language has been in terms of *formal* languages (languages with a capital "L," as it were), such as English, French, Arabic, and so on. These are the most highly developed examples *of* language, and the ones that most of us use most of the time; thus they are the easiest for most of us to "see," in the abstract, and understand. But it's important to realize that true formal languages are only a small specialized group in a broad array of signifying systems which also includes a more generalized group of what we might call "informal" languages (with a *small* "l"), and an even (much) larger group of what we might term "linguistic systems."

True *formal* languages are distinguished from these other, less-formalized systems by two factors. For one, the grammatical and syntactical rules which drive formal languages are *prescriptive* (as in "prescription") – that is, they tell a user of that language how its linguistic elements *must be* ordered (more or less), relative to each other, to make sense. At any given moment, the "rules" of a formal language are more assertively in play than are the "accumulated precedents" that give rise to them. And for the other, formal languages are *reflexive* – it is possible to use one to talk about itself (I'm doing that, of course, in the English language, right now).

In so-called *informal* languages, though, the "signs" that we "read" as meaningful are *not* usually words … though they are, as are words, generally all of a kind; and the "rules" by which those signs are meaningfully related to one another are *not* prescriptive, but *descriptive*. The conventions that drive such "informal" languages never approach the status of "rules" to nearly the degree that they do in formal languages, but rather are much more directly a function of "accumulated precedent." That is, they *describe* how sense *has been* made, in such systems, in past experience, but in no way suggest that that's the only way *to* make it.

A prime example of an informal language would be the so-called "language of clothes." Its signs, like those of formal languages, are all of a kind (articles of clothing, rather than words), and certain combinations of garments are conventionally understood to "make sense" in certain situations, just as certain combinations of words do. But rather than "rules," informal languages offer precedents about what sorts of attire have traditionally "made sense" in various

situations; and the "grammars" of informal languages are thus much more flexible than those of formal ones.

For instance, you might look a little odd, relative to these precedents, if you wore your surfing shorts to an interview at Harvard Business School ... but you *could*, and the interviewer would still be able to tell why you were there, by "reading" the signs of *other* informal languages *also* conventionally understood as appropriate, as "making sense," at such a time – the fact that you showed up at the appointed hour, certain deferential behaviors on your part, and so on (she would likely, in fact, given that you "made sense" in all these other, overlapping informal languages, see your choice of attire as some sort of a "statement" in the "language of clothes," and record what she thought it signified, in her notes on your meeting). Had you departed *too* radically from established cultural precedents regarding what "makes sense" in such an interview, so that the perceived significance of the shift was *not* more-or-less self-evident even given all those other clues – if you, say, wore nothing but sandals to that interview – the necessary explanation thus called for could not be made in the "language of clothes" itself, as informal languages are not typically reflexive. Rather, the explanation would require another language, presumably a formal one, as in "Oh, well I ... I mean ... I sort of thought that ..." Such "informal languages" permeate our culture, and we all know, as did that Harvard interviewer, how to "read" them, to ascribe significance to such things as the sorts of cars people drive, the sort of music they favor, their "manners" relative to established norms, and so on.

Far and away the biggest group of signifying systems, though, is those systems of conventionally related signs in which the signs are *not* all of a kind, but which are otherwise similar to languages. The "language" metaphor stretches unreliably thin, at this level; these are perhaps best thought of as "linguistic systems."

While formal and informal languages are relatively easy to see as discrete systems, "linguistic systems" are not, for most of us. They don't *look* like languages. The reason for this is that the "signs" involved in the broad category we refer to here as "linguistic systems" are typically of disparate types, unlike those of the systems we've referred to as languages.

Consider, for instance, a supermarket. Supermarkets can be understood as linguistic systems, in which produce, canned goods, checkout lines, Musak, coupons, chromed pushcarts, and so on are all "signs." The disparity of these signs makes us the more aware that

any one of them, in isolation, *could* refer to any number of things other than (and including) our idea of "supermarket." Musak might, on its own, refer us to, say, our idea of an elevator, or a dentist's office. A pushcart, on its own – or even one filled with shopping bags – might be taken as signifying the existence of a homeless person's substitute for a home, as readily as it might a supermarket.

But in fact, the disparate signs of a linguistic system function as such, just as do the signs of more homogeneous "languages," by virtue of their *simultaneously opposed relationships* to one another. When *all* of those "signs" I've listed above come *together*, in *simultaneous* opposition to one another and in certain conventionally understood relationships, they make sense to us *just* as a supermarket. The perceptual/conceptual ability that allows us to thus understand such sets of disparate, though mutually opposed signs in this way is exactly the same one that allowed us, a few paragraphs ago, to make sense of those jumbled words ("the, justifies, means, ends, the"), once *they* had fallen into conventionally understood, mutually opposed relations to one another.

And while we may not know how to "speak supermarket," exactly, we do know, based on our past experience of such systems, how to make sense in one, just as we know how to make sense in, say, English. If it were to occur to us, on encountering an enormous pile of grapes in the produce section of our local Food Mart, to take off our shoes and commence stomping them, we know that that would not make much sense, just as using certain words in certain ways to the police officer called by the store manager to deal with you wouldn't make much sense either. (At a traditional European winemaking festival, though – in the presence, that is, of an entirely *different* set of mutually opposed "signs" – the grape-stomping, at least, might make *perfect* sense.)

We make sense in this way, of and in all sorts of cultural institutions, from colleges to cotillions, board meetings to ball games; all of these are understandable as linguistic systems. In 1916, famously, a Swiss linguistics professor named Saussure had this dawn on him.[6] Saussure proposed, in fact, that *any and all of the institutions comprising human culture* – not only its formal and informal languages, but also its supermarkets, schools, social gatherings, penal systems, wine festivals, all of it – could in fact be described as linguistic systems ... and indeed, that culture itself amounts to an infinitely complex linguistic system, made up of all those interrelated others, all meaning whatever they do purely by virtue of their mutual opposition and relation to one another.

Thus, for instance, the juxtaposition of what we think of as "Renaissance portraiture" with what we describe as "Abstract Expressionism" with what we designate as "conceptual installation works" (like Fishbone's banana piles), and so on, can be described and understood as what we conventionally understand as the "history of Western art." And that history, juxtaposed against, say, the complexes of opposed phenomena we understand as the Reformation, or as World War II, or any number of other perceived, conceived events or periods, begins to form what we describe as "Western sociocultural history."

We humans, Saussure proposed, *cannot have* direct, unmediated experiences of our world (as presumably all the other animals do of theirs), because by our nature we see *everything* in that world – not just words – as "sign," see it *all*, inevitably, as part of seemingly infinite, infinitely intertwined systems of *linguistic relationships*, perceived and conceived by us as "making sense."

And that description of the world begins to be vaguely worrisome, for reasons which – if they've not begun to occur to you yet – we'll get to before we finish this chapter. Before we do that, though, have we come up *now* with any telling differences between language and "art"?

The tentative idea that we arrived at last time we checked – that this term "art" seems likely to refer to things that have meaning in some way other than the codified, rule-bound way in which languages have meaning – is still with us. It's harder now, though, to see how that could be, for everything we've said so far has suggested that we humans, as linguistic creatures, make meaning linguistically, by definition. And whatever else may be true of artists, they're surely human.

We'll consider this more in Chapter 6 (and even more in Chapter 8). Before we do, though, let's describe language in two new ways. Both of these – fair warning – will only serve to deepen our perplexity here … but that may not be a bad thing, in the end.

Three Descriptions

What we've said so far about languages suggests that they are essentially tools, albeit complex and evolving ones, that we use in interacting with the world. True enough. But languages are not, in

that, passive, in the way that, say, a hammer is, just lying there on the basement workbench, out of sight and mind until we need to drive a nail. Languages are always with us, not only facilitating descriptions of our experience, but actively shaping that experience, determining its nature, all the time. Here, then, are three propositions about language: language is something we use *to describe* the world; *a* language is a *description of* the world; language *is* our world.

The first of these – that we use language to describe the world, as we experience it – we've already noted.

And the second – that a language *is*, itself, a description of the world – is only slightly more difficult to grasp. If some group of people, some culture – as, say, the Inuit (the people that many of us think of as "Eskimos") – set out to describe what *they* see in the world, over time, as relevant to their existence, and hence worthy of discussion; and if they accordingly find ways to describe those things in a language that they all understand (i.e., in this case, the Inuit language, Inuktitut) ... then in time it becomes possible to look at the Inuktitut language as the *embodiment* of the choices that Inuit culture has made about what is worthy of note in the world, and how it seems to make sense ... as, that is, the Inuit view of, its description of, its world.

This description will certainly correspond with most others on most points, particularly those involving natural categories – though it will likely use different words to refer to them. But it will also certainly *differ*, here and there. Inuktitut has (famously) many more subtly-differentiated words for "snow," for instance, than does English; and there are surely other ideas and expressed relationships which are part of the Inuit description of the way the world works, but have no counterpart whatsoever in the English one. So it is with all languages, which of course is why there are translators.

It's important to note, too, that this description of language as description of the world goes beyond the relatively simple act of perceiving phenomena, like those categories and those behaviors, and agreeing on words to refer to them. A language's grammar and syntax – the rules by which those words must be related if they are to "make sense" – typically also embody assumptions about the way the world works. In English, for instance, the subject "does" the verb, while in certain other languages, the verb "happens to" the subject; the languages thus *embody* very different descriptions of how actions happen in the world.

And the third proposition – that language *is* our world – may seem rather a metaphoric "reach," at first glance … but given the first two, it's probably not, in fact.

Consider first that how we humans describe the world *is* how it *is*, for us (we've mentioned this already, in Chapter 2 and elsewhere). And as we've suggested, on a collective level, our languages embody descriptions of the world that have become so institutionalized that they have come to seem, for most of us, most of the time, to be … just … the way the world *is*.

In the early 1930s two American linguists, Edward Sapir and Benjamin Whorf, thought and wrote a great deal about the implications of this connection between our experience and our linguistic descriptions of it. Their work is often oversimplified and referred to as the Sapir–Whorf Hypothesis, which in its "strong version" goes so far as to suggest that in fact, if a language does not have a word for a thing, speakers of that language *cannot experience* that thing as such. This "strong version" has been largely discredited, though the "softer" version – that the way we describe a thing determines in great degree how we experience it – is generally accepted.

Thus, if you've never heard of or imagined "baseball," and if I hand you a smallish, hard sphere, covered in leather sewn together in a sort of interlocked figure-eight stitching pattern, then, while you'll know you have this hard round object in your grasp, you'll not experience it as a "baseball," per se – there'll not be, for you, any attendant connotations of Mom and apple pie, or sunshine on the bleacher seats, or the infield fly rule, or obscenely inflated player salaries. It may be, in fact, that if you only know smallish hard objects as weapons to be thrown in a killing game, you will experience this one as ammunition, and not as a "ball" at all. Your perception of the object, that is, and so your experience of it, are shaped by the way you describe it … and to that degree, in a way that it can (apparently) never be for the other animals, experience for humans *is* linguistic. From there, it's only a small leap to the proposition that indeed, language *is* our world, as we know it.

But Be Careful …

It's important to note here, though, that it would be a mistake to imagine, as a function of the evolutionarily silly scenario described in Chapter 1, us humans as situated more-or-less securely Over Here,

in the vantage afforded by our sense of self, looking out across a sort of experiential gap filled with linguistic descriptions of our *ideas* of the world, at the *actual* world Over There, on the other side ... for this is not the way it seems to work. Instead, rather than standing "over here," looking "over there," beyond the abstract descriptions that fill the gap between, we are in fact situated *in* the gap, looking out from it at both the subjective and objective sides that define it, and using language to describe both. We explain *ourselves*, that is, in the same language we use to explain the world beyond ourselves ... and our experience of *both* is as we describe it.

Again, if I think of myself, describe myself, as being, by and large, a reasonably good guy, then as far as I know I *am* one; and if I describe that painting or that symphony as being terrible, then for me, they are. Should my perceptions of either or both change, then so will the language I use to describe them. I'll either rear-range existing elements of the language to refer to my new ideas – as in, "Let me put that in a different way ..." – or more rarely, I'll coin new usages and use them in contexts that delimit their meaning to something pretty close to what I intend. We've all struggled (keep this word in mind for later) to do this at those moments when we need to express something that we "don't have words for." And as new meanings are thus attached to shifting descriptions, those descriptions shape our perceptions differently henceforward.

Thus – far from language being like a hammer – we find ourselves living in a linguistic world, a world of descriptions, that change as we do, and change us as they do, and on and on in an endless interplay of perception, conception, and linguistic description. (Perhaps no better example of this exists than the evolution of "art.")

Not only, then, is there a lot of language *in* our world; effectively, language *is* our world.

One (Crucial) Observation

Having said all of this about languages and linguistic systems, we should reassert one important observation about how they work on us, which may in fact seem, as we've suggested, vaguely ominous. That observation, lest you missed the implications of it earlier, is this: all these languages and linguistic systems – the structured,

abstract, convention bound systems by which we make sense of our world – ultimately function as *conservative forces* on how we see and understand that world.

We humans, as we've noted, *describe* … and when we're describing, whether to our parents or to our roommates or even just to ourselves, we use languages to do it. Our descriptions will accordingly only make sense – to *any* audience that understands that language – if they conform to the *conventional* expectations that that language embodies, about what needs to be seen as relative to what, and in what way. There is leeway, of course, as we've also noted – we all use some of it, all the time, and poets exploit it. But there are also "sensible" limits to that leeway, beyond which, if one refers to certain things in certain unexpected ways that are too far from the conventional linguistic norms, sense will not be made.

By way of an example a bit less silly that the wine-stomping one we mentioned earlier, imagine yourself in a time and place in which some group of people is habitually referred to with some sort of demeaning racial, or ethnic, or socioeconomic slur – we all know some hateful examples. And imagine that one day you blurt out, in some gathering of your peers who know such people only in terms of that slur, that Ms So-and-so, whom everyone knows as one of "those" people, is a truly fine and outstanding person. At first – at *first* – the people to whom you describe Ms So-and-so in this way will literally not know what you could mean, so far has your statement veered from conventionally accepted usage.

Or consider the much-touted "identity crisis" that we're all supposedly wading through in our mid-to-late teens – the struggle, once we really begin to experience ourselves as unique individuals, to define ourselves, *to* ourselves (and so then to others). It's a struggle, because the language(s) at our disposal have never had to account, before, for any such individual as this particular one, this "me"; we are trying to sort out our defining *un*conventionality, in a language that is purely conventional. And so on.

All of this is made the more so, too, by the fact that virtually all of our language use is *purposive*. That is, we tend to use and manipulate linguistic systems in ways that we hope will get something else accomplished. We speak English as carefully and clearly as we can *so that* our audience(s) will understand our points. We wear those clothes to that interview *so that* we'll be more likely to get the job. We check the egg box to see whether any of its contents are broken,

then go to checkout and pay for it, *so that* we can have breakfast tomorrow. Thus we tend even more to use conventional languages and linguistic systems as they're conventionally understood, *so that* what we want to have happen, will.

Language is effectively our world as we experience and know it. And the more linguistic we become, the more conventional – the more "usual" (unto banal) – that world tends to become. For the more carefully we use established, convention-bound linguistic systems as we're "*supposed to*" use them, and the more of them we use, the more difficult it becomes to say "What if we looked at things this other way?," to describe the world as we – self-conscious, idiosyncratic humans that we are – "*suppose*" it *might* be described.

So ... What?

So, does all this tell us anything more than we already knew about "art"? Probably, though perhaps only if we read between the lines. If we do that, there do seem to be at least three significant implications of what we've said here about languages and linguistic systems.

The first of those began to emerge when we suggested way back in Chapter 1 that our human experience is by its nature indirect, and *mediated* by language. It surfaced again, a little more pointedly, when Saussure (and I) suggested above that accordingly, as far at least as our conscious human experience is concerned, we experience *everything* as "sign"; and "signs," we pointed out, only function *as* "signs" when they're included in linguistic systems that relate them to other "signs" in conventionally accepted ways. On their own, remember, "signs" are inherently meaningless.

Think for a minute now about red, for example – not the *word* "red," this time, but just ... red, the color red, redness, the quality of being red. Like anything else, red is taken by us as a meaning-bearing entity, a "sign." But what does red *mean*, do you think?

On its own, red doesn't mean ... *anything*; it's just ... red. If it appears on the skin of your forearm, though, around that little cut you got last week, "red" is a sign of – it *means* – "infection, maybe." According to the old ditty "Red sky in the morning, sailors take warning; red sky at night, sailors' delight," red in the sky can be a sign of either good weather or bad, depending on when it appears. A red *light*, on its own, is just ... a red light; but when it's displayed

with a yellow light and a green one, in a row, near a traffic intersection, it means "stop," whereas when it's displayed over the door of a bordello, it means "come on in." What signs *do* mean is *purely a function of the context in which we encounter them* – of their *relation (s)*, that is, to whatever other signs exist around them in any given situation.

So the first important implication of all this linguistic discussion is this: *meaning*, to us humans, is *relative*.

And the second one is that – as far as we can empirically tell – *we've made it all up*. All we humans can empirically *know*, for *sure*, is what seems to "make sense" in the way we've constructed our *linguistic* world, which we *have* "made up," by saying over and over again, just as did our imaginary beastie, "Well, if we think about *this* thing *that* way, then it would only make sense to think of *that* thing as ... (whatever)." Just as our world is linguistic, that is, so are any "truths" that may seem to be part of it. Things – not just socio-cultural ones but all of them[7] – "mean" to us what we have conventionally agreed to *make* them mean.

And the third implication of all this talk about language is really only an extension of the first two: *meaning* is not something that we *find in* the world, that's been there right along, just waiting for our evolutionary beastie to stumble over it; rather, meaning is something we *make of* our experience of that world ... and we do so by manipulating the arrangement of signs – and so, of our ideas about the world, to which those signs refer – relative to one another. We understand our world not on the basis of any self-evident meanings that were there before we arrived, but rather on the basis of a vast cultural complex of made-up, interrelated sets of relationships between our ideas, our suppositions, about it, and about ourselves within it. Those conventionally agreed-upon sets of *relationships* are what make things – be they redness, or sound patterns, or articles of clothing, or produce and canned goods and chromed pushcarts, or our own identities, as we've said – mean to us whatever they do.

And all of *that* suggests that our attempts here to *find* a meaning for "art" may have been misguided. Perhaps we need instead to just ... make one up. Of course in a linguistic world, it's not quite that simple, for whatever meaning we do make up has to "make sense" in relation to the rest of the culture; but we'll see what we can do in that regard, in Chapter 6.

Okay? Back then, finally, to "art."

Notes

1 This conclusion requires the rather silly – but certainly arguable – position that *every single thing* any human ever said or did or made or thought was "creative," because that *particular* thing (utterance, action, product, idea) had never before existed ...

2 Technically, "symbols" are a specific *kind* of "sign," the meaning of which is inflexible – for all intents and purposes, a symbol means one and only one thing, to anyone who understands the language of which it's a part. Better, here, to think in terms of the more general "sign."

3 There are some very few exceptions to this, as in the case, for instance, of onomatopoetic words, which sound like whatever they refer to – like, say, "hiss," or "smack."

4 It's the presence in English of words like "bark," which you'd think would be the same word wherever you saw it, but which can actually be at least three different ones (the outside layer of a tree, the sound made by most dogs, a type of sailing ship) that make English such a notoriously confusing language to learn. Note though that words like "bark" refer to natural categories, so that each different use of the sign has a distinct meaning ... while "art" *doesn't* seem to refer to a natural category, and so *its* different meanings overlap and blur.

5 Steiner, George. *After Babel; Aspects of language and translation* (Third edition). Oxford, Oxford University Press, 1998. (p. 40).

6 Saussure, Ferdinand de, *Course in General Linguistics*. New York, Philosophical Library, 1959.

7 In a culture (like our own) in which science is often thought of as the one reliable source of unequivocal "truths," this may be difficult to accept ... until we remember that until recently, we were told that Pluto was a planet ... but now we're told that in fact it probably doesn't make sense to think of it that way, after all. Scientific "facts" may surely be more carefully argued and supported by data of various kinds than are most supposed "facts," but ultimately they too are just working hypotheses about how the world might usefully be described.

Chapter 6

(Re)Thinking "Art"

Before we go on, let's just remind ourselves: except for a certain number of historically demonstrable facts and generalities, everything you've read here so far has amounted to just *one description* of how the part of the world we call "art" has seemed to work.[1] We've been doing neither more nor less, that is, than what our evolutionary beastie was supposedly doing, way back when: relating some observations about the world in ways that seem, empirically, to make sense.

And when we explored what seems a closely related part of the world, the one we call "language," in Chapter 5, two things (at least) occurred which seem likely to be of particular importance to our quest. Early on in that discussion we sensed that "art" seemed to refer to things that were – somehow – less "rule-bound" than were the linguistic systems that constitute our world as we understand it; and that sense remains. And then we ended with some logical corollaries of this particular empirical view ... perhaps the most striking being that meaning is not *found in* the world, but *made of* it, by us. We suggested that we do that, we make that meaning, by manipulating the signs we use to refer to our experience of the world, in relation to one another.

In this chapter, then, we're going change our approach a little, and begin acting as that corollary suggests we might. Rather than continuing to try to *find* the meaning of the term "art," by various examinations of the world surrounding it, we'll begin to try to *make* sense of it, by piecing together some of the things that those examinations have turned up (plus a few new ones). Doing so can lead, as

I think we'll see, to an idea of "art" that – however true it may it may or may not seem in any other description of the world – works well and usefully in this empirical one.

What *About* Meaning?

The premise here is that *everyone* who is human can be said to interact with, describe, make meaning of the world by manipulating and relating signs in the way we discussed in Chapter 5. "Artists," of course, are humans like everybody else, and so presumably make meaning like everybody else. Or … do they?

Consider two brief examples. One of them, below left, is a well-known scientific notation; the other, below right, is a short piece of contemporary poetry by Hayden Carruth.[2]

$$E = mc^2$$

So be it. I am
A wholeness I'll never know.
Maybe that's the best.

Is it your sense, on reading these, that they "mean" in the same way? We may *know* that they do, on the broad linguistic bases we discussed in Chapter 5 … but do we *experience* them in the same way? Do they *feel* the same?

Certainly to me, they don't. Assuming that we understand the languages of which both are made – scientific notation in the case of the equation, English in that of the poetry – the meaning of the equation is clear, unmistakable, the same no matter who reads it, while that of the poetry is quite the other thing. So … maybe our vague sense, in Chapter 5, was correct. Maybe what sets "art" – the work of "artists," in the modern sense – apart from other, similar things is not anything to do with what those "art" things are or aren't, or with how they look or work in the world, but rather something to do with how they *mean*. Maybe we can make a case for seeing *that* as the source of the difference.

That equation, of course, is from Einstein's Theory of Special Relativity, and it means "Energy is equal to mass times the speed of light squared." That's it. That's what it means, and there's no room for musing. Admittedly, it may be a little unfair to use such an equation here, because in this scientific context, all of the signs that make

it up are not just signs, but symbols; they each mean (as noted at the beginning of Chapter 5) one and only one thing to anyone who understands the language(s) used in physics. But on the other hand, the certainty we feel when reading that equation – that we surely do understand its literal meaning – is pretty much the same, isn't it, as the feeling we have when we read most simple declarative statements? Consider "My favorite color is yellow," or "The bolts on the lower end of the assembly need to be tightened to between twenty and thirty foot pounds of torque." We *know* what these statements mean (or at least, we do once we've looked up "torque"), just as in the case of the equation.

Nor is that kind of clarity of meaning and certainty of understanding specific only to overtly linguistic phenomena like our examples here. We know, too, once we understand the codes involved, the meanings of diagrams and blueprints, even of patriotic anthems performed in strictly traditional ways. Such things convey their information (or in the case of the music, evoke their feelings) as clearly and unequivocally as did that equation. We *know* what they're saying.

But in the case of things we think of as "art" in the modern sense, that kind of clarity of understanding is rare, if not unheard of. The experiences we think of as "art" today seem to "vibrate," as it were, with possible meanings, or parts of possible meanings, in a number of directions at once; there seems always to be something of the *un*certain about them. Our response to Carruth's poem, for instance, far from being one of certainty, is apt to be more like, "Well … I guess it's … maybe sort of about this, in a way, but … I mean, I sort of *know* what it might mean, but I can't really *say* it."

Why this difference?

At the end of Chapter 5 we made at least two observations about such things as Einstein's equation, those straightforward sentences, those imagined diagrams and patriotic songs and so on, that may afford a beginning on answering that question. Like most linguistic statements or situations, the equation and the sentences and the diagrams and the songs are both *conventional* and *purposive*. They make sense as clearly as they do because they conform very closely to the conventionally agreed-upon, conventionally understood relationships and forms which allow sense to be made in the systems of which they are parts. And they conform as closely as they do to the conventional rules that make them mean what they do *so that* those meanings will be clear to all concerned.

But it seems quite clear that neither of these things is true of Carruth's poetry. In terms at least of the language of which it partakes, English, the poetry *isn't* conventional. It's laid out oddly on the page, with the second sentence broken in the middle (what does that mean?); the referents of several words are unclear (to what does that "that" refer? ... "the best" what?).[3] And we have to assume that at the very least, this writing isn't purposive in the same way that that equation and those straightforward sentences and diagrams and songs were purposive. At least, it can't have been the poet's intent to convey a straightforward message to his audience (i.e., us) as clearly and unequivocally as possible, for had that been the case, he would have used the language as conventionally as Einstein did.

Given that he didn't (and that Picasso didn't either, nor did Samuel Beckett or David Lynch or Bono or any of the other people whom we consider artists today), what are we to think? That work such as theirs is as it is because they are just inept at what they do? That they *didn't* write or paint or perform or compose conventionally *so that* we'd be as confused as possible by their work? Both of these seem pretty unlikely, if only because, were they the case, then all those grand poetry volumes and art museums and symphony halls and theaters would be essentially monuments to uncertainty and struggle ... which is certainly *not* the way all the docents and wall labels and playbills in those venues have made them seem.

Or perhaps "art" things are as ambiguous as they are because what they express can't *be* said in conventional ways. Were this taken to be the case, "uncertainty and struggle" *would* in fact characterize the making of "art," as artists, unable to describe clearly even to themselves just what they're trying to express, struggle to find ways *to* express it. This raises the question of *why* "art" things can't be expressed in conventional ways (which we'll get to a little further along), but meanwhile it also evokes certain romantic views of what "artists" are supposed to be – semi-mystic "seers," possessed somehow of special insights into the nature of things – that have prevailed on and off for centuries, and still do now, for most of us.

So perhaps we could take this, at least tentatively, as part of the working hypothesis we're trying to develop. Maybe we should think of "art" things as referring to ideas which are not – or are not *entirely* – about specific things that the audience is expected to "get right" *so that* something else will happen ... *so that* the new bridge will be built correctly, or even *so that* some specific point will be

made as the artist intends. Instead, "art" seems likely to be about things that are not easily expressed in conventional ways using conventional languages, and so, that are capable of being, and available to be, seen and understood in more than one way.

We are hardly the first to have noted this apparent purposive/ not-so-purposive difference between conventional linguistic statements and artistic products. The apparent lack of external purpose – of "*so that*" – in Carruth's words has been noted too as a defining characteristic of *visual* artworks; and as I've implied above, it seems to me that our broadly linguistic frame of reference here makes it possible to extend it to artworks generally. Let's consider some points made by two people who were thinking about this long before it occurred to us, and one person who thinks about it now but in a different way, to see if they'll help or hinder our hypothesis. Jan Mukařovský and Roman Jakobson were members of a group of European linguists and literary theorists known collectively as the Prague Linguistic Circle (aka the Prague School), who in the first half of the twentieth century were pondering just the questions that concern us here. And Ellen Dissanayake is a contemporary scholar who proposes that the class of behaviors we refer to as "art" is a Darwinian evolutionary adaptation that has served to make us what we are.

Autonomy

For his part, Mukařovský, writing about the visual arts, noted (among other things) that all human creativity is intentional – one *decides* to create something, be it a better mouse trap or a negotiated settlement or an artwork or whatever. Mouse traps, though, are created *so that* mice can be better caught, and settlements are negotiated *so that* peace can prevail between the parties to them. But artworks, Mukařovský suggested as we have here, involve no "*so that*." They too are created intentionally, but as ends in themselves, made just to ... be artworks.[4] This idea – or at least a version of it – has also become part of the broad idea of "art" generally assumed by many of us; we referred to it in Chapter 2 as that of the "autonomy" of artworks. If only for the sake of argument, then, we'll take it here as another piece of our working hypothesis.

At least one argument with Mukařovský's idea, by the way, does seem to be immediately available. Any self-respecting capitalist can

be expected to scoff at it, noting that artists do what they do for the same reason that everyone else does what they do – that is, *so that* they'll make money. Logically, though, in this discussion that's an empty position. While it's certainly true that people do whatever they do professionally *so that* they'll make a living, that's a given for *all* trades and professions and jobs, and so it's not even relevant to a discussion of observed *differences* and their likely causes. That discussion is at the next level, and concerns whether whatever sort of work one does has a practical aim *by its very nature*, whether one is hired and paid to do it, or not. At that level of concern, plumbers plumb *so that* fluids will go where they're wanted and when, lawyers argue cases *so that* the law will be understood as favoring their clients … but "artists," as Mukařovský says, make "art" purely for the sake of doing so.

We might take the number of young artists who work in relatively menial jobs to support their "art" – who work, that is, as waiters or museum guards or whatever, *so that* they'll be able to make their "art" when their shifts are over – as evidence that this may indeed be the case. And testimony from older, more established artists suggests that this sense of "art" as its own self-justifying pursuit doesn't go away once people begin to buy their work. Virtually all the established Renaissance artists who wrote about their work wrote not about what it was "for," not about *why* one might do such work, but just about how *to* do it. And Modern and Postmodern artists tend to write not about what their work is "for," either, but rather about what it *is*. The Modernist painter Wassily Kandinsky, for instance, wrote rather dramatically at one point that "Painting is a thundering collision of different worlds, intended to create a new world in, and from, the struggle with one another, a new world which *is the work of art*" (italics mine … and note that word "struggle").[5] Postmodern conceptualist John Baldessari said of his *Blasted Allegories* (1978) that, "I want those to be seen as … playing, mind-playing, as being interesting perhaps *in itself*" (italics mine, again).[6]

Mukařovský offers another insight that also lends credibility to his point about art's autonomy. He observes that "Intentionality deprived of a relation to an (external) aim adheres more closely to its human source."[7] (Parentheses mine.) If one intends to make something, that is, but that something doesn't need to affect anything else in any predetermined way – if it doesn't involve any *so that* – then it needn't conform to any of the predetermined requirements

that would otherwise pertain; it doesn't have to be any of the things it would have to be if it had some *so that* to fulfill. And freed of any such predetermined requirements, it can be much more the way – whatever way – the maker, the "artist," wants it to be, or feels it should be. (So, if a traditional landscape painter, say, sets up his easel before a stunningly beautiful landscape and sets out to "capture" it on canvas, but decides while doing early sketches that as beautiful as it is, it would make a more appealing *painting* if that cedar tree over there to the left were depicted instead on the right ... well, why not? He's not painting it *so that* a developer will know where he can most easily build condos ...) This observation, too, is essentially a logical one and so open to little if any debate, and it also conforms to long-standing general assumptions about "art" as expression of its maker's inner states and insights.

"Art," Craft, and "Part-Art"

To make either of Mukařovský's ideas work as part of the idea of "art" that we're hoping to formulate here, though, two significant shifts in thinking need to happen. For at this point, all those far-flung problems of linguistic usage that we described in Chapter 2 come home to roost. We suggested there how many different sorts of things the term "art" has come to be used to describe; and we've pointed out in several places that how we describe things is how and what they *are*, for us. So ... if we're considering describing "art" as by (working) definition without any external purpose, without any "*so thats*," how are we to account for, on the one hand, all of the clearly purposive things that we call "art" in the original sense of the term, those made before the modern idea of "art" was imposed upon them? What about those cave paintings and the figurines that historians claim as the start of "art," apparently made *so that* things would go better for the tribes, or those Anatolian villages, made *so that* early Anatolians would have shelter, or all those church icons, made *so that* religious truths could be revealed unto the peasants, and so on? And on the other hand, what of all the people to whom we often refer today as "artists" – those who draw caricatures at carnivals, greeting-card versifiers, composers of advertising jingles – who do in fact do what they do specifically *so that* they'll make money?

My idea is that if we're trying to figure out a meaning for this term "art" lately, we might be well advised to see these uses of the term as referring to "art" in the *original* sense. Relative to "art" as it's *currently* used, that is, these usages are figurative, either metaphoric and/or metonymic, or maybe both. Those purposive things – just like all the ones that were labeled "art" retroactively, once the modern idea had taken hold – are *like* "art" as we understand the term now, in one way or another, and those practitioners, similarly, *like* "artists." But perhaps they shouldn't be thought of as *literally* those things.

It seems quite likely that the term "art" has, over the centuries, encroached on the *term* "craft" in the same way that it encroached on all those craft*ed* objects and events that preceded the modern idea of "art." Again, "If this kind of painted surface is 'art' as we now understand the term," those early art historians might well have said, as they began looking backwards down the ages to make their history, "then maybe we could think of that other, older painted surface as 'art' in our modern sense too, for they're both at least made in the same basic way, even though there's something difficult to define about the modern one that's different." Similarly, once specially gifted painters and composers and poets began to be acknowledged as "artists" during the Renaissance, more prosaic, purposive painters and composers and poets came in time to be called "artists" too, for they were using the same basic process, even though there seemed to be something about what they did that was not as "artistic," whatever that meant. And that sort of metaphoric/metonymic usage has continued, until today even utterly formulaic painters and writers and composers and so on, painting and writing and composing primarily *so that* the work will sell, tend to be thought of as "artists," too, on the basis of the physical processes they share, but little else.

If we retreat from these figurative usages of "art" and "artist," though, things do begin to get clearer for our inquiry here. If, with Mukařovský, we measure whether or not a thing is likely to be "art" in terms of whether it seems to conform to conventional expectations of what it needs to be *so that* something else will happen (and to what degree it does that ... again, see below), and if we're strict about that, then a lot of the confusion surrounding the term drops away.

In this newly stringent view, if a portrait painter makes his portraits exactly as portraits are conventionally expected to be made in

the time and place in which he's working – say, with all the mimesis he can muster, his subjects in strictly conventional poses and lighting, all as expected – then even though he obviously *paints*, as do many "artists," it makes much more sense to think of him as a craftsman, *at least in that instance*, as having "crafted" his portraits to conform to his audience's conventional expectations ... *so that* it will be acknowledged as being what it is supposed to be. The portraits on American currency (though they're engravings, and not paintings, exactly) are good examples of this sort of work.

By the same token, if a highly designed cereal box, there in the cereal aisle, catches your eye immediately, but on thoughtful inspection it seems clear that the colors used, the graphics and fonts, were designed as they were *so that* you'd see them first, *so that* a certain aura (good health ... breakfast fun ...) would attach to the product, and *so that* you'd know right away what the package held, then even though we often think of designers as "artists" (as many of them surely are), in this case the designer has *crafted* this package to do what it does. And so on.

If this idea – that many of the things we're used to thinking of as "art" are more sensibly thought of as "craft" – amounts for you to a rather radical shift in thinking about all this, then so, probably, will one that follows from it. For even as we attempt to clarify our distinction between "art" and "craft," the realization begins to dawn that the vast majority of "art" things are in fact only "part-art." Indeed, one has to wonder whether anything that's *all* art, through and through, does or even could exist.

Perhaps this had already occurred to you, back when we spoke of "art" as being a constitutive category, rather than a natural one. The modern designation "art," we pointed out, is *added to* a vast array of things that are all something else, first. This is most obviously true of all those purposive "art" things in the original sense of the term that have now been dubbed "art" in the modern sense too, as we noted above. Thinking back to our Introduction for a moment, what was made as a perfectly serviceable carpet for a throne room still is a perfectly serviceable carpet for a throne room, only now it's referred to as "art," too, and so, it's "art" *in part*. All the (many) bureaus in the Boston Museum of Fine Arts were made to be, and still are, completely functional underwear storage units, but they've been dubbed "art," in part, too.

Of course, as we suggested in the Introduction, it's the degree of "fineness" in the carpet, rather than its function, and the degree

of inherently pleasing design and/or ornamentation in the bureaus, rather than just how well their drawers work, that elevate this particular rug or that particular bureau to the level of "art." But saying that only reaffirms the idea that "art," or in these cases the "art" *part* of these functional objects, is non-purposive, as well as reaffirming that such things indeed *are* "part-art."

And on this basis, *some* (though hardly all) of those pre-modern artifacts that we've just said were "art" only figuratively can be drawn back into the fold. For in fact, of the thousands of religious paintings that were made in and have survived since the Middle Ages and the Renaissance, the vast majority languish today in museum basements, of interest only to scholars, while only a select few are displayed and widely acknowledged as "art." The same can be said for, say, modern political posters, many highly designed objects (designed, that is, in ways that extend beyond mere functionality), and so on. Clearly, any such artifacts were made purposively, in pursuit of an external goal, whether reaffirming the faithful or convincing the voters or doing better whatever it is they do. But it's the non-purposive elements that characterize *some* cases, that constitute the "art part." (The critic Edmund Leach wrote eloquently to this effect about Michelangelo's Sistine Chapel ceiling, for instance.)[8]

Nor need we limit this "part-art" observation to all those works made prior to the institutionalization of the modern idea of "art" late in the eighteenth century. For even things made since then, made specifically to *be* "art" in the modern sense, can be seen as dualistic, as only "part-art," too. As we've noted, both Jimbo's Fly-By-Night Painters and Yves Klein use rollers to apply flat blue paint to surfaces – Jimbo's crew, to the siding on my garage, and Klein, to portable canvas panels. But Jimbo's efforts (made, we might note, *so that* my siding would look good and be protected from the weather) are *just* paint on a surface; while Klein's efforts (made to … be "art") are paint on a surface too, but *his* paint on a surface is dualistic, for it's *also* – and so, in *part* – "art," having been anointed as such by the critical tastemakers.

"Poeticity"

Roman Jakobson, one of Mukařovský's colleagues in the Prague Circle, had another thought about this art/non-art distinction. In the essay I'll cite here, Jakobson was specifically concerned with

determining how poetry differed from more prosaic sorts of writing.[9] His word for the quality of being poetic was "poeticity," and again, my sense of it is that the things he observes about "poeticity" can be generalized and posited as characteristics of what we might call "artness," the quality of being "art," at all.

"Poeticity" in a piece of writing, Jakobson suggested, isn't just a matter of unconventional structures and ambiguous meaning, though he certainly acknowledges these characteristics, even implies them as the *cause* of "poeticity." But he goes a step farther and suggests that what really makes a poem a poem is the kind of awareness it engenders in the reader. "Poeticity," he thought, is present when

> the word is felt as a word and not a mere representation of the object being named or an outburst of emotion, when words and their composition, their meaning, their external and internal form acquire a weight and value of their own instead of referring indifferently to reality. (p. 174)

That is, he suggests, in reading or hearing poetry one notices those unconventional structures, and/or the poet's word choices, the poem's rhythm, and so on, even as one registers what the poem seems to be about.

If this hardly seems a distinguishing factor for poetry (and/or for art in general), think back for a moment to our brief discussion of mediation, in Chapter 1. Straightforward, conventional, informative speaking and writing – like those declarative sentences we made up, at the beginning of this chapter – tends to *mediate* our thoughts pretty much as a window *mediates* our perceptions of what's outside it. Without the window, that is, we couldn't see, from within the walls of the house, what's in the backyard, just as without the sentences, we couldn't know the ideas they express. And once our carpenter installs a window and we grow accustomed to its being there, our attention is on the backyard we can see through it. We tend to look right through the window itself as if it weren't even there, paying attention to what's beyond, to the information it reveals to us. Similarly, with language: sentences like "The bolts on the lower end of the assembly need to be tightened to between twenty and thirty foot pounds of torque" tend to direct our attention to what they're expressing, toward the things and actions that

their words and phrases denote and connote. Except in the case of relatively unusual terms like the infamous "torque," we tend not to think of the words and phrases themselves, at all, but rather to look right through them, as it were, at the ideas and information *they* present. This of course is true as well of those diagrams and blueprints and so on that we mentioned above.

Not incidentally, this tendency to ignore the instrument of mediation (the window, the painting, the poem), and involve ourselves directly with the information it conveys, began under Modernism to bother artists of every kind, more and more. As their increasing attention to the nature of their pursuit heightened their own awareness of it, they realized that their audiences, more used to being entertained by artworks than to thinking critically about them as the Modernists were doing, tended accordingly to "look through" artworks, at what they represented (as they'd been doing since medieval times at least, as we noted in Chapter 2). And in doing so, they tended to ignore, to take for granted, the efforts and struggles (there's that word again – see below) that the artists had brought to the creation of the work.[10] Melville's *Moby Dick*, that is, seen purely as entertainment, becomes just a "really long story about a whale," Dennis Hopper's iconic 1969 film *Easy Rider* becomes a "great hippie/motorcycle flick," and so on. Much of the Modernist effort was accordingly involved with reasserting the artists' contributions, with insisting that the audience recognize that there had been an *artist* there, *making* the thing that entertained them. As we've seen, Modern artworks – images, plays, musical compositions, stories, all of them – tended increasingly to call attention to themselves, to assert their own identity, rather than just referring transparently, as it were, to whatever they depicted or described. Minimalist sculpture, which pointedly didn't depict or describe *anything* other than what it actually *was* – remember Carl Andre's *Herm* or Robert Morris's *Steam Cloud* – was perhaps the ultimate instance of this.

And the Prague School linguists, themselves definitive Modernists, were particularly attuned to this need to be aware of *the work itself*; hence, perhaps, Jakobson's observation that in poetry, the *signs* of which it was constituted – the words, their arrangement on the page, their aural and denotative relations to one another – were seen and experienced *as such*, to at least the same degree as they were "looked through." Again, in reading poetry, he suggests, our attentions are

drawn not just to *what* the work says, to what it's about, but also to *how* it says it, how the poet describes whatever part of the world she is describing. We could feel this in even the snippet from Carruth, a few paragraphs ago.

Moreover, as we noted in Chapter 5, the "signs" by which we humans make meaning are by their nature arbitrary, and when one recognizes them for what they actually *are*, out of their conventional contexts, their inherent potential to mean anything at all comes clear. Again, the sound pattern "d-aw-g," considered on its own, is just a noise, meaning nothing – or potentially, anything – until it's decided to *assign* it a meaning and include it in the English language, at which point it refers, of course, to Fido and others of his kind.

Thus if Jakobson is right about the nature of "poeticity," and we do tend to see the signs of poetry not only for what they mean but for what they *are*, then in experiencing poetry we necessarily become aware of two things. We come face-to-face with the process of the poet in relating those signs as she has, to make them mean whatever they seem to mean in the context they manifest; and at the same time, that palpable sense of these poetic signs as potentially meaning anything at all explains that "vibration," that uncertainty of apparent meaning that we noted in the Carruth example.

As I've suggested, it seems too that not only poetry, but Modern artworks of any kind can be seen in this way. And if one thinks, as I do, that the Modernists were indeed working down toward the essences of their pursuits, then indeed *any* artworks can be seen, by extension, as equally notable for their form, for what they *are*, as for their content, for what they're *about*. As soon as, in any time or place, traditional mimesis or any other kind of conventional form is forsaken by painter, playwright or poet, as soon as composers move away from accepted chord progressions or rhythms, we *notice* that shift away from convention, and in seeking – as humans will – to come to terms with it, to make sense of it, we become aware of the signs of which such works are made, *as such*. Think about how, when one examines Impressionist paintings closely, the individual brush-strokes suddenly become significant; or about how much more aware one becomes of the line breaks in Wordsworth once one has seen how they're used by e. e. cummings; or about how the apparent lack of sense in the dialogue of *Waiting For Godot* has us palpably strug-gling (there's that word *again*), as we watch the play, to make some. In experiencing all of these altered approaches to "art," we become

more pointedly aware of what these works by their nature *are*, of what they are *made of* – that is, "signs," of whatever sort, manipulated.

"Making Special"

So we seem at last to be closing on a working idea of what we might mean by "art," lately. We can now say with reasonable assurance that if you're involved with "art" today, you're pretty surely involved with objects or events that are, as we noted in Chapter 5, human-made, or at least intentionally affected by humans in some way, and/or with the sorts of behaviors that produce such objects or events.

That means too that "art" objects and events and behaviors are expressive, because *all* human products and behaviors are expressive. But we can see "art" things and behaviors as different from the rest in that they are – at least in part – also dualistic, idiosyncratic, and self-justifying. And they tend to draw our attention to how they're made, and of what (i.e., "signs"), and so to their inherent ambiguity. So far so good.

But then again … wait a minute. If you think about it, while these characteristics do indeed seem to attach to "art," as we're beginning to understand the term, they can be seen to attach as well to just plain old … fooling around.

Imagine that you're doing something that for you is … usual. You're, say, greeting a client who is arriving at the airport, something that you do all the time, as part of your job. And because it's so "usual" for you, you've learned well the customary protocols that attend such encounters – you hold a discreet sign with the client's name, when he appears you offer a smile, a hearty handshake, help claiming luggage, and so on. But in this particular instance, as the client emerges from the plane, you suddenly realize that he's an old and cherished friend (whose name is "Mr Smith," so you couldn't have known), and you are *so* excited to see him that, in one of those states of euphoric silliness that comes over most of us all too rarely, you alter the protocol in some impromptu way – you hide yourself, say, until he's passed you by, and then jump out and say "Boo!" or call him by an old nickname before giving him a hug.

Is that "art"? At least to an objective observer who knows neither you nor your client/friend, your silliness is self-justifying: it serves no apparent use other than to "be silly." And your behavior breaks

with accepted protocol in a way that certainly calls attention to the conventions being broken. But most of us would tend, I think, to say that it's *not* "art," for "art" has long seemed to most of us a much ... *weightier* institution, of much greater cultural significance than just fooling around.

On the other hand, think back now to John Baldessari's use, in his description a few pages ago of what he hoped his "art" could be seen to be, of the term "playing." "Playing" is pretty close to being a synonym for "fooling around," and it's not an uncommon word for artists to use, in describing how it feels to do what they do.

The scholar Ellen Dissanayake offers an explanation of why this apparent conundrum probably isn't one at all. Dissanayake's interest in art is at a level that underlies that of our inquiry here. A Darwinian, her question is why people engage in so-called "art" behaviors at all, regardless of the term(s) used to refer to them; if, as Darwin suggested, any of our significant human behaviors can be thought to serve some evolutionary purpose for the species, what, she wonders, can the purpose of "art" be? Her work on and around this question has involved study in fields including aesthetics, psychology, ethology, anthropology, evolutionary biology, and more. And one of the primary conclusions that she has drawn from her work in these fields is that, as far as she can tell, all of the things we call "art," in the modern sense, and all of the things we think of as play, arise from the same source, what she calls the human need to "make special." Not surprisingly, she is much more eloquent about this idea than any paraphrasing by me could ever be, and so I'll take the liberty of quoting her on it, at length, here:

> My own notion of art as a behavior ... rests on the recognition of a fundamental behavioral tendency that I claim lies behind the arts in all their diverse and dissimilar manifestations from their remotest beginnings to the present day. It can result in artifacts and activities in people without expressed "aesthetic" motivations as well as the most highly self-conscious creations of contemporary art. I call this tendency *making special* and claim that it is as distinguishing and universal in humankind as speech or the skillful manufacture and use of tools.
>
> In whatever we are accustomed to call art, a *specialness* is tacitly or overtly acknowledged. Reality, or what is considered to be reality, is elaborated, reformed, given not only particularity (emphasis on uniqueness, or "specialness") but import (value, or "specialness") – what

may be called such things as magic or beauty or spiritual power or significance.

Making special implies intent or deliberateness. When *shaping* or giving artistic expression to an idea, or *embellishing* an object, or recognizing that an idea or object is artistic, one gives (or acknowledges) a specialness that without one's activity or regard would not exist. Moreover, one intends by making special *to place the activity or artifact in a "realm" different from the everyday*. In most art of the past, it would seem, the special realm to be contrasted with the everyday was a magical or supernatural world, not – as today in the advanced West – a purely aesthetic realm. In both, however, there is a sort of saltation or quantum leap from the everyday humdrum reality in which life's vital needs and activities – eating, sleeping, preparing or obtaining food – occur to a different order which has a different motivation and a special attitude and response. In both functional and nonfunctional art an alternative reality is recognized and entered; the making special acknowledges, reveals, and embodies this reality.

Both artist and perceiver often feel that in art they have an intimate connection with a world that is different from if not superior to ordinary experience, whether they choose to call it imagination, intuition, fantasy, irrationality, illusion, make-believe, the idea, dream, a sacred realm, the supernatural, the unconscious, or some other name. Often, the work of art is considered to be symbolic of this other realm, as in primitive rituals or in psychoanalytic interpretations of art ... Insofar as he or she has access to this special realm, the artist – as indeed is frequent in primitive societies – may be looked upon with suspicion, fear, or awe.[11]

And in a later book, regarding the relation she sees between art and play, she notes that

I thought that the "metaphorical" nature of both art and play, the make-believe aspect where something is, in reality, something else, was the salient core feature (of both)."[12] (Parentheses mine.)

Clearly, Dissanayake and I have some places where our approaches to the question of "art" intersect, and some places where they don't. In her description, my skepticism about the selection process engaged in by the early historians of art is unjustified; she does not doubt that what they recognized as "art" *was* art, regardless of how else it might have originally been described (as magic, spirituality, etc.), for it all – or most of it[13] – clearly demonstrated some degree, at least, of

"making special." She and I do share some skepticism of the contemporary art world's elitist idea(s) of art that is somehow "*real* art," as opposed to the humbler behaviors and products often referred to as "art" by people in other domains; everyone, Dissanayake feels (and so do I, as we'll see), simply by virtue of being human, has both the potential and the *need* to make and/or experience things "made special," be they the exalted products of today's "art world," or those of tribal shamans, or even – as I think she'd agree – wearing fancy hats for Easter. And clearly, we are fully agreed that our reactions to "art" things differ from our reactions to "regular" ones; I've described those reactions here as a sense, in the face of "art," of a kind of ambiguity of meaning, while she goes so far as to call it a whole special realm of awareness.

But what is of most interest to our inquiry, in Dissanayake's work, is her idea of the close relationship between art and play. Certainly it goes a long way – *all* the way, in fact – toward explaining the sense of artists like Baldessari that their artmaking often amounts to "play." But that of course brings to mind right away all the artists who, like Kandinsky, often describe what they do as "struggle." "Play" and "struggle" seem to be, if not polar opposites, at least pretty far removed from one another in terms of the experiences they describe. What could artists be "playing" and/or "struggling" *with*, exactly, that can lend itself to such disparate descriptions of the experience?

Play, Struggle; a Paradox; and Juggling

Our view here from the beginning has been that we humans, in our self-consciousness (and in that, arguably uniquely and definitively), have conscious experience of the world only in the abstract. Certainly, as we noted in Chapter 1, there are parts of our experience that are *not* conscious – intuition, deep emotional responses, understandings of the world held so long as to have become virtually instinctive, and so on (though it's possible to *be* conscious, even of these). Insofar as we *are* conscious, though, the things of which we're conscious are, as we also noted in Chapter 1, *ideas* about the world and how it works. And we refer even to these, and even to ourselves, in the abstract, in terms, that is, of conventionally agreed-upon "signs" and the conventionally agreed-upon systems of relationships of signs which we call "languages." In that

view, as we've said, our *conscious* experience *is linguistic*, is made up, that is, just of those mediating signs and systems.

Given that description of things, it is only logical to suggest that "artists," in the modern sense of the term or even in Dissanayake's apparently timeless one, can best be seen as "playing" *with* – and/or struggling with – the ideas suggested by signs (virtually anything, you'll remember, as perceived by us humans), and *with* conventions, with the "rules" for relating those signs meaningfully. For as we've described it, that's what their experience *is*, after all.

But if "art" *is* "play" in that way, it's not therefore necessarily easy (and of course neither is struggle, by definition). Nearing the end of Chapter 5, we noted, somewhat ominously, the conservative influence of conventional sign systems – languages – on our perceptions of the world. Our linguistic descriptions, we said there, will only make sense to any audience that understands the language we're using if they conform to the *conventional* expectations that that language embodies, about what needs to be seen as relative to what, and in what way. There is leeway, of course, as we also noted … but not much, really, relative to the infinite number of ways in which it's at least theoretically possible to describe the world. There are "sensible" limits to the leeway in language use, beyond which, if we refer to certain things in certain unexpected ways that are too far from the conventional linguistic norms, sense will not be made.

Thus the more linguistic we become, the more the pressure mounts to describe the world in essentially the conventional way in which one's language(s) already describe it. And though we didn't mention it when we touched on this back in Chapter 5 (we did hint at it, at least, in Chapter 1), this conservative effect of language on our thinking suggests a paradox that we might in fact see as a defining one for us humans.

That seeming paradox is this: on the one hand, it is our nature as humans that we are self-conscious, and so able – indeed forced, by our nature – to "make sense" of our experience as we will, to consider how we *suppose* the world might be understood. We're (arguably) the only ones who perceive the world as "out there," in opposition to our *selves*, "in here" … and so, the only ones who need or are able to "make sense" of it. As we said in Chapter 1, for all the other beasts, presumably, experience of the world of which they're integral parts simply is what it is, right now, and neither means nor doesn't mean, just … *is*.

But on the other hand it is *equally* our nature as humans that we make that sense by *describing* those suppositions, in languages, in structured, more-or-less formalized sets of relationships. And the effect of thus describing things linguistically tends to be, as we've said, to transform our suppositions from the more-or-less informed, more-or-less speculative "supposings" that they are, into the way things are "supposed to be" ... that latter "supposed" pronounced with an altered inflection that implies not speculation, but authority. The more those authoritative conventions become "the way it's supposed to be," the harder it becomes – the more one has to *struggle* – to "suppose" the world in any other way, and to describe that other way in new ways that make sense ... and round and round we go. (Given that apparent paradox, it may be worth noting here that I'm writing this book, and presumably you're reading it, during the so-called "Age of Information" – the most concentrated proliferation of languages and linguistic systems in human history.)

In any event, this apparent paradox would seem to be at the very heart of the human condition. And its deadening effect on our ability to imagine alternative descriptions of the world is understandable, it seems to me, as the source (or at least *a* source) of the need Dissanayake says we all share, for "making special." It makes sense to me, at least, to describe the need to "make special" as a need to constantly renew our experience of ourselves *as human*, to experience what it *is* to *be* human, in the first, self-conscious, creative, arguably definitive way that we all share, before that part of our experience is suppressed by the *other*, automatizing, linguistic part that follows directly upon it, and codifies our suppositions into givens.

And seeing things that way leads me to think that the people we call "artists," existing as we all do in the middle of this apparent paradox, can be seen as "career supposers." Whether by predisposition or proclivity or both, artists suppose new worlds, in whole or (more often) in part, and find new ways to represent them (as, for instance, that landscape painter who "moved" the tree). Sometimes this amounts to play, sometimes it involves struggle; but in either case we value their presence and their products, I think, just because they make "special," hence noticeable, forms, by avoiding the "suppose/supposed" paradox that encumbers most of the rest of us most of the time.

It makes sense to describe artists, then, as jugglers of sign, and dancers on structures, engaging in what they do purely in its own

terms and their own, and purely for the sake of doing so. Artists of any kind can be thought of, I think, as dancing on and with the conventions that pertain in their media, and juggling signs as they do, throwing them up, out of their conventional contexts, according to the artists' own idiosyncratic lights, in variously beautiful symmetries and relationships, the better for us to see them, out of their conventional contexts, for what they are: *signs*, with the potential to mean anything we want them to. And in doing so, they bring their audiences to renewed, direct, experiential awareness of what it is to *be* human, first – that is, to *notice* "signs" and *suppose* what and how they might be made to mean.

Or at least this is what artists *try* to do. Artists, by *any* definition, surely struggle to learn the specific sets of skills that inform their work (as I would surely struggle to learn to dance or juggle). And insofar as the "suppose/supposed" paradox I've suggested here is indeed a real one, then to spend one's time resisting it, clinging to one's inherent ability to "suppose" the world anew and give it form, while holding at bay the equally powerful inherent tendency to describe it conventionally, is surely a struggle too, often indeed the biggest one of all. Seen in this light, Kandinsky's apparently melodramatic statement about painting as "a thundering collision of different worlds struggl(ing) with one another" seems a lot less melodramatic, even unto straightforward: his "struggle" is to represent coherently the world (or the part of it) that he senses/supposes *could* be, in the world as it's conventionally supposed *to* be.[14] (Remember too how long the Impressionists struggled to give coherent form to their new ideas about painting.)

One could argue that it's this "struggle" component of art that lends it more sociocultural significance, more "weight," than just "fooling around" … and it's tempting to just leave our search for a working meaning for "art" there. "Art," in the view we've developed so far, seems to refer lately to the sort of "supposing" behavior we've just described, and/or the things and events produced by it, all of which demonstrate the characteristics we've noted above – "art" things are human-made, creative, expressive, dualistic, idiosyncratic, self-justified.

Of course what we've done there is described the apparent *referent* of "art," and not, technically, its *meaning*. The two are often used interchangeably, though, and accordingly this seems a perfectly workable answer to the problem with which we began here. So if

you want – remembering, of course, that you can describe the world in pretty much any way that suits you, so long as it's ethical – you can leave it at that. We'll speak to some of the implications of doing so, at the end of this chapter.

But as long as we're at it, I want to take things one step further.

"Flow"

I want to introduce here the idea of "flow," a distinct and observable state of consciousness that has been described most thoroughly by the psychologist Mihaly Csikszentmihalyi[15] (and which I've been lucky enough to experience a couple of times, myself).[16]

"Flow" sometimes occurs, typically after much practice and drill over time, in human endeavors of various kinds. It is characterized by the attainment of levels of mastery in which the need for conscious attention to how one is "supposed to be" doing what one is doing falls away; practitioners report finding themselves able to "just do." And at least in my own experience, it involves, in the process of "just doing," acute awareness of *everything* that pertains to oneself and to one's project in the moment, an undifferentiated, non-hierarchical awareness in which all the components of the experience – the work at hand, one's emotional state, that cobweb up in the corner of the room, all of it – are just … *there*, all on an equal basis, none more or less important than any other, to be responded to, played with, juggled in whatever way(s) the practitioner supposes they could be, until they take some meaningful form. And all of this supposing, responding, playing, juggling, forming is experienced as *effortless*, and *without conscious thought*.

Does that sound at all familiar? It should. In the terms we've been using here, "flow" amounts to *direct, unmediated experience* of whatever is going on in the moment. That's just the sort of experience, as we noted in Chapter 1, traditionally ascribed to animals other than ourselves (and yes, I know … possibly the whales). The difference between *this* direct experience and those ascribed to animals other than ourselves, though, is that, humans, being humans, respond in the abstract by giving *their* direct experiences *form*.

In states of "flow," though, the forms practitioners develop are not necessarily conventional *linguistic* forms, not necessarily the forms one's usual, convention-bound, conscious mindset might

suggest they're "supposed to be." Rather, response to "flow" experiences seems instead to involve direct, unmediated reaction *to* the work (whatever that may be), in terms just *of* that work, in relation just to the "being" – the idiosyncrasies and intuitions and skills and life experiences – of the maker. Given that extremely close relationship to the singularity of the person experiencing it, "flow" *may* result in more-or-less conventional, linguistic products or performances ... but maybe, indeed probably, not.

In the description we're building here, that is, "flow" experiences can be described as _pre-linguistic_. They seem to involve pure awareness of the moment and of everything it contains, and "supposing" how some or all of that might be rendered into whatever sort of significant form, *before* it's described in conventional ways. And that, I want to suggest, makes a sort of *ultimate* sense as the difference we've been seeking, between "art" and everything else.

That may seem a rather arbitrary claim, if you've heard much about "flow" before encountering it here. For "flow" is most frequently talked about in discussions not of "art" but of what most of us think of as (formalized) "play" – that is, athletics, particularly those played at high levels of achievement. Baseball pitchers at any level above Little League are typically told by their coaches to seek a level where they no longer have to "aim" their pitches to get them over the plate, but can instead "just throw." Michael Jordan, possibly the greatest basketball player who's ever lived, famously referred at the peak of his career to often finding himself in what he called "the Zone" (quite clearly another term for "flow"), in which he had so internalized his skills and the rules of the game and their implications that he could "just play," with a kind of focused awareness and instinctual creativity utterly unavailable in more mediated states. In my own memorable experience in a swimming race, many years ago, I found myself suddenly able to "just swim," without *thinking* about what I was doing, at all (and when I did "just swim," my time for the event was almost unbelievably better than it had ever been before, when I had *always* consciously focused on how I was swimming as I swam). The corporate slogan of Nike®, the (in)famous manufacturer of sporting goods, is "Just do it." And so on.

But interestingly – especially in light of Dissanayake's thesis about art and play – "flow" is *also* the state aspired to by every *artist* of any kind that I have ever known, as they enter their studios in hopes of getting good work done. Painters hope that maybe today, if only for

a while, they can work without the need to *think* about what they "*should*" do with that canvas, and instead just react directly to it, just … paint. Actors speak of hoping to "become" the role they've studied and thought about for so long, rather than having to think about how it's "*supposed to*" be performed; dancers, of seeking places within themselves where they can cease concentrating on the choreography and execution they've worked so hard to master, and "just dance." Writers speak of their characters telling them what happens next, or of stories "telling themselves."

When it does occur, "flow" does not necessarily happen for entire performances – for the entire execution of a painting, a whole game, the complete working out of a formula – though it can. Some years after I had that "flow" experience while swimming fast, I had another, this time while working with a photograph in the darkroom, that lasted perhaps four or five hours, until the print that emerged in the developing tray was finally … just … *right* (although I surely had no words then that could explain *how* it was "right," nor do I now). More often, though, "flow" moments come in fits and starts. The brilliant Abstract Expressionist painter Willem DeKooning drew a famous analogy between "standing upright" and seeing the world in the ways it was conventionally seen, and "falling" and "glimpsing" the world in unexpected ways that only made sense to him. He seems to have been describing what we're here calling "flow," and in what amounts, I think, to a wonderful description of most artists' *intermittent* experience of "flow," he said of his work that

> … When I'm falling, I'm doing all right; when I'm slipping, I say, hey, this is interesting! It's when I'm standing upright that bothers me: I'm not doing so good; I'm stiff. As a matter of fact, I'm really slipping most of the time into that glimpse. I'm like a *slipping glimpser*."[17] (Italics mine.)

People who have experienced "flow," who know from experience that it's a real and possible phenomenon, seem inevitably to seek to experience that "glimpsing" again and again; and they don't seem to do so because "flow" necessarily results in "better" external products or performances than those resulting from more consciously calculated efforts, though – as in my swimming episode – it can and often does. Rather, by all accounts the primary value of "flow" to those who experience it (including DeKooning, apparently, and certainly me) seems to be one of the quality of that experience

itself, per se, of giving oneself over totally to direct, concentrated interaction with the world, perceiving and responding to it directly, purely in its own and one's own terms, and purely for the sake of doing so. Artists *and* athletes in my acquaintance have used terms like "exalting" and "transforming" to describe that sort of experience. It is, I think, precisely the sort of experience that the American philosopher/educator John Dewey suggested in 1934 as the source of the aesthetic.[18] I think it's also what the linguists of the Prague School saw, at about the same time, as the defining factor in art. And it seems to me that one *could* argue it as the "special attitude and response" that Dissanayake notes as integral to "making special."

So … What if we think about it this way?

What if, then, in describing *our* world – which, again, remember, we can do in any way that seems sensible to us, so long as it doesn't harm anyone else – we decide to understand "art," now and henceforward, as referring *just* to the products of such moments? What if we take true "art" things to be those made or performed by humans, which appear to partake, more or less and at least *in part*, of direct, non-purposive, *pre-linguistic* response to their makers' perceived, supposed, idiosyncratic experience of the world? (And again, what if we think of similar things that are made more or less the way they're conventionally "supposed to be" made, as "craft"?)

One thing that does *not* happen if we think about the world this way is that Saussure's idea that "it's all language" isn't threatened – though at first it may seem that it must be – by this "*pre*-linguistic" idea. For the social institution that has grown up over time around the idea of "art" is a linguistic system like any other; and artists give significant form to their "artistic" experiences, and we come to terms with those forms, in essentially linguistic ways, as we'll see. We're positing here only that the work of artists is *based* in pre-linguistic experience, rather than in the sort of conventional, codified experience that has come by now to underlie most of our actions. That leaves Saussure's observation unscathed.

What *does* happen, though, if we think about "art" in *either* of the ways we've suggested here – "art" as the activity or products of (sometimes) struggling jugglers, or "art" as those of "slipping glimpsers" – is that two distinct benefits accrue.

For one, in either case that time-honored description of artists as specially gifted "seers," or words to that effect, makes more empirical sense. What people have long thought of as semi-mystical, even God-given, insight on the part of artists can now be explained in relatively straightforward human terms as the products of the heightened personal awareness of oneself in relation to the world in the moment, whether that awareness is consciously struggled for, or achieved seemingly effortlessly in states of "flow."

And as a function of this, many of the apparently odd, enigmatic pronouncements often made by artists and often dismissed by the rest of us as irritating affectation or "artspeak" or worse, now can be seen as resulting from artists' searches for ways to describe sensibly an essentially pre-linguistic experience, whether those searches are characterized by struggle or by "flow" (or by a sense of play, which seems to me to fall midway between the two). In that light, they become less off-putting, and more comprehensible. We saw this with regard to Kandinsky's apparently melodramatic quote, above; I think we can see it again in a recent quote from an artist/curator in Boston, who said that "The artist creates something. That is a *pure moment.* Then it's released into the world. It takes on *new lives that the artist can't control*" (italics mine).[19]

But one *very* significant benefit – to which that quote, as it happens, serves to point us – accrues less to the self-conscious, "struggling" idea of art than it does to an understanding of "art" as involving "flow." And that is, that if we do think about "art" in terms of "flow," art's real and immediate *relevance* – to *anybody*, not just the artists themselves, and not just the mavens and power-brokers of the "art world" – suddenly comes clear. For if we think of "art" as inhering in direct, unmediated response to experience, and in giving form to that response, directly, in a process untainted by any purposive concerns or struggles with any pre-established structures ... then the making of "art" becomes in our description a *paradigmatic* human experience. Art becomes the pure, unsullied experience of what it is that humans – *any* humans – definitively *do*.

Think about it. Artworks *start* as creative ideas, which are generally understood as arising from the unconscious. And we're proposing now that artworks (or, the art *parts* of them) *end* in a state wherein conscious intent (beyond the initial intent to make or do whatever one is making or doing) is not involved. Thus the process of making "art," of creating artistic form of any kind, starts and

ends, in this description, in pre-linguistic states, states in which there is no conventional structuring of signs and ideas operative, at all – in, that is, what the curator we quoted above called a "pure moment." In this "flow"-based description, art is made in just the sort of situation in which our imaginary evolutionary beastie, our first, "missing-link" proto-human, found itself, back there just this side of the evolutionary bridge to self-consciousness, before linguistic systems began to accumulate and multiply.

Art, seen thus, is not then just *ambiguous* in its meaning; its meaning is, as was that of the world as initially perceived by that imaginary beastie, entirely *open*, to be determined by whomever chooses to bring her consciousness to bear and do so. In this view art (or the art part of a thing) is a non-purposive, creative array of signs worked together by the maker, not *so that* an encoded "message" of any kind will be transmitted to an audience, but as an end in itself, and so, for audiences to see as and make of what *they* will. The "new lives that the artist can't control" mentioned in the quote above are whatever meanings audience members do make of it.

In this description of "art," then, both *artist and audience* indulge the very same behaviors (the lone difference being that art audiences do so in the presence of signs "pre-selected," as it were, by the artist). They both – necessarily, if "art" is to happen – pay open, nonjudgmental attention to what they perceive to be at hand, notice what they notice about the experience, and relate those things noticed in ways that seem to make sense, all for no purpose other than to do so. In effect, in the presence of a work of art, the audience *becomes* the artist.

And because there's no *so that* involved in the work, there's no risk for either artist or audience of failure with regard to anything outside the work itself. One makes and/or experiences art more-or-less effectively, of course. But in this description there's no way to get art "wrong."[20]

Thus from either vantage, the "art" experience presents itself as a sort of no-risk experiential rehearsal of what it is to *be human*, perceiving and conceiving the world as attentively and creatively as we're able, and so making it up, thoughtfully, as we go. The experience of art, as we're describing it, serves as a reminder of what we're fundamentally about, here, no matter how awash we may be in externally purposive linguistic systems most of the time. Amid all that linguistic hubbub, the experience of "art" is definitively, paradigmatically human, and in that, essentially silent, and centering, and

grounding. And therein, I think, lies its "weight," its relevance and its value, in whatever culture includes it (and – as Dissanayake points out – whatever they may call it.)[21, 22]

Paying Attention(?!)

And therein too, it seems to me, lies another working, workable answer to our original question here, this one specifically addressing what this term "art" might *mean*. For if (again) you think about it, what we seem to have come to, finally, is this: when we say "art," what we *mean* is something that invites – and justifies – a certain kind of attention. It seems to be that simple.

"Art" *refers*, as we noted above, to a class of things and behaviors that are human-made, creative, expressive, idiosyncratic, self-justifying ... and dualistic. And that "dualism" turns out finally to be a likely key to what "art" seems to *mean*, lately.

We've said that "art" things are "dualistic" in that they're something else, first, but then they're "art" (in part), too. And we've noted that that's the case because "art" isn't a natural category, it's a *constitutive* one: if we *say* something's "art," describe it as being "art," then it *is* art, at least until we can be convinced by someone else, some other "describer," that it isn't. That argument, if it occurs, will be about how one "looks at it" (as in "Well, yeah, but if you look at it *this* way ..."); and "how one looks at" something is just another way of saying "how one describes" it, which is the same as saying "how one thinks about" it ... which is really just a paraphrase for "what sort of attention one pays."

Think back for a moment to our cow, back in Chapter 1, standing there in the field while the dairy farmer and the zoologist and the cult member considered it, and referred to *how* they considered it, in various terms. And all the while the cow just stood there, just as it had been before anybody had come along and started talking about it. "Art" things, left to themselves, are like that cow, indeed like any other sorts of things at all. Until we come along and pay them a certain kind of attention, *describe* them, as humans will, they're neither "art" things nor *not*-"art" things, neither do nor or mean anything at all in any way. They simply "are," standing in the field, in the case of the cow, or propped against the wall or lying on the desk or the piano over there in the corner of the studio ... until we come

along and pay them a certain kind of attention. In the case of the cow, that was either a sort of "profit/loss" attention, on the part of the farmer, or a "species-specific" attention, in the case of the scientist, or a kind of awed reverential attention, for the cult member. In the case of "art" things, we pay our "art" attention; and in so doing, we "activate" them, as it were, to become (for us) what we've thought/said/described them to be, i.e., "art."

So, what's "art attention"? It seems to me that it can be most usefully thought of as the kind of attention that we've noted as characterizing "flow" – open, pre-linguistic (pre-conventional, pre-descriptive), non-hierarchical, nonjudgmental, fully aware attention, with no strings attached. "What have we got here?," one needs to say in the presence of an artwork, and then, refusing to indulge any inclination to think of it conventionally (as in, "Oh, well, this is pretty much just one of those so-and-so's"), to attend as carefully and openly to any and all aspects of the thing, and of one's experience of it, that one can perceive. Learning to pay that sort of attention, to put aside how one is "supposed to" experience it and instead do so as you suppose you might, is surely a struggle, here in our ever-more-linguistic universe. But to the extent that one can indeed learn to do it, there's some chance at least of having the kind of reaffirming, centering experience we've attributed to "art." (And without that kind of attention, there's probably not.)

For most of us, of course, "flow" is not about to happen whenever we confront an artwork as we're now understanding the term; we don't get enough practice. For "art" as we've described it here is rare. Even if we spent hours every week looking at things that our culture has said are "supposed to be" artworks, maybe 1 or 2 or 3 in 100 (on a good day) would strike us, personally, as justifying much more than cursory attention. But still the process we've noted as characterizing "flow" – the open, unassuming, focused attention on our experience of the work, the noticing of what we notice, and then the making some sort of formal "sense" (a paper, an article, a persuasive argument, even if only to ourselves …) of that – needs to be the same whether one finds oneself in a "flow" state or not. In the absence *of* "flow," then, one needs to learn how to pay this so-called "art attention" *willfully*, when the need arises, if one is to have the sorts of "art" experience that are made so much of in our culture. And again, in Chapter 7 we'll try to offer some further descriptions of how one might approach doing that.

But ... particularly here in a Postmodern world, in which everything *can be* art but not everything *is* ... how do you *know* when you need to pay that kind of attention? How do you know whether you're in the presence of an "art" thing or not?

Well, you don't. You can't. That plaque on the building there by the bus stop might just be a plaque ... or it might be art.[23] That garden over there is very beautiful, even *beyond* beautiful, somehow ... how should I think about that? Even in known art venues – museums and galleries and such – there are going to be crude colonial tables and what seem at least to be little more than highly crafted portraits ... though maybe they're *not* just that; and so on.

But at least you *can* use this idea of art as a sort of index. If there's something that attracts your attention (as Jakobson suggested art things do), and it can't be explained away conventionally (as one could explain away that cereal box), then try paying your "art attention."

When you do, you'll find out very quickly whether or not that attention may be justified. For "art" things are complex by nature, especially if we understand "flow" as part of that nature. The openness and idiosyncrasy of the "flow" state leads to focused, non-preferential attention, as we've said, to *everything* that pertains in the moment – the work at hand, the personal and cultural contexts and conventions from which it comes, one's physical and emotional "presence," that cobweb in the corner, everything. So if you bring your "art attention" to bear and find that the thing to which you're attending explains itself and exhausts your interest quickly and conventionally, as did that cereal box we mentioned earlier, you're probably well advised to move on. But if your initial consideration of a thing leaves unanswered questions and unexplained feelings, that lead to other questions and feelings, and those to still others, you'll probably be well served if you look at it as at least potentially "art," bring your "art" attention to bear, play around with your observations of it and your responses to it and your ideas about it for awhile, and see what sense you can make.

Doing so truly can be, when it happens, a reaffirming experience like no other.

One Last Thought (for now)

Finally, perhaps the *most* important thing to realize about this description of "art" that we've come to here, is that regardless of how the "art world" and its concerns have come to seem lately relative to

the rest of us, "art" is anything *but* an elitist activity, by its nature. Rather, as I've tried to suggest, it's a fundamental – perhaps *the* fundamental – human one. We all, just by virtue of *being* human, have the inherent ability to *observe* and *suppose* and *make meaning*; we all have the ability to recognize beauty (and/or "special"), of whatever kind, when we come across it.

Our cultural histor(ies) may seem to have conspired to push "art" to the elitist edges of our everyday concerns, even as the proliferation of linguistic systems that is the "Age of Information" leads most of us most of the time to try to behave and think more or less as we're "supposed to" *so that* our lives will go forward as we hope they might. But the ability to pay closer attention to our*selves* in response to what we're being, doing, making, is there in all of us. That "artists" seem to be able to do that, maybe insist upon doing it, is perhaps the only difference available between how "they" make meaning, and how we do. But all of us *could* do it more … and involvement with artworks as we've described them here can serve to further that cause.

But more about this in Chapter 8. First, though, in Chapter 7, let's work awhile at explicating this "art attention" for which we've made so many claims.

Notes

1 This, happily, leaves you free to say, should you be citing some point from this book and be challenged by a teacher or some fellow-attendee at your next gallery opening, "Well, that's *Shipps's* take on it."

2 Carruth, Hayden. "Five Short-Shorts" (fifth poem), in Hayden Carruth (ed.), *The Voice That Is Great Within Us: American Poetry of the Twentieth Century*. New York, Bantam, 1970. (p. 483).

3 There may be – surely there *are* – conventions specific to poetry which might add some clarity for those readers who were familiar with those conventions … but only some, and none at all for those *un*familiar with them.

4 Mukařovský, Jan. "The Essence of the Visual Arts," in Matejka, Ladislav and Irwin R. Titunik (eds.), *Semiotics of Art: Prague School Contributions*. Cambridge, MA, MIT Press, 1976. (pp. 229–44).

5 Kandinsky, Wassily. "Reminiscences," in Robert L. Herbert, ed., *Modern Artists on Art*. New York, Spectrum, 1964. (p. 35).

6 Baldessari, John. "Recalling Ideas" (Interview with Jeanne Siegel), in Jeanne Siegel, *Art Talk: The Early 80s*. New York, Da Capo, 1988.

7 Mukařovský, *op. cit.*, p. 235.

8 Leach, Edmund R. "Michelangelo's Genesis: Structuralist comments on the paintings on the Sistine Chapel ceiling." *Times Literary Supplement*, March 18, 1977. (pp. 10–12).

9 Jakobson, Roman. "What Is Poetry?" in Matejka and Titunik, op. cit., pp. 164–75.

10 There had certainly been historical exceptions to this, though they were typically spurred by aspects of physical execution (as in the "Would you look at how he *did* that!" case of the astonishing mimetic skills of seventeenth- and eighteenth-century Dutch painters, as noted in Chapter 3), and nothing more.

11 Dissanayake, Ellen. *What Is Art For?* Seattle, University of Washington Press, 1990. (pp. 92–3).

12 Dissanayake, Ellen. *Homo Aestheticus.* New York, The Free Press, 1992. (p. 44).

13 There do always seem to be exceptions to anyone's descriptions of what "art" is, things that are generally acknowledged *as* art that don't fit the formulation at hand – Copley's portrait of Revere for me, the utterly crude, not-special Colonial dining table in the "Period Rooms" of the Boston Museum of Fine Arts, for Dissanayake (or so I would guess). My idea about these apparent "glitches" is that they're often the result of overzealous decision-making on the parts of curators and the like.

14 A dear friend of mine, an internationally known painter currently living in Thailand, wrote to me on her return to Bangkok after several weeks of visiting with family and friends in the United States, "I think I understand why people STOP being artists; it is SO HARD to get back on track after one has gone away, done something else, etc."

15 Csikszentmihalyi, Mihaly. *Flow: The Psychology of Optimal Experience.* New York, Harper and Row, 1990.

16 I spent about twelve years of my life as a fairly good competitive swimmer, and another, different twelve years as a working artist (my primary medium was photography). I can offer personal testimony to the truth of Csikszentmihalyi's description of "flow," and add here some description of my own, based on two memorable experiences of it, one in a swimming pool, the other in a darkroom.

17 Quoted in "Project Narrative" at www.analogyshop.com/slipping%20 glimpser%20page.html (among other places …).

18 Dewey, John. *Art As Experience.* New York, Wideview/Perigee, 1980.

19 Lisa Lunskaya Gordon, in McQuaid, Cate. "Thinking Inside The Box." Boston *Globe* "Calendar," October 19, 2006. (p. 4).

20 The critic Robert Hughes, in his autobiography *Things I Didn't Know: A Memoir* (Knopf, 2006), notes that the arts are "the only area – other

than sports – in which human inequality can be displayed and cele-
brated without doing social harm." (Quoted in Yardley, Jonathan.
"A way of seeing." *Washington Post*, November 24, 2006. (p. BW02).)

21 For more on this point, see Peckham, Morse. *Man's Rage For Chaos*.
New York, Schocken, 1976.

22 I have to wonder whether the "beauty" that most of us assume of art-
works lies not in their being conventionally "pretty" (so many aren't,
after all), but rather of this sense they afford of what it is, at base, to be
what we are.

23 The artist Jenny Holzer has for some years been putting hauntingly
enigmatic quotes in various formats – bronze plaques, LED billboards,
engraved stone benches, etc. – in unexpected venues all over the world.

Chapter 7

Pragmatics

Well. All that said, now what? In fact, *so* what? In this chapter I'll try to answer the first of those questions, and in the next one, the last.

A few pages ago, we suggested that you can't get art "wrong," because according to the theory we've developed here, there's nothing in the art part of a thing to get "right." But you *can*, we said, experience art more or less effectively. In this chapter, we're going to put theory aside for awhile, and talk about practice, about how to pay this "art attention" we've mentioned, in the name of experiencing art *more* effectively. And once we've done that, we'll try to describe the critical process that can grow from it.

To say it just one more time, before we begin here: your task in approaching any artwork is essentially that of our imagined beastie, back there just this side of the evolutionary bridge. You need, in the presence of art, to attend to your experience of it as openly and care-fully as you can (that's the "art attention"), then notice what you notice, and relate some or all of the things you notice, in whatever way(s) seem to you to make sense (that's the critical process).

Only you can know, of course, how much you want to work at doing any of this. How careful/thorough do you want to be? Maybe you don't care to work at it at all; you'd be happy just to be *told* what to think about art (though if that's the case, it seems unlikely that you'd have picked up this book, much less have read this far). You may be, like many of us, an unstudied "appreciator" of art, casually explor-ing ideas that could broaden your appreciation in ways that you may not have come to on your own. Or perhaps you're a student in a course about art or art history, and your interest in how to think about

all this is more pointed, if only because you may have to *write* about art, before the term's over. I'm going to operate here on the assumption that the latter is indeed the case, and so try to explain this idea of "art attention," and the critical process, as thoroughly as I can, here … but you should read this chapter as casually or as carefully as your interests suggest, and take from it whatever you find useful.

The First Thing: Having the Experience

The first thing that *any*one needs to do in approaching an artwork is perhaps the most difficult. To really have the experience of an artwork, on your own and for yourself, you have to teach yourself to pay *open* attention, to open up *to* the experience. As we've noted, in the increasingly linguistic, increasingly described and codified world in which we're all used to operating, that's harder for most of us to do than it might seem. Nonetheless, if you're ever to have art experiences like the ones I mentioned in the preface, you need to be able to attend *openly* to any and all aspects of the experience that you're able to perceive. And to do that, you have to come to an artwork without indulging any pre-established, conventional expectations of how you're "supposed to" be experiencing it.

For all our talk in Chapter 6 of art being a safe site for practicing that sort of open receptivity, it can certainly seem, every time you read a wall label or a playbill or a textbook, or listen to a lecture, that what you're reading or hearing is how you're "supposed to" think about the work at hand – those writers and that lecturer are all presumably art "experts," after all. The fact is, though, that any such inputs can and should *only* be taken as suggestions for your consideration, ideas that you might find relevant, regarding the work in question; if what we've said about the impossibility of right or wrong in art is true, they couldn't be anything else. And while you'll quite likely *want* to consider these suggestions, ideally you should try to avoid doing so until *later*, as we'll see. Ideally, that is, you should try to approach artworks before you've read or listened to anybody else's ideas about them … or at least, try to put out of your mind, on actually encountering a work, anything that you might have heard about it beforehand, and so, see what *you* see about the work, first.

Here's an example. A few weeks ago my family and I attended the first concert in a classical series to which we'd subscribed. The work

to be performed that night was an unfinished opera called *Moses und Aron*, written by the Modernist composer Arnold Schoenberg around 1930. I remembered just enough about Schoenberg, from a "music appreciation" course I took long ago in college, to suspect that this work would be different from the sorts of older, more familiar sorts of classical music (by Beethoven or Mozart, say) that most of us typically associate with the term. But I was also in the middle of writing this part of this book, and so I consciously sought to ignore those vague preconceptions about Schoenberg, *not* read the program notes beforehand, and just … see what happened.

On that basis, it seemed to me that what did happen was literally amazing: confusing, strident, dissonant, filled with passages in which the soloists' voices were lost in the orchestration – some of it seeming almost not what I thought of as music at all, and all of it more anxiety-producing than satisfying in any traditional way. It was … tortuous, I felt, nearly impossible to "follow" in the way that one can usually make reasonably predictable sense of more traditional music.

Meanwhile my wife and son, neither of whom have ever had any formal instruction in music, but who certainly did have expectations for symphonic music based on their past experiences of it, thought the Schoenberg work was tort*ur*ous; when their expectations were not fulfilled (to say the least), they were disappointed (also to say the least).

Certainly none of us would have chosen *Moses und Aron* as background music at our next lawn party. But I found myself, as I've said, amazed, at how utterly, viscerally *difficult* the experience of the music had been for me (how could music *do* that?), how filled it had been with struggle and angst. (*What* struggle and angst? Schoenberg's?[1] About what? Or was it my own struggle and angst, at not knowing how to listen to and think about music like this? Or both?) Rather than sharing my family's sense of having suffered through a concert that was disappointing for what it *wasn't*, I was left with the palpable awareness that I'd just *had an experience*, and one so striking that I couldn't *not* try to figure out what to make of it.

This is, I think, how art should work – though most of the time it won't do so quite so dramatically, or necessarily involve anything like torture or angst. Only by putting aside any and all preconceived notions, from those wall labels or playbills or textbooks or even past experience, of what this or that work mostly "is" and what it likely entails, any and all preconceptions of how you're "supposed to"

respond to it, will you be able to pay that kind of full, open, non-judgmental "art attention" to *what is there* – regardless, at least at first, of how others may already have described it – and to your responses to that: how it makes you *feel*, what it makes you *think*, *how* it makes you think.

Again, for most of us, this sort of openness and attention takes practice … but the results can be, on those rare occasions when you really connect with a work of art and as perhaps this example will suggest, palpable, unexpected, moving (in whatever way), even thrilling – the kinds of results many of us might have said are "supposed to" attach to art experiences. When we approach art with preconceived expectations, though, or received information about how it's been seen by someone else, we almost inevitably experience it to be just … predictable, at best (or disappointing at worst). So at least at first, you need to try to have your own, full, open, nonjudgmental experience of art; *that's* "art attention." Then if you want you can balance what others have suggested about the work against it, later.[2]

Which brings us to the critical process. Once you've paid that art attention, then what? Then comes the noticing.

The Second Thing: Noticing What You Notice

While you're attending as openly as you're able to the work at hand, and/or once you've done so, you need to *notice what you notice* about it, and about your experience of it.

Saying that may seem to fly in the face of another widely held idea about art, namely, that when one really connects with a work of art, finds oneself affected by it as strongly, say, as I was by the Schoenberg opera, one tends to be swept away by that connection, lost in a sort of floating haze of free-association and recognition, and that to tamper with that by examining it too closely would demean the whole experience. Even if we acknowledge that as a fair characterization of the art experience for casual art appreciators, though, when or if you wish or need to *understand* that experience, you'll have at some point to *think* about it, to try to relate aspects of it in ways that will make linguistic sense.

Indeed, conditioned as even the most casual observers of art are today by art that's just about ideas and so *has* to be thought about, thinking about artworks has for many of us become virtually

instinctual. Even as I was "swept away," if you will, by that opera, I was almost immediately thinking back to the stridence and dissonance I'd noticed, to the angst that it made me feel (and to that note in the playbill), in an attempt – albeit a casual one – to explain to myself the reaction I'd had.

But if your interest in an artwork is more than casual, you've got to pay attention at levels deeper than just that instinctual one. At some point you need to look objectively and pointedly at the work and your experience of it, and as we've said, *notice what you notice*. All the things that you do notice, you'll remember (from the end of Chapter 5), are "signs," by definition; and we've said that artworks are, also by definition, complex. And to the extent that you include in your analysis "signs" from outside your own experience of the work – that is, other people's ideas about it – things become more complex still. So keeping track of the signs involved in the experience of art can be, depending again on how far you want to pursue it, complicated.

If you want or need to *criticize* an artwork, your task is to assemble as broad and diverse an inventory of the signs that make up this experience, and that attend it, as you can. The more successful you are in doing that, the more – and/or the more subtle – choices you'll be able to make when you begin to make sense of it by relating some or all of those signs.

None of this "noticing" part of an encounter with art needs any sort of specialized training or knowledge. Any normally functioning human can do it, to one degree, at least, or another. The encounter is between you and the work, and regardless of the sorts of knowledge or insight you may or may not bring to it, you can notice whatever you do notice, purely by inspection, whether you're a complete beginner or an experienced critic; and in either case, those observations are inherently valid. On the other hand, the more knowledge you *can* bring to the process, the more you'll be aware of things that are there *to* notice … and the more of them you notice, the richer your experience, and your critical explanation of it, will be. So now we need to delineate some of the basic ways in which one *can* consider artworks, in the name of examining them from as many different vantages as possible.

Really "connecting" to an artwork on an immediate, personal, visceral level is for most of us a fairly rare occurrence, even if we've learned all the things that this chapter will suggest we ought to learn about approaching such a work. Most of the time, you'll be perhaps a

little interested in one aspect of the work or another, perhaps vaguely admiring of this quality or that … and then you move on. Only once in a great while will you be so struck by a work that you're – at least at first – at a loss to find words even to express the experience, much less explain it.

Either way, though, those personal responses are where the critical process starts. You need to note what they are; and then you need to ask yourself, "What about this work so drew me (or cheered me, depressed me, irritated me, amused me, bored me, made me think of my grandmother, completely blew me away, whatever)?" And once you've noted your reactions to it, there are at least three broad aspects of the work itself that need your critical attention.

Two of these – a work's *content*, and its *form* – are there to be examined in any artwork, of any kind. The *content* of an artwork is what it's "of," or "about," or what it *can be seen to be* about. And an artwork's *form*, as we noted briefly in Chapter 4, is what it actually *is*, as an object or event in real time and space.

Neither content nor form is necessarily any more or less important than the other; sometimes one may be, sometimes the other, and sometimes they work together equally. Nor are they mutually exclusive; indeed they almost inevitably overlap, sometimes more, sometimes less. Neither of these concerns really *are* concerns, though, as the point of examining the work at all is to notice all that we can about it, and so if we find more content-related "signs" than formal ones, or the other way around, or if we chance to notice a given aspect twice, once while considering content and then again while assessing form, no harm is done to our inquiry.

The third aspect of an artwork that you need to consider is the *meaning* of the work, its *significance*. Meaning, though, is different from content and form, in that meaning, as we suggested at the end of Chapter 5, is not something that's *found in* the work, but rather something that you *make of* it, by considering and relating aspects of the first two concerns, plus your reactions to them. So we'll deal with that in a separate section.

First, though, let's consider content, and then form.

Content: Subject Matter

As we've noted, the *content* of an artwork is what it's "of," or "about," or what it can be seen to be about. Content might seem as

though it'd be pretty easy to assess, but in fact it can be a little more complicated than it appears.

The *first* thing you're likely to notice about an artwork's content is its *subject matter*. The subject matter of most representative paintings or drawings is what they're images "of" – a landscape, a bowl of pears, a historic event, whatever; and the subject matter of most stories or plays or poems is what their plots are "about" – a suburban teenager growing up, a Scottish queen with imaginary blood on her hands, the "love song" of a lonely man. Identifying subject matter in works like these is fairly easy.

But subject matter isn't always so easy to determine. For one thing, questions of artistic subject matter are confused – or at least, they *appear* to be confused – by virtually all Modern and Postmodern art. Much of this work is "titled" *Untitled*, or may say in its title that it's about so-and-so, but doesn't really look or sound anything like the way so-and-so could be expected to look or sound.

This seeming source of confusion, though, is easily addressed. You'll remember our saying in Chapter 4 that beginning in about 1850, Western art increasingly becomes "about" *itself*. Once Modernism (and photography) had fostered concerns about the essential nature of the arts, and the reductive search(es) for those essences had begun, the arts began to deal increasingly in ideas *about art*, and in the various kinds of abstraction that followed from them. This of course was most easily seen in the visual arts, but it occurred in all the arts once artists began to question their traditional, conventional assumptions about what an "art" painting, or composition, or play or poem or dance *was*. By this time, remember, "art" was understood as *things*; and the art things made in response to these concerns became less and less mimetic and illusionary, and more and more assertive of what they – the art things themselves – *were*, of their (apparently inherent) *form*.

Again, any survey of the history of any of the arts will offer examples of this; and they'll present progressions of artworks that over time became *purely formal abstractions* – all those "problematic" paintings like Pollock's or Klein's, Cage's silent symphonies, Beckett's *Breath*. Getting to *pure* form was a gradual process, though; at first, Modernist artworks were just partially abstracted from the forms they'd traditionally held, then a little more, then more still. And what you need to realize is that insofar as any artwork is (intentionally) abstracted, it is, in that, understandable as being *about* its own *form*. Picasso's famous

painting "of" a group of prostitutes (Figure 9) is surely about those prostitutes … but insofar as it's abstracted in the Cubist style, it's about painting and what it might be thought to be, too. And those *totally* abstract works are *just* about form, in every bit the same way that a traditional painting of any more "readable" subject matter is about that. Cage's works were about the nature of music, as he saw it, and Beckett's *Breath*, about the nature of the theatrical experience; Pollock and Klein were addressing the nature of painting, in purely formal terms; Modernist experiments in "automatic writing" and

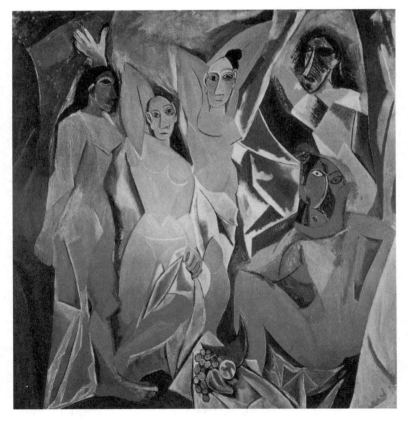

Figure 9 Pablo Picasso, *Les Demoiselles D'Avignon* (1907), © Museum of Modern Art, New York, USA / Lauros / Giraudon / The Bridgeman Art Library © Succession Picasso / DACS London 2007

the like were just about the nature of writing, and so on. And *all* Postmodern art, as we noted too, is thought to be about *all* Postmodern human products, including, then, itself. So in all these cases, the artwork's form is to one degree or another its subject matter. The form *is* the content. (I warned you about the overlaps.)

And then sometimes, there isn't any subject matter at all. With the exceptions of those Modern and Postmodern works which can be seen to be about themselves, music (without its lyrics, which are *added to* music, anyway), and dance and architecture in most cases have *no* identifiable subject matter, but instead are essentially *pure* form.

While the titles of some few Modernist musical works do indeed suggest subject matter (or at least sources of inspiration) – Copland's *Appalachian Spring*, for instance – most classical works are referred to simply by identifying labels that refer to their form, like "5th Symphony" or "Sonata in D"; the titles of songs almost invariably refer to their lyrics, and not to their scores. And certainly none of those symphonies or sonatas or for that matter song scores are "about" any external subject matters in the way that traditional stories or mimetic paintings are.

In dance, the titles of traditional narrative pieces like, say, Tchaikovsky's *Swan Lake*, often do tell us, just as the works themselves show us (in stylized ways) about subject matter. But the titles of Modernist works such as Merce Cunningham's *Points In Space* have at best a relationship to the piece that is so abstract as to offer no clue about what it's "about" (other than dance itself)[3] ... and indeed the work itself doesn't appear in any way *to* be about anything else.

Architecture, of course, isn't usually titled at all (though it may be "named," usually for either the source of the money it cost to build or operate, or for its primary use), nor obviously, does most of it tell any stories or depict anything that it isn't.[4] Architecture can seem to be problematic as a "fine art" as we understand that term today, because clearly it's *not* "autonomous," virtually ever.[5] Buildings *do* things, other than "being art," in a way that other art forms do not typically share. We've accounted for that here (I hope) in our discussion of "part-art"; architecture can be seen as perhaps the most obvious example of this. But if one thus takes the functional part of a building out of consideration as subject matter (it's what a building *does*, after all, rather than what it's *about*), what's left over – the

architectural design and construction – is essentially without subject matter; it too is best seen as pure form.

Content: Context and Convention

Nor are all these complicating factors around the apparently simple question of subject matter in art all that you have to worry about, with regard to content. For subject matter is, again, only the first, most accessible part of content. It's what an artwork is "about," as we've said ... but then there's that "or can be seen to be about" part that we mentioned, too.

In Chapter 3, we noted that anything that emerges from the ground in an archaeological dig – from humblest potsherd to most glorious statue – is seen by the archaeologist as expressive of the culture that produced it; in that way, it's *about* that culture. And so it is with artworks, which can be seen in that same way as "about" the historical *contexts* that gave rise to them, and the artistic *conventions* that prevailed in the time and place in which they were made.

Consider our description in Chapter 6 of "flow," the idea of which we offered as a useful index to what we think of as art and what we don't. In a state of "flow," we suggested, an artist is acutely and indiscriminately aware of *everything* that impacts on her experience at that moment – "the work at hand, one's emotional state, that cobweb up in the corner of the room, all of it," we said. That means that the historical circumstances, the *contexts*, both public and personal – the weather, the political situation, her socioeconomic one, that bothersome sore knee, the cobweb, all of it – that pertain at that moment will necessarily be "there" for the artist, in her head as she works, just as will the prevailing *conventions* about what she's culturally expected to be doing when she does what she does (whether or not she chooses to *work* "conventionally").

And so if you're accounting for an artwork as thoroughly as you're able, you need – ideally – to take these things into account, too. You'll need to do research on who the artist was, what he was known as, and for, what was going on in and around the artist's life in and around the time he made this work, what conventions prevailed at the time pertaining to the kind of work he was doing, how the work reflected those conventions or didn't, and so on.

If this research component strikes you as *way* more work than you can ever imagine *any* artwork ever justifying, you're not alone ...

but you should perhaps think back yet again to our imaginary evolutionary beastie, from Chapter 1. Its task, we said, was to notice all those parts of the chaos that *seemed to have something to do with it* (for it couldn't possibly have dealt with it all, all at once), and then to relate *those* things, in ways that seemed to make sense. So, too, with you, in researching an artwork's contexts and conventions: you need, you'll be happy to hear, only to *skim* historical sources, biographical information, and the like – at least at first – in search of *things that seem likely to be relevant to the work at hand*. All the rest of it is of little consequence, and you can let it go, at least until you discover some reason to look back at it or study something in more detail, later.

That said, all of this content – subject matter (if there is any), context, and convention, and your personal reactions to any/all – needs to be noted, considered, researched, and taken into account when examining an artwork. And then, so does form.

Form

Again, the *form* of an artwork – indeed, of anything at all – is what it physically *is*, as an object or event in real time and space.

Say that you've heard from a friend that he's recently seen a ghost. Startled, you ask, "What *form* did it take?" That he saw *something* wasn't the issue for you (you trust him implicitly), but what he actually did see, was. In a similar way, when you look at a traditional mimetic painting of, say, a Mississippi riverboat, what are you actually seeing? Not a riverboat, of course; that's all illusion. What you're actually seeing is paint on a canvas, colors, shapes, lines ... all of these and more (see below) aspects of the work's visual form. And what you're actually experiencing when you read a traditional narrative isn't the plot as it unfolds, it's literary form. Most music, as we've said, is *just* form. And so on.

Artists, we've suggested, having those direct "flow" experiences of the world which are perhaps not *so* different from those long ascribed to animals other than ourselves, don't just *have* those experiences, as coyotes or koalas presumably do; they *give them form*. That is, they *make* something in response. The *formal* question that you need to ask yourself about an artwork, then, is this: "So, okay, what has this artist made, and of what, and (especially) how?"

As we've just established, you do of course need to notice the subject matter of an artwork, and consider the historic contexts and conventions that inform it; but in fact the content of an artwork may often be less important than the form in which it's presented.

Think of any well-known story or image. We mentioned Melville's *Moby Dick* here a while ago, for instance. Even if you've never actually read it, you may know that it is *very* long, very involved … and that most literary experts and many of its readers see it as one of the most remarkable works in American letters. But here, basically, is the story it tells: A sea captain who has had his leg bitten off by a white whale gets really upset about it, so he looks for the whale for a long time, in his ship, and when he finds it he tries to kill it, but he gets killed instead.

Does it seem to you that my version of the story is likely to be seen as one of the most remarkable works in American letters? Probably not, don't you think? And yet the stories Melville and I tell are essentially the same. Only their *forms* are different.

Alternatively, think of, say, Leonardo's portrait of *Mona Lisa*; and then think of the picture a four-year-old might have made of her, had he been hanging around da Vinci's studio at the time, with some crayons. Would *these* likely seem pretty much the same? The subject matters of the two images would be the same, after all … but my guess is that their impacts – the *experiences* you'd have of the two images – would be quite different. I'm sure you get the point: the form of an artwork surely *is* important to notice, in taking stock of the work.

Learning to see a work in terms of its form, though, can be fairly complicated, involving a lot more than simply noticing that a painting is made of a certain kind of paint on a certain surface of a certain size, or that a book is words printed in a certain typeface on a certain number of sheets of a certain kind of paper. If you happen to be in an introductory course about one of the arts, as you read this, or if you've been in such courses in the past, you'll surely be (or have been) exposed to the elements of form of whatever art(s) the courses cover. If you're not in such a course, though, the *basic* elements of form, and discussions of how they work, are to be found in the sorts of books such courses assign – primers, basically, of visual arts, or of poetry, or music, or whatever. Should you find yourself, then, in need of instruction in aspects of form in a given artwork of a kind you know little about, such books are where you should look.

But to give at least an indication here of what you're likely to find in them, these, for instance, are what are generally thought of as the *elements of visual form* (not just of visual art, that is, but of *anything* visual): point,[6] line, shape and mass, space and volume, texture and pattern, time and motion, light and color. Any visual field necessarily incorporates some or all of these elements, coming together in certain ways to constitute whatever it is – or the illusion of whatever it is – that you see when you look at it.

For instance, as I write, it's a sunny day in January, and outside my window there are (mostly) leafless tree branches, in sunlight, against a blue sky. In terms of visual form, though, what I'm seeing outside the window are more-or-less jagged *lines* of various thicknesses. The intersections of these lines are *points*, as are the few dried-up leaves that still cling to them. The lines are grayish in *color*, or black where the *sunlight* casts shadows; and the *shapes* defined by the branches are blue ones, given the color of the sky. I can see bark-like *texture* in the larger branches, even from a distance, and indeed where the many smaller branches at the tops of the trees intersect with each other, they create a visual texture of their own.

Of course no artist made this "image." But visual artists do make what they make by combining some or all of these visual elements in whatever ways ... by "juggling" them, as it were, according to the description we suggested in the last chapter. Formally, graphic images and sculptures (and even buildings) are arrangements of all or some of these elements, in whatever media.

The reason it's important to note this is that – as you've just experienced, sort of, with the whale stories and the *Monas* – all elements of form have observable effects on whomever encounters them. Among the elements of visual form, for instance, vertical lines tend to confer a sense of poise, and horizontal ones, a sense of rest; softly rounded organic shapes "feel" very different to the viewer than do sharply angled geometric ones; and so on.

And so it is in any artwork. What is a poem made of, for instance? What does a poet "juggle"? Subject matter, sure, and words, of course ... but also some or all of these: purely formal elements such as rhyme and alliteration, rhythm and meter, lines and line breaks, stanza forms; and less-formal elements which attach to these formal ones, such as denotation and connotation (which are aspects of the words chosen), sentence structure, imagery, various types of figurative

language, rhetorical devices like irony or ambiguity, and so on.[7] All of these affect very strongly the "feel" of the poetic experience. Fiction writers juggle all of the latter, and word choice of course, plus such additional formal elements as plot, characterization, paragraph structure, and so on.

What does an actor "juggle" in creating a role? The character's lines, of course, and their content ... but also posture, gesture, physical mannerisms, body language; intonation, speech patterns, accent ...

What are the formal elements of a film? All of the visual elements we mentioned, of course, and at least in narrative films, many of the poetic and fictional ones, actors' performances ... as well as camerawork, score ... The lists go on.

Form in "new" sorts of art – "new" even to the modern meaning of the term with which we're concerned here – isn't easy to characterize, for it varies so widely ... though the principle of assessing forms stays the same. Performance art takes the form of, well, people, sometimes with props or costumes of various kinds (which have their own form), performing in various ways and situations. The form of installation art is often easier to "see" than that of traditional representational media, for an installation typically is what it is; there's no illusion to "look through." Formally, Doug Fishbone's banana piles are ... piles of bananas (which have shape, and texture, and color, and mass ...), and the actions of the people who dismantle them are ... just that. It may take some thought to determine the *content* of works like these – which is usually an idea, made manifest – but their form, though infinitely variable, is generally right there to see.

Obviously, the scope of this little book doesn't allow any more than the suggestion that you do need, ideally, to learn to look for and at all the formal elements of any work of art, of any kind, and to look for and at your personal reactions to any and all of them, and to take all of these into account in analyzing your experience of it. But indeed, you do, if the critical process is to be indulged as fully as it can be; and if indeed you've the energy and motivation to inquire further into matters of form, doing so can only deepen your experiences of art.

So if only for the sake of argument, let's assume that you've assessed content and form until, as far as you can tell, there's nothing left to notice. Now what?

Outside Sources (?)

Now is when you *may* choose to bring into play the ideas that others have suggested as relevant to the work. Perhaps you'll want to check, now (as I did when I read the playbill after experiencing the Schoenberg), to see whether those notes on the wall label or that passage in the textbook makes sense in terms of what you've found in the work, or indeed whether you've already come on your own to the observations they suggested. *Maybe* you even want to seek out other criticism now, in the name of adding to your collection of "things noticed," of "signs" found by you in and around this work you're analyzing. Other critics' ideas, if you decide to include them in your thinking about an artwork, become "signs" too, of course. The only difference between these "signs," these "things noticed," and the ones you came to on your own is that you need to cite these outside sources, if you decide to write a paper about it all.

If you do decide to use outside critical sources, you again only need to concern yourself – at least at first – with those whose relevance to your argument about a work seems clear. The fact that something's published doesn't automatically make it relevant, and if you're skimming some essay on the work in question and, after three pages, find yourself muttering, "*What* is this person *talking* about?," you may be well advised to simply give that essay up and move to another. (The exception here would be, of course, if it seemed that what the writer *might* be talking about *might* be relevant if you took the time to figure it out; then you'll have to go back and do that.) But by and large, the reaction you should be watching for in yourself as you read criticism is one of recognition, of "Oh! Of *course*! I would *never* have thought of that, but ... of course!" Then you know you've found something that you can use (and cite).

And then, finally, you have to figure out all of this adds up to – what it *means*, to you. Now you become the artist.

The Third Thing: Making Meaning

As we've already suggested, there are a lot of people who'll be more than willing to *tell* you what a given artwork means. Again, though, what those "experts" offer can only be what it means to *them*. And insofar as you may choose to accept our extremely selective

description of art as involving "flow," that's even true of inputs from the artists themselves. For remember that in our description, if someone decides ahead of time what a work must be to do or express whatever she wants, and then executes the work in that way, so that it does do or express what she wants in clear and conventional ways, that product is, by (our) definition, craft. The maker can explain *those* things, if need be, with some claim to authority. But art, as I've proposed we might understand it, grows rather out of experiences in which the artist is not intent on doing anything, but is instead "just doing." If that's taken to be the case, then the artist's after-the-fact pronouncements about the work produced are no more, or not appreciably more, privileged than anyone else's, are only statements of his or her critical opinions about whatever it was that those "art"/ "flow" moments produced. And that leaves the problem of figuring out what and how an artwork means to *you, up* to you.

Lists

Okay. Now, at least in theory, and ideally, you've already noticed what you've noticed. You've examined, attentively and thoughtfully, every aspect of the experience of that artwork that you can think of, from every vantage you can think of; you've had your friends put in their two cents' worth, noted the expert's opinions, assessed your own responses and reactions to any and all of these. (If you're not working as hard at this as you "ideally" might, the process is the same, just that much more casual.) Next, you need to look at all you've noticed, see what things noticed relate *in any way* to what other things, and how ... and begin to construct a meaning.

To that end, at this point we probably should get *really* pragmatic, and talk about lists. You don't need to keep lists, of course, if your involvement in this process is *completely* casual, if you never get beyond, say, noting that Picasso's famous anti-war painting *Guernica* is depressing, and then shrugging that "Well, it's gray, after all, and gray's a bummer, so ..." Any involvement much more focused than that, though, is likely to produce a *lot* of things noticed, and if your memory isn't photographic, the most obvious way to keep track of them is to list them. Should you (wisely) choose to do that, here are a couple of things to keep in mind.

First, for reasons that we'll get to a little farther along, you should ideally try to keep the entries on your lists fairly short, less than, say,

eight or ten words. Make notes like "Young boy wearing red coat," "Pools of water reflecting light," "Lots of horizontals," " 'Frankly, Scarlett, I don't give a damn,' " "Made during Franco-Prussian War," and so on.

And second, make three lists. Keep one list of things that you objectively notice *about* the work; another of your subjective reactions *to* it and/or your judgments on it; and keep the historical facts that you think might be relevant on a separate list, too.

That historical background list is likely to be fairly straightforward; all you need to do is assess relevance as well as you can as you read (or skim), and keep in mind the difference between points that are historical facts and ideas that are just conventions. The first two lists, though, can be a bit more difficult to sort out, for it's easy to put things that belong on one list, on the other (and sometimes vice versa).

To avoid confusion, you want to make sure that the things you notice *about* the work itself are things to which you can literally *point*, if challenged by some friend or colleague or teacher about your interpretation of the piece, later on. You could point, for instance, to that little boy in the red coat, or those pools, or that piece of dialogue.

What you *make* of those things, though, goes on the other list. If you find yourself noting that a painting or a piece of music you're considering is, say, "lush," or "sad," as clear as it may be to you that they are those things, you couldn't *point* to the "lushness" or "sadness," for "lush" and "sad" are in fact *characterizations of your reactions*, and not observations. They're bound to be reactions, though, to things that you did observe and *could* point to ... the rich colors of the painting, say, or the number of complex minor chord changes in the orchestration of the music, and it's those things that belong on your "things noticed *about*" list. "Lush" or "sad" go on your list of reactions/judgments.

Juggling

So, you've had your experience, and sorted it some, perhaps into lists. Now, what can you *make* of it?

Once you've developed those lists to what seems to you a reasonable degree, you need to begin examining them, to see what parts of which of them can be related – *in any way at all* – to any other parts

of any of your lists at all. This is how meaning is made. That imaginary beastie of ours found itself beholding the chaos, and it coped by noticing what it noticed about it, and relating whatever it could to whatever else it could, in ways that seemed to make sense. In time, those perceptions and conceptions were codified, into languages and linguistic systems, which have by now become the nature of our experience. Artists, though, as we've described them here, seem able to break away from that linguistic "ordering" of experience and have "flow" moments (or hours, or days) in which *they* behold the *pre-linguistic* "chaos" that's still there, just beneath that apparently ordered surface; and *they* relate things they notice in it in ways that make sense to them (sense that we've come to call "artistic"). Now you get to try it.

Obviously, though most of us have long been conditioned to think that it should be, the point here is *not* to discover what the artist was trying to "say"; we've noted several times that in the description we're offering here, the artist wasn't trying to "say" *anything*, in those definitive "flow experiences," they were "just doing." And even if you chose, back in Chapter 6, not to go that extra step, but instead to think of artists as "simply" struggling to express the linguistically inexpressible, the problem remains. For even if you can find artists' writings on their work, those aren't the work itself; instead, they're the products of the same struggle (or play) that produced the work itself, hence just as (notoriously) difficult to make sense of as was the work that drove you to them in the first place. And what of all those artists who did *not* write of their work, and who are now long dead? To claim that you know what *they* were saying in the art parts of their work seems not only to be sheer hubris, but also to avoid responsibility for what *you* think, by passing it off on *them*.

Nor is the point here to simply describe or paraphrase the work … for most of us, that went out with those ninth-grade book reports on *Ivanhoe*, or whatever. Rather, the point here is to assemble some of the things you've noted on those lists into a coherent explanation of how the work in question (or part of it) is significant – how it *means* – to *you*.

Just one more suggestion, before we try to offer an example of how this "meaning making" works. It's much easier to make it work if you have the luxury of getting some distance from the art you're analyzing, before you start. Ideally, try to let a few days or a week go by between your examination of the work and your examination of the lists it

generated. If you can't do this, if the work is too fresh in your mind when you begin looking at your accumulated lists, you risk seeing only the relationships between things on those lists that existed in the work itself ... and ultimately, then, of restating those relationships in somewhat different terms, perhaps, but basically just paraphrasing the experience you had (as in that ninth-grade book report). If you find in your lists, say, several notes referring to "dark hair," or "darkness" or "hair," your tendency will be to immediately flash on what you saw when you made those notes – the fact that the family central to the plot was dark-haired, or that that scene that you were watching when you noted "darkness" took place on a moonless night.

The more you can separate yourself from the work, though, the more likely it'll be that you'll begin to see your "signs" – dark hair, darkness, hair – for what they *are*, in and of themselves, rather than for what they are in the artwork. And this is the key to seeing and (re)ordering them in new critical and creative ways.

Sooner or (better still) later, then, you need to begin to look – attentively and thoughtfully – at your lists of the things you've noticed, and try to find anything that either stands out to you as surprising or unique in itself, or that seems to keep showing up, in one form or another, in a lot of your notes. And as you begin to find such things, "turn them over" in your mind, as it were, asking yourself whether, if you think about them in such-and-such a way, they could be related to any of the other things that stand out in your list.

Let's say that as you read over your lists you notice one particular sign that for some reason stands out, for you, from the rest. Let's say that your list of "things noticed" about the work has one entry that reads "yellow bird," and that your attention seems to constantly be drawn to that.

So, you begin to juggle other things noticed, selecting a few that seem as though they might be relevant and throwing them up, as it were, to see whether they can be made to come together in any useful ways. You play around with them, hoping to assemble possible explanations for why that yellow bird seems so significant to you – ideally, as we've said, reasons *other than* whatever place the yellow bird may hold in the work you're considering. "Let's see, 'yellow bird' ...," you say to yourself, " 'yellow bird' ... Is it the only bird I saw in the work?" (You scan your lists.) "Seems to be ... but hey! There are six or eight other *animals* here, or at least animal *references* ... that black furry shape I noted, there in the back of

Scene Three, that could be a bear, maybe? And there's a lot of talk about animal *sounds* ... stomachs 'growling,' brakes 'screeching,' engines 'purring' ... Hey, the animals that make the sweetest sounds are birds, right? ... So, what? I don't know yet. But at least that animal stuff is *there* ... now what about yellow, I wonder? Any yellow to speak of, other than the bird? Let's see ... nothing on these lists, but now that I think of it, wasn't the *light* kind of yellowish, in a lot of places? ... Yeah, WAIT a minute, when it wasn't that yellowish light, it tended to be kind of bluish! ... Yellow and blue together make green, right? And green's the color of nature! Where animals live? ... But still, what is it about that bird? ... Flight, maybe? ... Is there anything here about flight, or the opposite of flight, whatever that'd be? ... Let's see ... no ... well, then, maybe I should check into iconography[8] ... I'll have to go back to the library ...," and so on.

Ideally, if you can keep this juggling going, you'll come in time to ideas of bigger themes than some of the things you've listed can be seen to constitute by themselves (we'll offer an idea for keeping track of this, in a minute). Then, with any luck, you'll maybe be able to repeat the process, and – juggling now with weightier elements – relate those themes to one another (as, animals, and blue/yellow/ green, with nature).

If you can get that far in this process, one of two things will have happened. At the very least, if the artwork you were considering was obviously "about" nature – say, it was titled "Ode to Nature," even though the only "natural" thing you saw at first glance was that yellow bird (Hey! Maybe that's why you kept coming back to it!) – then you'll be able to title that critical paper something like "The Construction of Nature in So-and-so's 'Ode.'" The paper will amount to a description of your juggling and its results, which establish how one theme that you found in the work was manifested, was developed (consciously or not) by the artist. And the things used from your lists, the "point to" observations, the relevant outside ideas you've cited, and so on, are right there to be marshaled as evidence for your arguments.

Or – much more rarely – you may reach a real epiphany about the entire work, realize that it *could* be seen *not* in the way it's been conventionally seen, but as something else entirely ... as far as you're concerned, what's long been dismissed as just another romantic comedy is indeed a propaganda piece; that short story is actually a parable; that historical painting can be seen as biographical. Your

title, then, could be something on the order of "So-and-so's 'Ode' As (Something Else Entirely)."

Two things may have occurred to you by now. One of them is that, while all of this may be well and good for works like, say, Tiepolo's painting in Figure 5 (which contains a *red* bird), how many things will there be to notice about minimal artworks like Klein's (Figure 9), or a silent symphony by Cage? The answer here is that, almost without exception, older, more visually or narratively or dramatically or musically complex artworks, those made before Modernist questions about the nature of the whole pursuit began to arise, will offer more tangible things – red birds, Cupids, and so forth – to notice ... and the conventional/theoretical bases on which they were made will be relatively straightforward. As works become more and more "simple" under Modernism, though, that ratio tends to reverse – while there may not be much to notice that's tangible – like, just "blue" – the theories and ideas on which the work is based will need a lot of untangling and explication. So one way or the other, there'll be plenty to inform this process.

The other thing that may have occurred to you is that if artworks are indeed as complex as we claim, there'll be an awful lot of things to keep track of and relate, if this process succeeds. True enough; it can get pretty crazy. If your artwork is a relatively simple one, and/ or if your mind tends to be more organized than most, you may well be able to do all this in your head. If you have any doubts about your ability to keep track of all the ideas and relationships that you're coming up with, though, keep two things in mind.

One is that almost no one ever writes papers or delivers speeches titled "Everything There Is To Know About (Anything)." Almost all critical responses to artworks involve developing one theme, or relating two or three, of the many that tend to be available in a work – "Water Imagery in *The Graduate*," for instance, or "The Use of Color and Emotional Crises in *Roadrunner* Cartoons." While there may be an awful lot to juggle overall, then, in the end you'll likely be able to choose just *some* things to work with, and do your really refined juggling with them.

(Just a suggestion ...)

The other thing that you *may* want to keep in mind is *purely* pragmatic, and just a suggestion, albeit one that works well for a lot of

people. To the extent that you're trying to engage this critical process as completely as it can ideally be engaged, there's a way of seeing and sorting relationships – and ultimately, making meaning – that lets you literally watch yourself think. It involves "sticky notes" (and/or index cards and pushpins).

Try this: Get yourself three or four packs of sticky notes, more or less the size of standard index cards, each pack a different color. Find a wall or bulletin board that you can stick them on. Assemble your lists.

As you peruse your lists and notice signs on them that strike you *in any way*, write them down on sticky notes (this is why you kept your entries brief) – "things noticed about" on one color, "reactions to" on another, context/convention on another; and the critical ideas of others, if you're using them, on the fourth. And once you've written a note, stick it on the wall. (You can even select signs to write down on the notes totally at random, if nothing seems to "grab" you in any notable way.)

Either way, when you've got, say, twenty or thirty notes on the wall, stop for awhile, and look at what's there. If two or three or four of your notes seem to be in some way "of a kind" – they all mention a color, or they're all about interrupted communications, or whatever – move them so that they're together on the wall. Keep doing that until you can't anymore, because the notes that are left neither fit in any of the groupings you've made, nor have much to do with one another. Move these to the side, or take them down (they may well come in handy later; but on the other hand you're under no obligation to consider everything, just because it's there).

Now go back to your lists, and see if there's anything there that you didn't seize upon in the first inspection, that now seem likely to augment one of those groups. Write these down, and add them. If you notice any new groups while you're looking, write them on notes and add that group to the wall. If you find things that seem to sort of go with this group, and/or sort of with that one, write them down and put them up as sort of "connectors," between the two. And so on.

When you've done this for awhile, stop again, and look at what you've got on the wall *now*. What you've got, of course, are groups of (somehow) related signs, and probably some signs that seem to connect some groups. If you want, you might now label the groups somehow – this one's "Colors," that one's "Broken Communication,"

whatever – to help you see what you're assembling overall. Write notes to yourself about connections that occur to you, and stick them in the appropriate spots, if you want.

And then you juggle. This can be fun, or frustrating, or both. Ask yourself, "Is there any other way these could be grouped, that'd be better? What if I moved this note to that group? Or that other one to the group on the left? Should those two groups be combined, maybe?" Try these things out as you go. The fun, if you find it so, is in the "fooling around," *playing* with your groupings this way, seeing what you can make. The frustration, though, can arise when you *sense* a relationship between this group and that – "I just *know* there's a connection there" – but you can't put your finger on what it is; then you need to *struggle*, to figure that out. ("Playing" ... "struggling" ... remember what we said about the beholder of art becoming the artist?)

What you're effectively doing here, of course, is developing potential themes about which to write, and simultaneously amassing evidence for them. If all goes well, in time you'll be able to select a theme or two or three – the biggest groupings, or ones that are related in ways that seem the most unexpected, or whatever – and write down (or speak about) what you've seen in this work, and what *you've made of it* ... and out of what, and why.

For whether you've chosen to indulge this sticky-note methodology and watch your own thinking take shape, or done it all in your head, that *is* what you've done – you've *made* something, in the sense of the oft-heard exclamation in the presence of something unexpected, "Whoa! What do you make of that?" And what you've made of it, is meaning.

All of this is only possible if you credit "flow" as part of this "art" idea (thus taking the "artist's intent" out of play), and stand up, as it were, and take responsibility for what *you* think about an artwork. And if you do, then every time you encounter another artwork and pay this kind of attention, you'll have learned something – about how the artist's ideas came together, consciously or otherwise (for you can't know); about yourself, and how you think about things; and so about your world – in ways that simply don't seem to be available anywhere else.

But more on that in (finally) Chapter 8.

Notes

1 Interestingly, English subtitles – translations from the original German – were projected over the orchestra as the opera proceeded. And one of them, early in the second act, read, "Do not expect form before idea, they come as one." Remember all our talk in Chapter 6 about artists struggling to give form to things they can't express conventionally?

2 When I *did* read the playbill, *after* the Schoenberg opera, I found that *Moses und Aron* had been, at least in part, an attempt by Schoenberg to express his "struggle to reconcile his German and Jewish identities in the face of the growing chaos" during Adolf Hitler's rise to power. This, of course, served to validate the remarkable experience I'd had of the work.

3 One has to be careful, too, if relying on titles for clues to intended subject matter, about apparent titles for *all* sorts of artworks which are in fact nicknames that were added later – Diego Velazquez's famous painting *Las Meninas* (1656) was never called that by Velazquez himself (he called it *The Royal Family*); many jazz compositions are named after they're written, based on how they sound when finished, rather than written "about" what the titles suggest; and so on.

4 There are the extremely rare buildings, most of them American, constructed to resemble hamburgers, say, or ice cream cones, in the 1940s and 50s; those few that survive today generally do so by virtue of funds aimed at preserving historical oddities.

5 Architectural competitions in the French *Acadèmies* featured fantastically ornate and detailed architectural drawings of buildings that were never meant to be built and never were; these were "autonomous." But any architecture that's actually built can't be.

6 A "point," in this sense, is any small discrete mark in a visual field, and/or the intersection of two lines.

7 Altenbernd, Lynn, and Leslie L. Lewis. *Introduction to Literature: Poems.* New York, Macmillan, 1975. (pp. 4–27).

8 Iconography is the study of what visual images held what conventional meanings in a given time or place.

Chapter 8

Or, Maybe …

So, again … what about this whole idea of "art"? Since the last time we asked that, we've offered an approach to thinking about it that works well in the world, however "true" or not it may indeed be. Now it's up to you to decide, of course, how much of that approach makes sense to you. Before you do decide that, though, we owe ourselves a look at the "other" side of the question, the one that holds that "art" and its history are "over." Then I want to suggest one other way of thinking about "art" that combines a little bit of both positions, and perhaps works even better than either … and then we'll be done.

The End(s)? Or Not?

So … what about this idea of "*not*-art-(anymore)," the one that some theorists have lately held, that "art" and its history are *over*?

Let's be clear. As we noted in the Introduction, some or all of the behaviors that we've been *calling* art have been present in all known human cultures, and presumably they won't now suddenly cease to be, just because of yet another wave of philosophical speculation. That's not the issue. Rather, the issue is whether or not it makes any sense *to* call them that, anymore.

And again, we're certainly *not* taking the reactionary position that "If you ask me, nobody's made any *real* art since the Renaissance!! (or whenever)," the sort of thing one will often hear in response to works like those blue paintings by Yves Klein or the pile of bananas

that appears on the cover of this book. Reactions like that almost certainly grow out of reluctance to countenance change and/or possibilities, a tendency which may in fact be exaggerated in domains as supposedly sacrosanct as "art." But as we've suggested here, if one *is* willing to accept change and explore possibilities in the world of so-called "art," and to think about "difficult" works as we've suggested here one should, then as we've seen, our "art attention" reveals Klein's canvases, for instance, as – at the least – incisive moves in the pursuit of formal "essence" that art had become under High Modernism (and International Klein Blue really *is* a *nice* blue, as well). As to Fishbone's banana piles, while they're surely not Renaissance altarpieces like the one I mentioned in the Preface, they just as surely have an effect on the viewer not much different from the one that altarpiece had on me. An enormous pile of bananas would certainly make *me* gasp, were I to come around a corner and behold one; they're sensually striking, have texture, shape, color, and so on; and while they're not "about" the religion that characterized the culture that gave rise to the altarpiece, they certainly *are* "about" concerns that are current in the culture that gives rise to *them*, including among others hunger, philanthropy, and not least among these, the question of art's connection to the public, all as manifested by Fishbone's distribution of his "materials" to passersby. With enough information and thought, one can reach understandings like these for pretty much any work of art, however "outrageous" it may initially seem; so much, I submit, for reactionary refusals to see such things *as* "art."

But still, and again: "art" and its history as *over*?

The idea that art *history* is "over" is in fact a fairly easy one to understand, at least logically. In Chapter 1, you'll remember, we suggested that we humans are (arguably) defined by the fact that we relate to our conscious experience through *ideas* that we have about it, and that we use signs to refer to those ideas. In Chapter 5, we suggested that the world we know is in fact made up just of those ideas, which we embody in languages, and that hence, language *is* our world as we (intellectually) know it. And so histories – any histories – are ultimately *about* ideas, about their development, struggles over their meaning and implications, and at least potentially, their "ends," their loss of relevance.

We've sketched here the history of the idea we refer to as "art" – its development, the historicization of its artifacts (and so the distortion

of other ideas), the Modernist inquiries into its nature. And at the end of those inquiries, we saw that history come back to where it had started, to the (re)realization, the idea, that "art" was ... just ... an idea. The history of "art," then, had come back to its own beginning, closed its circle ... and thus *does* seem, logically at least, to have ended.

The question of whether "art" itself is "over" necessarily follows from that. If the *history* of an idea is over, can the idea continue anyway? Does it make sense, any longer? Does it make sense to call Fishbone's work "art," given that it was done after what we've described as the end of art history? It turns out that it's just as easy to say that it can't and doesn't as it was to say that it can and does.

Summon up just a little bit of healthy skepticism now, and consider. We said at the beginning of Chapter 5 that we use our linguistic "signs" to refer to areas of our experience that are distinguishable from other things ("dogs" as distinguishable from "logs," and so forth). If "art" is to be a useful term, then, it must refer to something that's distinguishable from everything else. As we've seen here, though, all the traditional ways of thus distinguishing art from other things don't really work anymore, or at least, don't work well enough to be really dependable. The extension of art history backwards in time from the eighteenth century made artists' intentions irrelevant to the discussion; and it rendered autonomy an uncertain criterion at best, available in most cases only via the "part-art" idea that we suggested in Chapter 6 ... and that idea is (admittedly) fragile, as it reduces ultimately to individual judgments – yours, or hers, or his, with no objectively "true" determination available – about which parts of a thing are the "art" parts. And the Modernist search for essences systematically eliminated all the *rest* of the traditionally supposed criteria, so that by the mid-1970s, "art" was (re)revealed – to say it one more time – as just an idea, not inherently distinguishable from any other. Since then, as we've also said, it's come to be the case that literally *anything* can *be* art ... so obviously no *formal* distinctions are available either.

Thus by the end of Chapter 6 we'd come down to the idea that perhaps the differentiating factor in art was the sort of *attention* it demanded and justified. But – did you notice? – when we tried to spell out in Chapter 7 how one might pay that "art attention," what we were describing was in fact the sort of attention you'd pay to *anything at all* with which you wanted or needed to come to terms.

If you came across any thing or event at all that was unlike anything you'd experienced before, and so demanded your attention, and you had no immediate idea of how to meaningfully respond to it but thought you'd better, wouldn't you just ... pay careful, open attention to it, noting what you noticed about it, wondering where it had come from, and when, and why? So the "art/non-art" distinction isn't available either in terms of the attention art demands of its audience (more on this below).

That leaves us with the attention that the "artists" themselves pay to what they're doing. Do artists – whether struggling to express the unsayable, or playing with conventions and seeing what happens, or responding to "flow" – attend differently to those endeavors than other sorts of people do to theirs? It doesn't seem so.

We've already noted that paying attention to our experience and making of it what we will is what *all* humans do, by definition ... though we have suggested that art involves pointedly pre-linguistic, as opposed to conventionally linguistic, responses to that experience. If you bring your healthy skepticism to bear here, though, you'll realize that all sorts of people other than "artists" – shoemakers, plumbers, scientists, cooks, spies, programmers, all sorts of others – *can* (and often do) bring the selfsame kind of attention to what they do that we've traditionally ascribed to "artists," supposedly in defense of calling them that. We've noted here that "flow" – the most extreme characterization we've offered of the source of "art" – is actually more familiar to most of us with regard to sports, than to "art" ... and indeed it can and does occur in all sorts of other endeavors, too, as Csikszentmihalyi has noted.[1] Artists themselves certainly know this. Al Young, Poet Laureate of California, to cite just one of many such instances, wrote recently that "When a mathematician creates a wildly beautiful equation, what shines and pulsates at the other side of that equal sign, that bottom-line sum-up is poetry."[2]

As we said in Chapter 6, the history of "art" as we've sketched it here suggests how it's come to be that "art" and "artists" are so widely considered as a class apart. It's the way we've described the world for a very long time, and so it's come to seem to be the way the world *is*. "Of course there's 'art,'" we can say with aplomb, "there's some right over there." And of course that's right; those things over there have long been referred to as "art," and so, the category "art" being a constitutive one, they *are* "art." But referring to things made *lately* as "art" seems arbitrary at best, for given the

seeming impossibility of distinguishing art from anything else, the designation does seem lately to be effectively empty, and the question of "art" or "not-art" a non-question.

Still, the vast majority of the people who concern themselves with "art" at all – quite possibly including you – don't see it that way ... and that may be perfectly fine. For how many people *do* concern themselves with "art" lately, anyway? Not many, really, for "art" today has come to be widely seen not only as a class apart, but indeed as an elitist pursuit, essentially irrelevant to the day-to-day concerns of most of us.

If you think about that, though, it seems odd, given the view we've taken here. There seems to be some sort of odd reversal going on.

A Gathering Irony (?)

If only for the sake of argument, let's abandon our skepticism at least for the moment and assume that "art" *is* a valid idea; and let's describe it as we've suggested here that we might, as resulting, that is, from periods of "flow." If those things are taken to be the case, then as we suggested in Chapter 6, the meaning(s) of artworks can be seen as completely open. And in that, art can be seen as a – maybe *the* – paradigmatic human activity, just like that indulged in by our imaginary proto-human beastie, for whom all meaning *was* open, until the beastie made it up in the best way it could manage. What artists do at base, that is, is what humans do at base.

If artists, then, are paradigmatic – that is, "typical" – examples of humans, then *non*-artists must, just logically, be *less* typical as humans. But obviously, our culture assumes just the inverse relationship: to most of us, it's the *artists* who are atypical, sometimes even notoriously so. This situation seems ironic at least; and I think that, again, it's maybe a cause for some concern.

We've posited art as "paradigmatic" – "typical" (even "defining") – human behavior, in that it happens on the uniquely human (pending that input from the whales) "supposing" side of the human paradox that we conjured up midway through Chapter 6; it resists that paradox's other, conventional, linguistic "supposed to be" side. Most "non-art" responses to experience from "non-artists," though, *are* conventional, for they *are* linguistic, in one way or another. "Non-art" tends, that is, to situate itself on the "supposed to be"

side of the paradox. To the degree that this is true, artists, whom we've theorized as "typical" humans, *are* the exception. How did this happen?

I wonder if it's not a function of – here's another irony – the very linguistic practice on which we've based our inquiry here. I suspect that it's happened as a function of Western culture's shift over time to literacy, and of what's happened since that shift.

Remember that to some historians, the "Modern Age" began at just the time that the growth of a middle class had (with many other factors) ushered in the Renaissance. We noted one implication of this in Chapter 4, namely that "Modernity" is often seen as a function of the awareness, inherent in that middle class, of its role as the bearer(s) of the new, of breaking with (Medieval) tradition and forging a new, "modern" world. We might point out here too that one "new" thing that characterized that middle class was that it was, to one degree or another and increasingly, literate, something that the vast majority of its forebears had not been, for centuries.

As Walter Ong makes clear in his seminal *Orality and Literacy*,[3] in predominantly *oral* cultures, those in which cultural information is transmitted orally in stories and poems and songs passed down from one generation to another, the human self-consciousness with which we began this book tends to be suppressed to some degree, as one's attentions tend to focus outwards, on remembering and interpreting defining cultural lessons which are "out there," and relatively fleeting in their form. At least statistically, the feudal system that held sway throughout the Middle Ages was surely such a culture; while some few priests and monks *could* read and write, the vast majority could not – they looked (at those images in the cathedrals) and listened, and tried to remember what they'd seen and heard.

But as cultures become *literate*, Ong says, and begin to *write down* their thoughts and fables and value systems, members of those cultures are freed from the need to remember – they can always look it up, after all – and so their attentions tend to turn inward; their consciousness of their idiosyncratic *selves* can occupy more of their thinking.

This would seem to go some distance toward explaining the increasing assertion of idiosyncratic personality that began in the Renaissance, as literacy was growing, and has continued since – or *nearly* since – in Western culture. It would seem, too, to have much to do with the fact that as soon as the literate middle class was

established once and for all as a primary component of Western culture in the eighteenth century, its attentions to the category it knew as "art" – the products of what we've claimed here as a defining human activity – turned inward, becoming ideas, first, as the peeling of that Modernist artichoke began. We've already seen, though, how the increasingly arcane ideas that attended that "peeling," and the products made to demonstrate them, left the public ken ever further behind.

But ... why? If literacy allows us more inner-directed thinking, and if art is understood as a definitively human pursuit, then why should inner-directed thinking about "art" be of less and less interest to the literate, certainly human, public as a whole?

We've hinted once or twice at the vaguely sinister implication of that defining human paradox we've posited here: that languages, embodying what we know of our world and prescribing how we must describe it, conventionally, if we wish to make sense, tend to function as conservative forces with regard to the ways in which we see that world. "Supposing," that is, tends to go on less and less, the more overtly linguistic a culture becomes.[4] Artists, as we've also noted, can be seen as "professional supposers," people who seem able to maximize their innate human ability to suppose, and minimize their concurrent tendency to codify in conventional ways. If we do see them in this way, then they're no different from the rest of us, except possibly in terms of that somewhat shifted emphasis. Is that shifted emphasis enough to make us see them as an elitist minority whose interests have little or nothing to do with our own? To me, it doesn't seem so. Everyone has emphases that are "shifted" to one degree or another relative to one's own, but that hardly makes them irrelevant.

I suspect that we might wonder instead if our culture's tendency to see artists that way isn't a function of the increasing dominance of linguistic systems in that culture. It's as if the linguistic organizing of ideas we've already had about the world, and the writing down of those ideas for reference as needed, has come to overshadow the ability of most of us to "suppose" new ideas, especially here and now, in the so-called "Information Age."

So much of the world has been described by now, and so many of those descriptions made the more permanent for being "written down" in whatever form, so much of our described experience has thus come to seem to be the way it "is," that most of us are forced

today to spend unprecedented amounts of time learning how things are "supposed to be" and/or "supposed to be done," and then doing them that way, so that our lives will proceed satisfactorily. For most of us, most of the time, there seems to be neither reason nor psychic energy to do things as we might suppose they *could* be done differently (or even to remember *that* they could).

Bodies of knowledge large and small, authoritative or otherwise, proliferate, are written on pages or screens,[5] and compete for our attention. They tend to be accessible only via instructions (often translated from other languages) about how to access their information and deal with it the way one is "supposed to" do so. Electronic commands need to be performed as they're "supposed to be" performed, *so that* programs will work in computers and cash will be delivered by automated teller machines (ATMs); jobs need to be performed as they're supposed to be performed, *so that* we can eat. Forms have to be filled out as they're "supposed to be" filled out, *so that* all manner of things will happen as we wish. Advertisers assault us at every turn with things we're "supposed to" want, *so that* they'll earn the money they're "supposed to" earn for convincing us of that. We are numbed by all the information through which we have to sort every day, and so our experience of our experience, of "art" or of anything else, becomes increasingly numbed as well ... becomes, that is, increasingly *anaesthetic*.

Culture is more rife with such linguistic behaviors – doing things as they're "supposed to be" done, *so that* – than it's ever been in the past, by far ... and it's easy, again, for that to seem as though it's just the way life "is." Might that be why the sorts of attention that artists pay to themselves and their work are seen as an increasingly irrelevant, increasingly elitist, side issue, at best?

Maybe. It's interesting, at least, that artists – again, those able to "suppose" more successfully and more often than the rest of us (might this be why they spoke so clearly of the Modernist Project, when it began?) – tend to suppose that they're *not* all that different from others of us, accepting as a given that the *potential* to do what they do is shared virtually across the board by humans. They assume, that is, that the ability to pay close attention to our idiosyncratic reactions to experience, and to make things special in response, to craft our programs and equations and foreign policies, our sentences, our casseroles, our celebrations, our paintings and poems as creatively and carefully and beautifully as our skills allow, is universal. So,

even, is the potential for "flow," though precious few of us ever realize it … which brings us back to what seems to me alarming about how "art" is seen by many of us today.

If "art" refers, at least in part, to heightened ability to "suppose" worlds in ways other than those that our culture is "supposed to" understand, then to the extent that we dismiss "art" as an irrelevant and elitist pursuit, we dismiss too the possibility of supposing *our selves as* artists, of whatever kind and – this is important – *to whatever degree.* How many times have students said to me, "Me? An *artist?* Oh no, *I'm* not an artist, I'm a … (whatever)"? In slipping into such a mindset, we dull and delimit our inherent ability *to* "suppose," in a world that, safe to say, needs all the (re)imagining, all the "supposing," it can get, in all sorts of ways.

So, What? (A Middle Ground?)

Here, then, is perhaps the biggest irony of all: it seems to me finally that a possible, probably partial, solution to the rather alarming world-view yielded by our inquiry into the meaning of "art" can best be attained by abandoning the idea on which that inquiry centered. I think that in the name of making sense of our world as it's come to be today, we might do well to abandon the term "art" after all – and so the idea behind it – except as historical references.

Make no mistake, here: it's still very much worth attending carefully to the things we *have* called "art." Many of those things are among the most wondrous, complex, incisive, human documents ever produced; they're the source of the "something like awe" that I mentioned in the very first sentence of this book, and you'd be, frankly, foolish *not* to pay attention to them, even to seek out chances to do so. But the designation "art" as it's widely understood *now*, serves most of the time only to *separate* most of us from those great examples … and from the possibility of our *making others*, of whatever kind – not paintings or poems or symphonies, perhaps, but whatever sorts of things our own sets of skills may provide – extraordinary relationships, ethical positions, beautiful equations, new vaccines, public policies, whatever.

I suspect finally that we should revert to calling the things that we've *been* calling "art" by the names we called them before that designation in its modern sense was added to them. It seems to

me that if we just thought and spoke and wrote of how well or poorly painters paint, sculptors sculpt, dancers dance, professors profess, gardeners garden, plumbers plumb, and so on, then – freed of our habitual relegation of things done beautifully in their own right to "artists" – we could more readily acknowledge and accommodate the *aesthetic*, rather that the anaesthetic, in *all* parts of our lives. Though the Leonardos among us will surely be few and far between, still the rest of us would be freed by this "new" description of the world to pay more thoughtful and caring and careful attention to how we, each of us, see our lives – our worlds – and to make what we make and express what we see as skillfully and imaginatively and beautifully as *we* can, in whatever form ... just the sorts of behaviors, that is, that we *used* to reserve for "artists."

That the change I'm proposing here is "just" a linguistic one, and that those I suggest might follow from it are likely to be too, doesn't matter. For language, remember, is our world, and so such new descriptions are what change *is*, in human society.

To say it one last time: we needn't look far to see that there are things in our world today that could surely use some (re)thinking, and (re)describing. And I suspect that, if we didn't have "artists" making "art" to trust with doing that for us while the rest of us got on with our conventional, anaesthetic day-to-day lives, we all just might then tend to do more of it ourselves.

Doesn't *that* make sense?

Okay. I'll leave you with this, from William Carlos Williams:

> It is difficult
> to get the news from poems
> yet men die miserably every day
> for lack
> of what is found there.[6]

Notes

1 Csikszentmihalyi, *op. cit.*
2 Mosby, Rebekah Presson (producer). *Poetry On Record 1888–2006.* Los Angeles, Shout! Factory LLC, 2006. (p. 11).
3 Ong, *op cit.*
4 A case in point: in 2002, Stephen Wolfram, a young scientist widely acknowledged as "one of the brightest minds of his generation,"

published a 1200-page book, *A New Kind of Science*, which proposed just that – an entirely new way of describing the universe. Though certainly controversial, it could be dismissed out-of-hand by virtually no one. Still, Keith Devlin, executive director of the Center for Study of Language and Information at Stanford University and a friend of Wolfram, said this about the book: "Even if Wolfram is correct, and the adoption of his new kind of science could, in fact, lead to an important new understanding of the universe and life in it, I suspect that will not happen. This is not a question of scientific right or wrong. It simply acknowledges the sociology of how science is done." (Noted in Cook, Gareth. "A challenging view of the universe." Boston *Globe*, June 19, 2002. (p. A1).)

5 Lest this seem a melodramatic claim, a news broadcast announced that a much-touted computer operating system that had just been released had required *50 million lines* of code, to produce.

6 From Williams, William Carlos. "Asphodel, That Greeny Flower," Book 1, in *Journey To Love*. New York, Random House, 1955.

Bibliography

Agamben, Giorgio. *The Man Without Content*. Stanford, Stanford University Press, 1999.

Altenbernd, Lynn, and Leslie L. Lewis. *Poems* (3e). New York, Macmillan, 1975.

Anderson, Richard L. *Calliope's Sisters*. Englewood Cliffs, NJ, Prentice-Hall, 1990.

Arnason, H. H., and Marla F. Prather. *History of Modern Art*. New York, Prentice-Hall and Abrams, 1998.

Barash, David P. *The Hare and the Tortoise*. New York, Viking, 1986.

Barthes, Roland. *Elements of Semiology*. New York, Hill & Wang, 1968.

——. *S/Z*. New York, Hill & Wang, 1974.

——. *Image, Music, Text*. New York, Hill & Wang, 1977.

Baxandall, Michael. *Painting and Experience in Fifteenth-Century Italy*. Oxford, Oxford University Press, 1972.

——. *Patterns of Intention*. New Haven, Yale University Press, 1985.

Berger, Karol. *A Theory of Art*. Oxford, Oxford University Press, 2000.

Blunt, Anthony. *Artistic Theory in Italy 1450–1660*. Oxford, Oxford University Press, 1962.

Bonds, Mark Evan. *A History of Music in Western Culture*. Upper Saddle River, NJ, Pearson/Prentice Hall, 2006.

Booth, Eric. *The Everyday Work of Art*. Naperville, IL, Sourcebooks, 1999.

Burgin, Victor. *The End of Art Theory*. Atlantic Highlands, NJ, Humanities Press International, 1988.

Carey, John. *What Good Are The Arts?* Oxford, Oxford University Press, 2006.

Carruth, Hayden (ed.). *The Voice That Is Great Within Us*. New York, Bantam, 1970.

Cook, Gareth. "A challenging view of the universe." Boston *Globe*, June 19, 2002. p. A1.

Crow, Thomas E. *Painters and Public Life in Eighteenth-Century Paris.* New Haven, CT, Yale University Press, 1985.

Csikszentmihalyi, Mihali. *Flow: The Psychology of Optimal Experience.* New York, Harper and Row, 1980.

———. *Creativity: Flow and the Psychology of Discovery and Invention.* New York, Harper Perennial, 1996.

de la Croix, Horst, and Richard G. Tansey. Gardner's *Art Through The Ages* (8e). New York, Harcourt Brace Jovanovich, 1986.

Dissanayake, Ellen. *What Is Art For?* Seattle, University of Washington Press, 1988.

———. *Homo Aestheticus.* New York, The Free Press, 1992.

Danto, Arthur C. "The End of Art," in *The Philosophical Disenfranchisement of Art.* New York, Columbia University Press, 1986.

———. *After The End Of Art.* Princeton, NJ, Trustees of the National Gallery/Princeton University Press, 1997.

Dewey, John. *Art As Experience.* New York, Perigee, 1980.

Eco, Umberto, with Richard Rorty, Jonathan Culler, and Christine Brooke-Rose (Stefan Collini, ed.). *Interpretation and Overinterpretation.* Cambridge, Cambridge University Press, 1992.

Edwards, Steve (ed.). *Art and Its Histories.* New Haven, CT, Yale University Press, 1999.

Elkins, James. *The Object Stares Back.* New York, Harvest, 1996.

Gablik, Suzi. *Has Modernism Failed?* New York, Thames and Hudson, 1984.

Getlein, Mark. (Gilbert's) *Living With Art* (7e). New York, McGraw-Hill, 2005.

Goldwater, Robert, and Marco Treves (eds.). *Artists on Art.* New York, Pantheon, 1945.

Gombrich, E. H. *The Story of Art.* Englewood Cliffs, NJ, Prentice-Hall, 1995.

Griffin, Donald R. *Animal Thinking.* Cambridge, Harvard University Press, 1984.

Guthrie, R. Dale. *The Nature of Paleolithic Art.* Chicago, University of Chicago, 2006.

Harris, Roy. *The Necessity of Artspeak.* New York, Continuum, 2003.

Herbert, Robert L (ed.). *Modern Artists on Art.* New York, Spectrum, 1964.

Janson, H. W. *History of Art* (4e). New York, Abrams, 1991.

Krauss, Rosalind E. *The Originality of the Avant-Garde and Other Modernist Myths.* Cambridge, MA, MIT Press, 1986.

Kristeller, Paul Oskar. "The Modern System of the Arts," in *Renaissance Thought and the Arts.* Princeton, NJ, Princeton University Press, 1980.

Langer, Suzanne K. *Philosophy in a New Key.* Cambridge, Harvard University Press, 1957.

Leach, Edmund R. "Michelangelo's Genesis: Structuralist comments on the paintings on the Sistine Chapel ceiling." *Times Literary Supplement*, March 18, 1977, pp. 10–12.

Linden, Eugene. *Silent Partners*. New York, Times Books, 1986.

Lorenz, Konrad. *Behind The Mirror*. New York, Harcourt Brace Jovanovich, 1973.

Lutz, Tom. *Doing Nothing*. New York, Farrar, Strauss and Giroux, 2006.

Martindale, Andrew. *The Rise of the Artist in the Middle Ages and Early Renaissance*. London, Thames and Hudson, 1972.

Matejka, Ladislav, and Irwin R. Titunik (eds.). *Semiotics of Art*. Cambridge, MA, MIT Press, 1976.

McQuaid, Kate. "Thinking inside the Box." *Boston Globe* "Calendar," October 19, 2006, p. 4.

Minor, Vernon Hyde. *Art History's History*. Englewood Cliffs, NJ, Prentice-Hall, 1994.

Mosby, Rebekah Presson (producer). *Poetry On Record 1888–2006*. Los Angeles, Shout! Factory LLC, 2006.

Ogburn, William F., and Dorothy Thomas. "Are Inventions Inevitable? A Note on Social Evolution." *Political Science Quarterly*, March 1922 (37: 83–98).

Ong, Walter J. *Orality and Literacy*. New York, Routledge, 1982.

Page, George. *Inside the Animal Mind*. New York, Doubleday, 1999.

Parker, Robert B. *A Catskill Eagle*. New York, Penguin, 1987.

Peckham, Morse. *Man's Rage for Chaos*. New York, Schocken, 1976.

Poggioli, Renato. *The Theory of the Avant-Garde*. New York, Icon, 1971.

Pollitt, J. J. *Art and Experience in Classical Greece*. Cambridge, Cambridge University Press, 1972.

Preble, Duane, Sarah Preble, and Patrick Frank. *Artforms* (6e). New York, Longman, 1999.

Reese, W. L. *Dictionary of Philosophy and Religion: Eastern and Western Thought*. Atlantic Highlands, NJ, Humanities Press, 1980.

Riedelsheimer, Thomas. *Andy Goldsworthy, Rivers and Tides: Working With Time*. Mediopolis Films, 2004.

Rorty, Richard. *Contingency, Irony, and Solidarity*. Cambridge, Cambridge University Press, 1989.

Rothenberg, Albert, and Carl R. Hausman (eds.). *The Creativity Question*. Durham, NC, Duke University Press, 1976.

Sassoon, Donald. *Becoming Mona Lisa*. New York, Harcourt, 2001.

Saussure, Ferdinand de. *Course in General Linguistics*. New York, Philosophical Library, 1959.

Sebeok, Thomas (ed.). *How Animals Communicate*. Bloomington, IN, Indiana University Press, 1977.

Shiner, Larry. *The Invention of Art*. Chicago, IL, University of Chicago Press, 2001.

Shusterman, Richard. *Pragmatist Aesthetics.* Cambridge, MA, Blackwell, 1992.

Siegel, Jeanne. *Art Talk: The Early 80s.* New York, DaCapo, 1988.

Staniszewski, Mary Anne. *Believing Is Seeing.* New York, Penguin, 1995.

Steiner, George. *After Babel; Aspects of language and translation* (Third edition). Oxford, Oxford University Press, 1998.

Tarnas, Richard. *The Passion of the Western Mind.* New York, Ballantine Books, 1991.

Thorpe, W. H. *Animal Nature and Human Nature.* Garden City, NY, Anchor/Doubleday, 1974.

Tinbergen, Niko. *The Animal in Its World.* Cambridge, MA, Harvard University Press, 1972.

Warburton, Nigel. *The Art Question.* New York, Routledge, 2003.

Williams, Raymond. *Keywords.* Oxford, Oxford University Press, 1983.

Williams, William Carlos. *Journey to Love.* New York, Random House, 1955.

Yardley, Jonathan. "A way of seeing." *Washington Post*, November 24, 2006, p. BW02.

Index